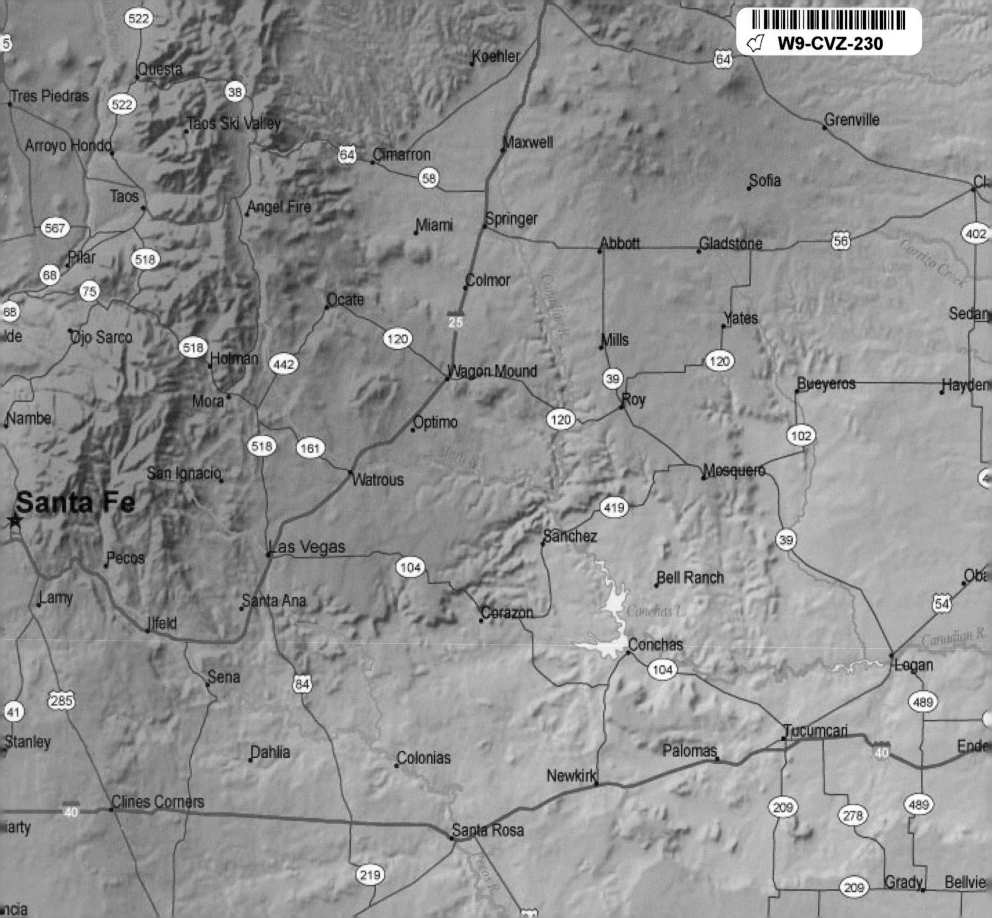

NEW MEXICO
PAST AND PRESENT ™

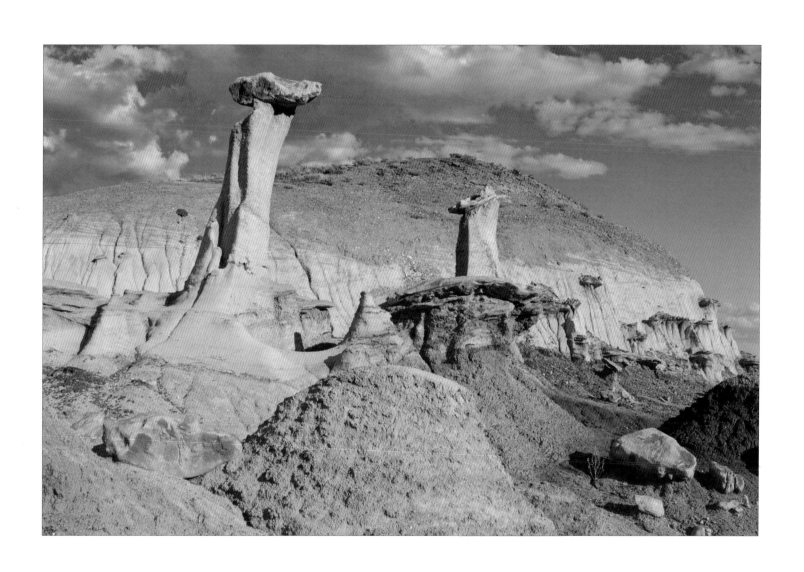

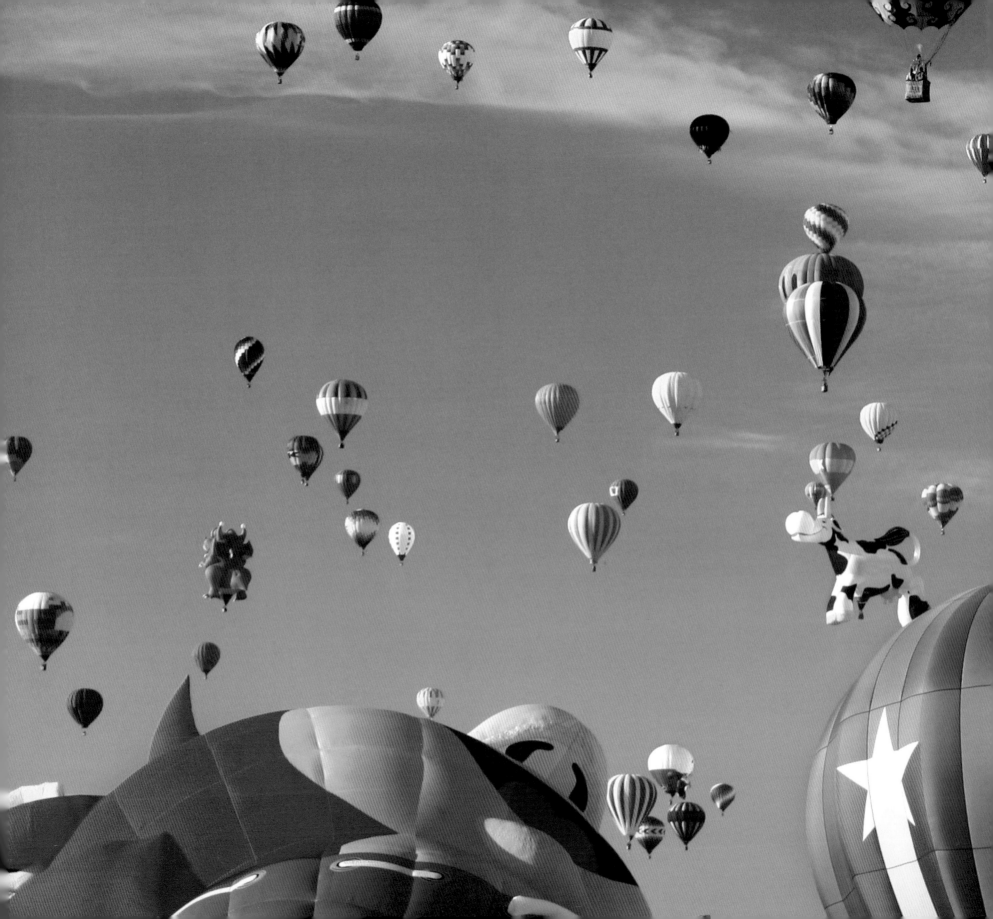

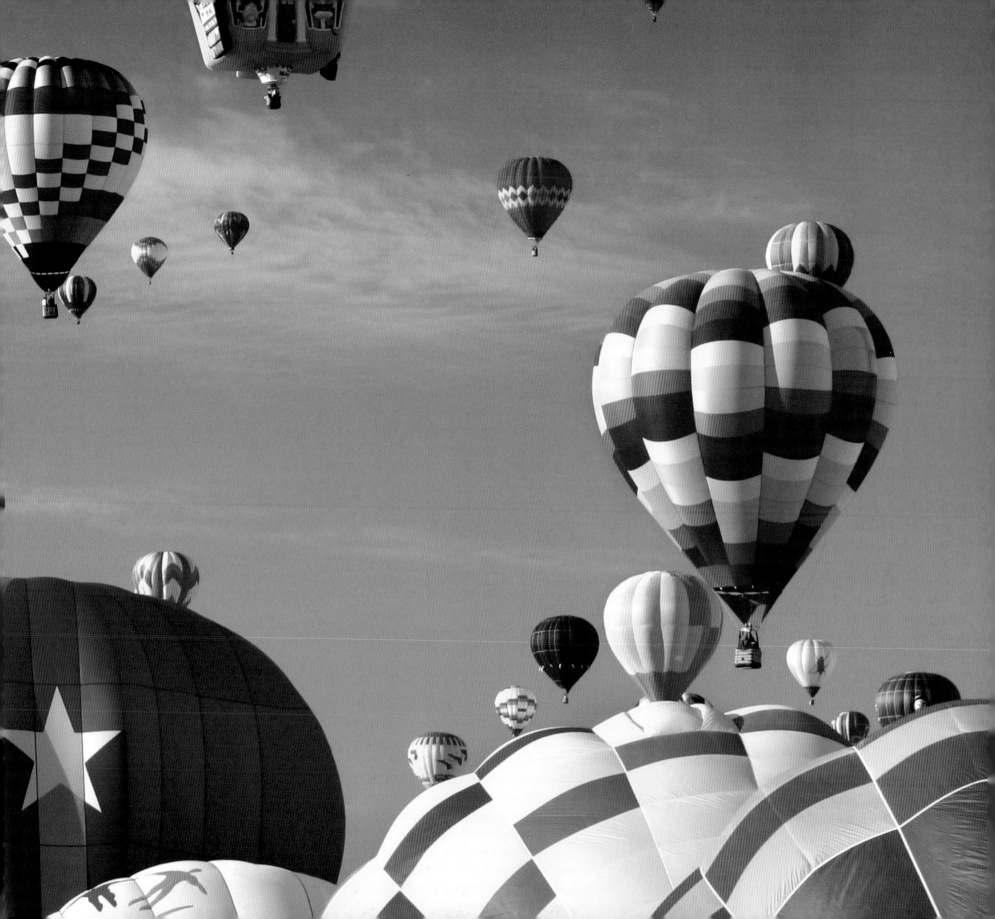

NEW MEXICO
PAST AND PRESENT™

THUNDER BAY
P·R·E·S·S

San Diego, California

Thunder Bay Press
An imprint of the Advantage Publishers Group
10350 Barnes Canyon Road, San Diego, CA 92121
www.thunderbaybooks.com

**The publishers wish to thank Daniel Kosharek and his staff for their invaluable help
with the historical images from the archives of the Palace of the Governors Photo Archives.
The publishers also wish to thank the numerous staff at the tourist offices throughout the state
for their expert help and friendliness with this project.**

ISBN 13: 978-1-60710-019-5
ISBN 10: 1-60710-019-3

Library of Congress Cataloging-in-Publication
data available upon request.

Printed in China.

1 2 3 4 5 13 12 11 10 09

CONTENTS

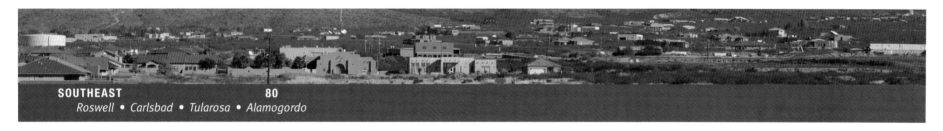

HISTORY

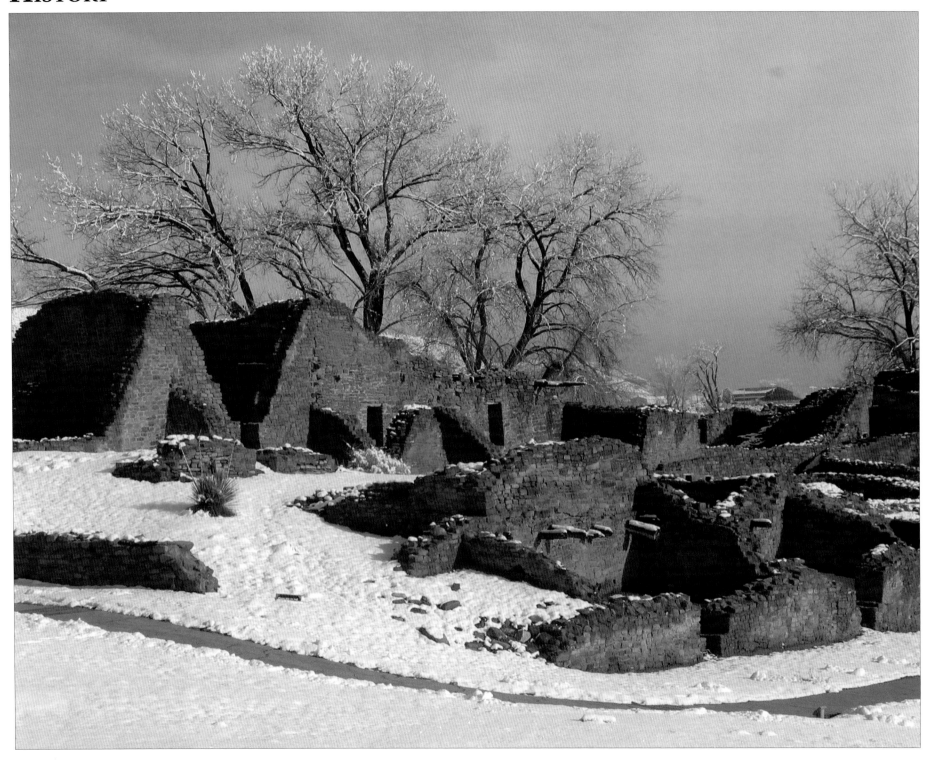

Aztec Ruins National Monument located in the City of Aztec.

History

The first foreign explorer to discover the lands which became New Mexico was the Spaniard Francisco Vásquez de Coronado who searched the area for gold in 1540–42 and claimed the "Kingdom of New Mexico" for the Spanish crown in 1540. However, it took over fifty years (until 1598) before the first Spanish settlement was built beside the Rio Grande by Juan de Oñate, and then an additional twelve years before Santa Fe was founded.

The Spanish settlement was not popular with the 100,000 or so native Pueblo peoples who were particularly infuriated by the attempted Spanish obliteration of their traditional way of life and the prohibition of their ancient religion in favor of Catholicism. At this time the New Mexico Native Americans spoke nine different languages and lived in approximately seventy pueblos in multi-storied adobe houses. Many Indians were compelled into forced labor on the *encomiendas* (trusteeship labor system that was employed by the Spanish crown during the Spanish colonization of the Americas) of the colonists and possibly also into the silver mines of Chihuahua. However, the Spanish settlement did introduce better agricultural practices and new farming equipment as well as providing added security and relative peace against Apache and Navajo raiding parties.

Disaster struck the region in the 1670s when years without sufficient rain caused drought and famine among the Pueblo peoples and their neighboring nomadic tribes. The latter in their desperation increased their attacks on the Pueblos in the hope of finding food, and even the Spanish were unable to defend against the raiders adequately. The weakened Native population also found their numbers enormously depleted by European introduced diseases such as smallpox and measles.

Such catastrophes cast enormous doubt about the protective powers of the Spanish crown and in particular the Catholic Church, so when the Native Americans returned to their old gods the Franciscan missionaries were furious and instigated a wave of repression: Pueblo medicine men were accused of witchcraft and three were hanged. One of the captured medicine men was a San Juan Indian known as Popé, who, after his forced release, instigated the Pueblo Revolt. From Taos Popé sent out runners to all the Pueblos, each messenger carried a cord knotted to show the number of days to wait until their mass uprising planned for August 18, 1680. The plot was discovered when the Spanish captured two young Tesuque Pueblo message carriers and forced the information out of them; finding out about this and in an attempt to thwart the Spanish intervention, Popé in turn brought forward the date of the rebellion to the feast day of San Lorenzo (St. Lawrence) on August 13. But on August 9, a Spanish soldier was killed and the revolt started the following day as the Pueblo Indians began to attack their oppressors.

The revolt started in Taos, Picuris, and Tewa pueblos and in the first few days eighteen Franciscan priests, three lay brothers, and 380 Spanish men, women, and children were killed. Running for their lives the Spanish settlers fled to the Spanish stronghold of Santa Fe and Isleta Pueblo, one of the few non-rebelling pueblos. When Popé's rebels set siege to Santa Fe by surrounding the city and cutting off the water supply, the Spanish governor of New Mexico, Antonio de Otermín, ordered a general retreat and on September 21, the Spanish left Santa Fe for El Paso del Norte. Not all the pueblos rebelled against the Spanish, as well as Isleta, Piro Indians left with the Spanish: the people of Isleta founded the Texan settlement of Ysleta, and still live there today.

The Spanish abandoned New Mexico, leaving the country to Popé and his supporters. Popé ordered, under penalty of death, that everything Spanish and Catholic be destroyed, with particular reference to religious imagery—this included destroying Spanish livestock and crops. The Pueblo culture remerged as Popé issued a series of orders: religious ritual rooms—known as kivas—were reopened and Indians were ordered to bathe in soap made from yucca root.

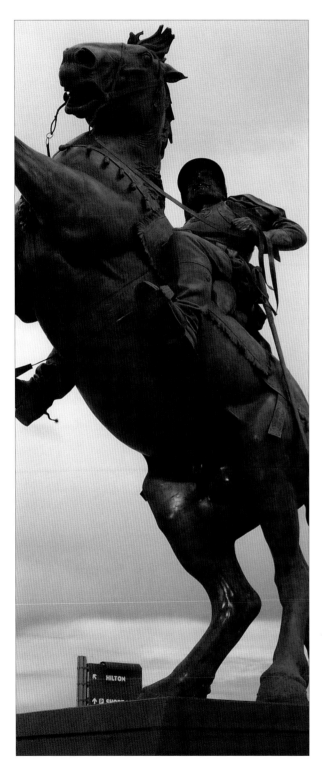

Statue of Don Juan de Oñate at El Paso Airport.

Any man married under Catholic rituals had his marriage annulled and was ordered to dismiss his wife and take others according to tradition. Wheat and barley were forbidden to be planted because of their Spanish introduction. Popé took over for himself the Governor's Palace in Santa Fe and collected tribute from each pueblo until he died in around 1688.

Inevitably after Popé's death the different pueblos disagreed as to which of the groups should occupy Santa Fe and rule the country. Such power struggles, suspicions, and rivalries, between the Pueblo peoples, combined with a seven-year drought, and regular raids from nomadic tribes weakened the Native Pueblo Indian cause and cleared the way for the Spanish return.

In July 1692 Don Diego de Vargas, accompanied by a small group of soldiers, returned to Santa Fe and surrounded the city. On September 14, the inhabitants surrendered after two months siege and agreed to the return of the Catholic Church and to swear allegiance to the king of Spain. Known as the "Bloodless Reconquest," the peace lasted for some six months before the Pueblo people went back on their agreement and recaptured Santa Fe. This time De Vargas retook the city by force and hundreds of Pueblo Indians died. During the following years De Vargas undertook several military campaigns against the rebels—but still in 1696, during the Second Pueblo Revolt, the Pueblo Indians rebelled again, in the process killing five missionaries and twenty-one Spaniards, but the revolt was largely ineffectual. The unrest did result in the Pueblo Indians gaining small concessions from the Spanish, their culture and religion were tolerated, and each Pueblo was granted substantial areas of land for their own use and a public defender was appointed to protect Pueblo Indians' rights and represent any Indians who came up against the law in the Spanish courts. Accordingly, with only minor local outbreaks of unrest, Spanish colonization of New Mexico gained acceptance and was completed by the turn of the eighteenth century.

A major aspect of the Spanish colonization was the introduction of the horse to the southern territories and the establishment of the Indian horse culture which rapidly spread across western America. During the Pueblo Revolt of 1680, huge numbers of horses were captured and even more were taken over the following years as escaped Spanish horses were collected up by the southwestern Indians who used them for raiding Spanish ranches where they stole more horses (as well as cattle), and for raiding the scattered Spanish missions across New Mexico. By the mid-seventeenth century, Native Americans were coming to New Mexico from as far away as Canada to steal horses to take home. Across America, Spanish horses were stolen or traded from tribe to tribe until virtually every tribe west of the Mississippi was mounted on Spanish animals brought to the New World. The natives also bred their animals for their own use and for trading so that when the 1803-06 Lewis and Clark expedition explored the West they traded with the Natives for their mounts. In the far West it was only the geographically isolated Native American tribes of California who remained horseless until the Spanish missionaries and settlers arrived in the 1780s.

Discovering the Southwest

Adventurers, trappers, and explorers followed in Lewis and Clark's footsteps across western and southwestern America. At the beginning of the nineteenth century, tension was high between the Spanish-held southwestern territories and the American-held northern lands, and the outbreak of a territorial war was generally anticipated. Political tensions increased after the U.S. paid France for southern lands in the Louisiana Purchase of 1806 and the politically motivated Zubulon Pike expedition of 1807 was commissioned ostensibly to define the southwestern borders of Louisiana, but probably in reality to scout the Spanish territories using Native American guides and gather intelligence with the intention of capturing Spanish-held lands. In the process, Pike reconnoitered all the way to Santa Fe where he was briefly detained in February 1807, before returning through Texas.

Other notable explorers of the Southwest after 1810 include a number of fur trappers such as Manuel Lisa, Anthony Glass, and James McLanahan. Then, in 1821, trader William Bucknell took a mule train to Santa Fe and in the process demarcated the route which became known as the Santa Fe Trail—from Missouri, thru Kansas, Oklahoma,

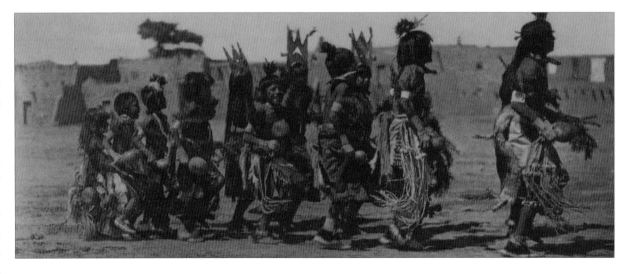

Tewa Pueblo Indians performing the Tablita dance.

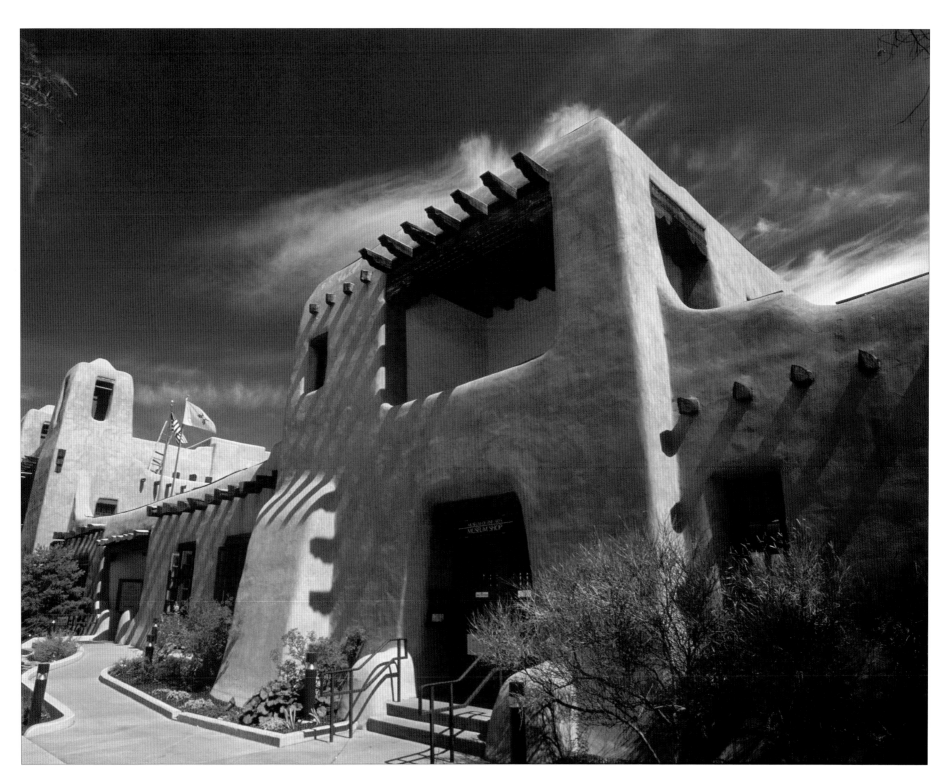

The New Mexico Museum of Art is a part of the Museum of New Mexico, which also includes the Museum of International Folk Art, the New Mexico Museum of Art, and the Palace of the Governors, Museum of Indian Arts & Culture, located in Santa Fe.

and Colorado, to New Mexico—then on to newly independent Mexico.

Mountain man Jedediah Smith started exploring the Southwest in 1822 when he traveled over most of the Old Spanish Trail. He is believed to be the first non-Native to cross the Great Basin in Nevada, the first to traverse Utah from east to west and south to north, and the first non-Native American to enter California overland from the east and to leave by another route—in all Jedediah Smith is thought to have "discovered" more of the West and Southwest than any other explorer.

Later, soldier, scout, trapper, and Indian agent, fourteen-year-old Kit Carson left Missouri in 1826 and headed westward with a wagon train to Santa Fe. In 1828 he made his base at Taos from where he went fur trapping to the Rocky Mountains of Colorado, before heading farther west into the Sierra Nevadas of California. In the process he worked with many Native Americans and became so immersed in their culture that he married an Arapahoe woman, and then a Cheyenne. Stories were soon told about Carson with his unassuming manner, honesty, and courage and that he was a man whose "word was as sure as the sun comin' up." In 1842 Carson met politician and explorer John Charles Fremont on a Missouri riverboat, and the latter hired Carson as a guide for his first expedition to map and describe the Western trails through Oregon and California to the Pacific Ocean. Fremont's popular reports describing his travails and companions soon made mountain man Kit Carson into a national hero.

After becoming embroiled in the Mexican-American War of 1846, Carson returned to Taos and his third wife Maria Josefa Jaramillo, and to a new life as a sheep rancher. But increasing Navajo and Apache plundering raids made Carson abandon his intent to retire to his ranch and instead, in 1853, he accepted an appointment as U.S. Indian agent, working from his headquarters at Taos from where he successfully fought against the mostly Navajo insurgents who refused to be confined in their designated government reservation.

Centuries of continued conflict with the Apache and the Navajo plagued the territory. In 1864 Carson waged brutal war against the Navajo by destroying their crops, livestock, and orchards: with no option but to surrender the following year, almost 8,000 Navajo took the brutal "Long Walk" from Arizona to Fort Sumner, New Mexico, in 1860–61. Although harshly repressed, the Navajo continued their raiding and returned to most of their lands in 1868. The equally rebellious Apache continued sporadic raiding until their chief, Geronimo, finally surrendered to the authorities in 1886.

Mexican-American War

Following the annexation of Texas from Mexico by the U.S. in 1845, the Mexican government refused to accept the situation, and armed conflict broke out between the two protagonists in 1846. That year, U.S. General Stephen W. Kearny with his army of 300 cavalry men, 1,600 Missouri volunteers, and the 500-strong Mormon battalion marched down the Santa Fe Trail and entered Santa Fe without opposition. There, Charles Bent (a Santa Fe trail trader living in Taos) and Kearny established a joint civil and military government with the former as acting civil governor.

Kearny divided his forces into four commands: one group under Colonel Sterling Price (the newly appointed military governor) and his 800 or so men, was tasked to occupy and maintain order in New Mexico. The second group of a little over 800 men under Colonel Alexander William Doniphan was ordered to capture El Paso and Chihuahua and then join up with General Wool. Kearny himself took the third command of about 300 mule-mounted dragoons and headed for California. They were supported by Lt. Col. Phillip St. George Cooke and the mostly infantry Mormon Battalion who had instructions to follow Kearny with wagons to establish a new southern route to California. However, almost 200 of Kearney's dragoons were sent back to New Mexico when Kearny encountered Kit Carson, traveling eastward and bearing messages that California had already been subdued.

Kearny also protected New Mexico citizens under a form of martial law called the Kearny Code: his and the U.S. army's promise that religious and legal claims

The Kit Carson House in Taos, New Mexico, is a designated National Historic Landmark.

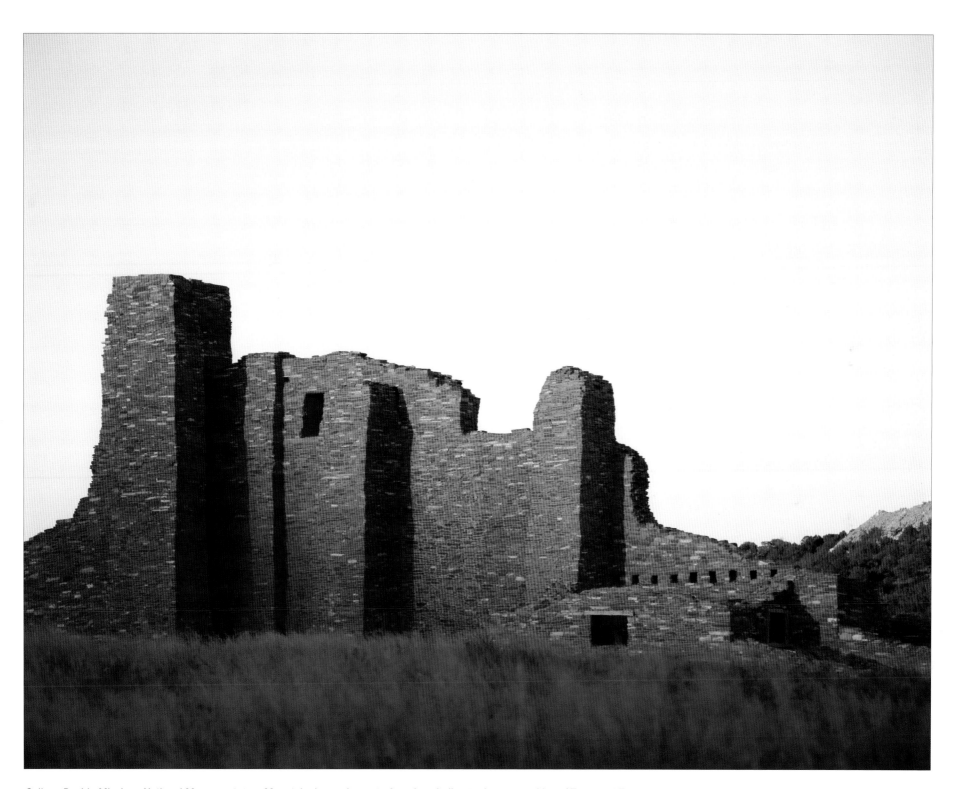

Salinas Pueblo Missions National Monument near Mountainair was home to American Indian trade communities of Tewa and Tompiro-speaking Puebloans.

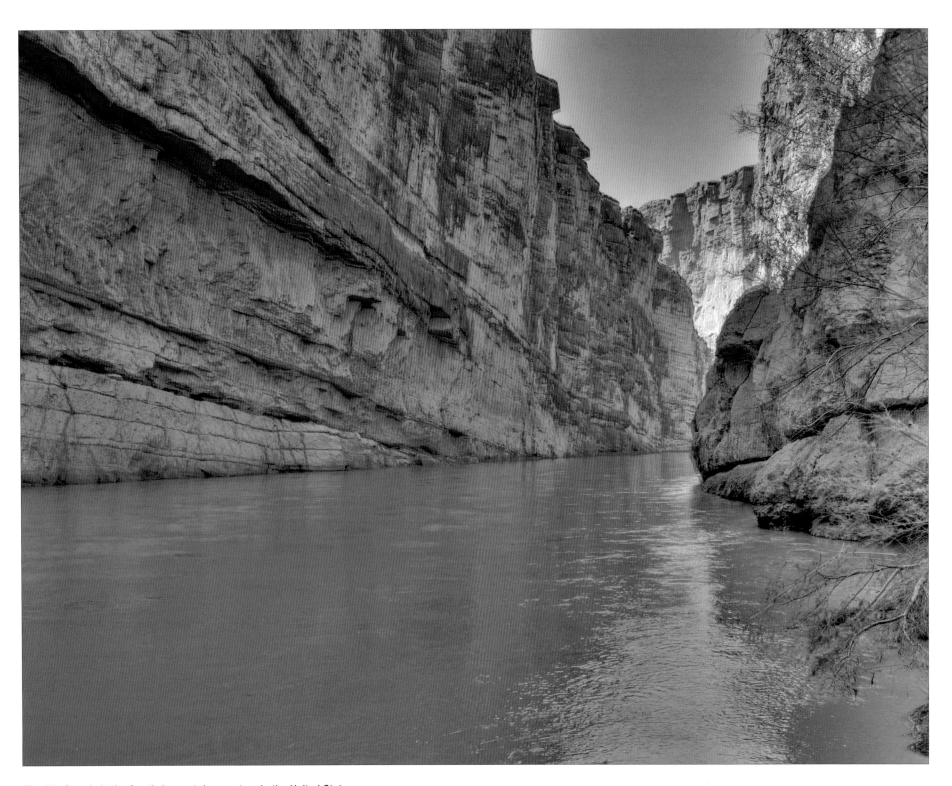

The Rio Grande is the fourth-longest river system in the United States.

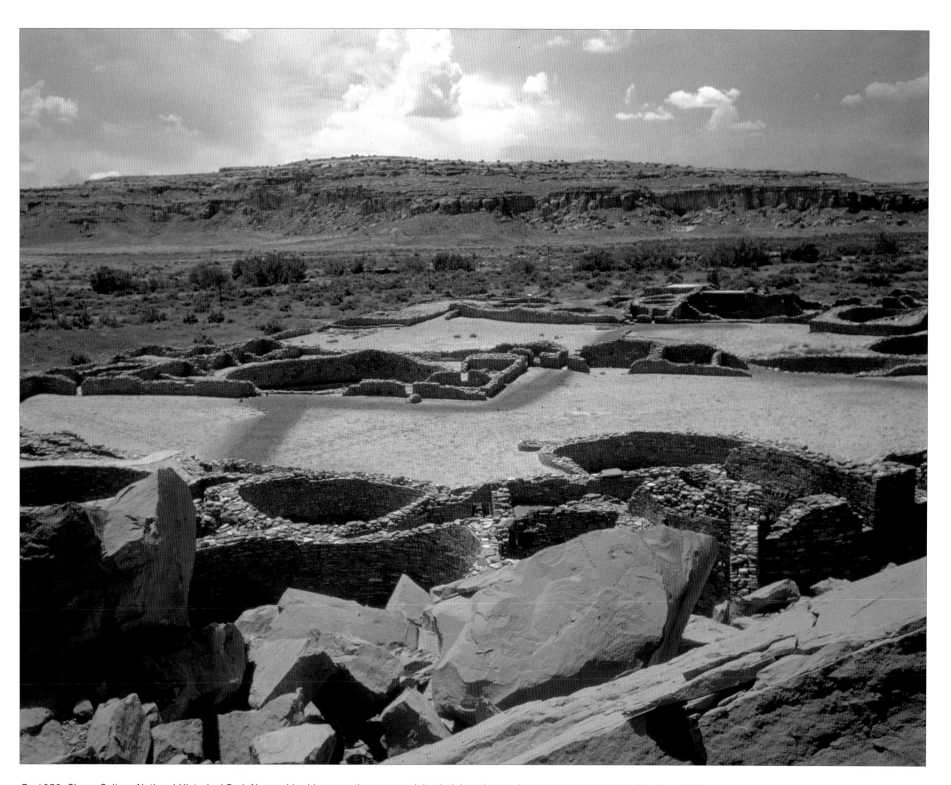

By 1050, Chaco Culture National Historical Park Nageezi had become the ceremonial, administrative, and economic center of the San Juan Basin.

El Malpais National Monument in Grants. El Malpais means "the badlands" with lava flows, cinder cones, pressure ridges, and complex lava tubes that dominate the landscape.

would be respected by the U.S. with law and order maintained by the U.S. Army.

Kearny's arrival and takeover in New Mexico was virtually uncontested as the Mexican authorities absconded with all the available money and retreated into southern Mexico. When Kearny left, a minor rebellion broke out in Taos Pueblo. On January 19, 1847, the Taos rebels—nearly all Pueblo Indians—ambushed and killed acting Governor Charles Bent alongside about ten other Americans living in the town. Immediately, a U.S. detachment under Colonel Sterling Price marched on Taos and attacked the rebels who withdrew into a strongly built church. Concentrated cannon fire killed about 150 rebels and led to the capture of 400 more; six rebel leaders were arraigned for their role in the Taos Revolt, tried, and on February 9, 1847 hanged. Price had to fight two more engagements against the rebels (again mostly Pueblo Indians), but by mid-February the revolt was virtually stifled out.

Treaty of Guadalupe Hidalgo

At the end of the war, the peace Treaty of Guadalupe Hidalgo (1848) provided for the Mexican Cession in which Mexico handed over much of its mostly unsettled northern holdings (areas now known as California, Nevada, and Utah, as well as parts of Colorado, Arizona, Wyoming, and New Mexico) to the U.S. in exchange for an end to hostilities, the evacuation of Mexico City, and many other areas under American control, but the retention of Mexican citizens' property rights. Texas was also recognized as a part of the United States. In return, Mexico received $15 million cash, plus the assumption of slightly over $3 million in outstanding Mexican debts.

The territory between Texas and California was named New Mexico and contained sufficient population to comprise a state, but Congress refused to pass the necessary legislation. The new areas acquired directly by New Mexico were the territories of Alta California and Santa Fe de Nuevo Mexico, and the Rio Grande became the border between Texas and Mexico. More controversially, the Senate removed Article X, which stated that vast land grants (mostly gifts from local authorities to favored people) would remain in Mexican ownership and could be passed down to their heirs. This hugely unpopular decision still causes grievance, especially as millions of acres of land, timber, and water rights were removed from the Hispanic communities and transferred to the public domain. However, the earlier Spanish-issued land grants were almost all upheld, including those made to the various Pueblo peoples.

American Territory

In 1850 the anti-slavery movement dominated American politics and the Congressional Compromise of 1850 halted a bid by New Mexico for statehood under a proposed antislavery constitution. Texas transferred eastern New Mexico to the federal government and in the process started a lengthy boundary dispute. Under the Compromise, the American government established the New Mexico Territory on September 9, 1850; the territory included all of Arizona and New Mexico, with parts of Colorado. Santa Fe became the official capital in 1851.

The new U.S. territory of New Mexico held a census in 1850 that found 61,547 people living within its jurisdiction. Although there were never many slaves in New Mexico, the issue of slavery was still hotly debated and New Mexico's proposed statehood and constitution were intertwined with the issue. New Mexico could apply for statehood but only Congress could grant it, but decisions had to be reached about slavery. Some Congressmen (including Illinois politician Stephen A. Douglas, the Democratic nominee for the presidency in 1860) maintained that the territory could not restrict slavery, while others (including Abraham Lincoln) insisted that older Mexican legal traditions, which forbade slavery, took precedence.

The U.S. acquired the mostly desert southwestern boot heel of the state and southern Arizona below the Gila River in the Gadsden Purchase of 1853. The reasoning for buying the land from Mexico was that a much easier route for a proposed transcontinental railroad was located slightly south of the Gila River and west of the Rio Grande. The Southern Pacific built the second transcontinental railroad though this purchased land in 1881. This territory had not been explored or mapped when the Treaty of Guadalupe Hidalgo was negotiated in 1848. The land was sold because the president of Mexico, Santa Anna, was in power again in 1853 and needed the money from the Gadsden Purchase to fill his coffers and to pay the Mexican army that year. With this latest land the territory of New Mexico was complete.

On January 14, 1861, the House of Representatives Committee of Thirty-Three finally concluded its long debates concerning slavery: a majority now agreed on a constitutional amendment to protect slavery where it existed and also the immediate admission of New Mexico Territory as a slave state. After the Peace Conference of 1861, a bill for New Mexico statehood was tabled by a vote of 115 to 71, with opposition coming from both Southerners and Republicans.

During the American Civil War, Confederate troops from Texas briefly occupied southern New Mexico before Union troops recaptured the territory in early 1862. As Union troops were withdrawn to fight elsewhere, Kit Carson helped to organize and command the 1st New Mexican Volunteers to engage in campaigns against the Apache, Navajo, and Comanche in New Mexico and Texas as well as participating in the Battle of Valverde (1862) against the Confederates. Confederate troops withdrew after the Battle of Glorieta Pass (1862) after the Colorado Volunteers and New Mexican Volunteers defeated them.

As the American West opened up New Mexico filled with settlers and became more regulated. The Roman Catholic Church established an archbishopric

in Santa Fe in 1875, and the Santa Fe Railroad reached Lamy, New Mexico (only sixteen miles from Santa Fe in 1879), and then Santa Fe itself in 1880, replacing the fabled Santa Fe Trail. The new town of Albuquerque grew around the old settlement as the Santa Fe Railroad extended westward.

The railroad encouraged the great cattle boom of the 1880s and the development of accompanying cow towns. Brutal feuds between cattlemen and sheepherders—as well as the authorities—became the norm for a time. In New Mexico one of the most notable incidents was the Lincoln County War of 1878 between wealthy ranchers and the rich owners of the general store in Lincoln County—this became the stuff of Western legends as characters like Billy the Kid became notorious. The sheepherders finally prevailed and in time the homesteaders and squatters fenced in the land and plowed the "sea of grass" on which the cattle fed. The more people arrived, the greater the number of conflicting land claims between the original Spanish settlers, incoming cattle ranchers, and even more recent homesteaders. Nevertheless, despite the destructive overgrazing, ranching survived as a mainstay of the New Mexican economy. Albuquerque, on the upper Rio Grande, was incorporated in 1889.

Finally, on January 6, 1912, New Mexico was admitted as the forty-seventh state in the Union. Neighboring Arizona Territory, which had been split from New Mexico as a separate territory in 1863, also became a state a few weeks later on February 14, and completed the contiguous forty-eight states. In New Mexico equal voting rights for women proved almost as difficult to achieve as removing slavery and New Mexico's legislature was the thirty second state and one of the last to ratify the 19th Amendment to the U.S. Constitution in 1920 allowing women to vote.

New Mexico today

New Mexico is a land richly blessed with natural resources and is a leading supplier of potassium salts and uranium as well as natural gas, petroleum, gold, silver, copper, zinc, lead, and molybdenum. Since 1945 such resources have helped New Mexico become a leader in energy research and development with the prestigious Los Alamos Scientific Laboratory built by the U.S. government in 1943 during World War II. Top-secret personnel developed the atomic bomb, first detonated at the Trinity site in the desert on the White Sands Proving Grounds not far from Alamogordo, on July 16, 1945. Also, Sandia National Laboratories (founded in 1949) carried out nuclear research and special weapons development at Kirtland Air Force Base, south of Albuquerque. Both institutions lead investigation into nuclear, geothermal, and solar energy resources. In other areas, New Mexico's economy is driven by the manufacture of food products, chemicals, transport equipment, lumber, electrical machinery, and products made from glass, stone, and clay. Two-thirds of the state's farm income is derived from livestock products, principally sheep. The most important field crops are pecans, cotton, and sorghum, although peanuts, corn, onions, beans, chilies, and lettuce also have prominence.

New Mexico tourist attractions include the Carlsbad Caverns National Park, Inscription Rock at El Morro National Monument, the ruins at Fort Union, Billy the Kid mementos at Lincoln, the White Sands and Gila Cliff Dwellings national monuments, Bandelier National Monument, and the Chaco Culture National Historical Park.

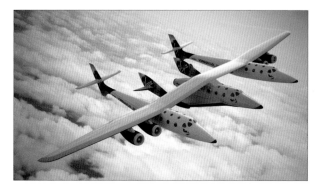

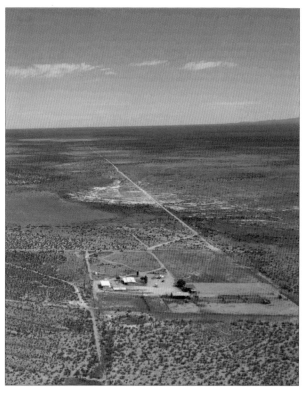

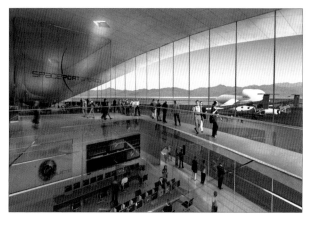

In 2005 Governor Richardson and Sir Richard Branson announced that Virgin Galactic will make New Mexico its world headquarters. Virgin Galactic is a company within Sir Richard Branson's Virgin Group which plans to provide sub-orbital spaceflights to the paying public. Spaceport America's construction began in 2008 and is expected to be completed by 2010. It is currently being developed on 27 square miles of state-owned desert near Upham, an uninhabited place in Sierra County, New Mexico. The site is 45 miles north of Las Cruces. The design concepts of the Spaceport were created by URS/Foster + Partners with construction advice being given by the URS Corporation.

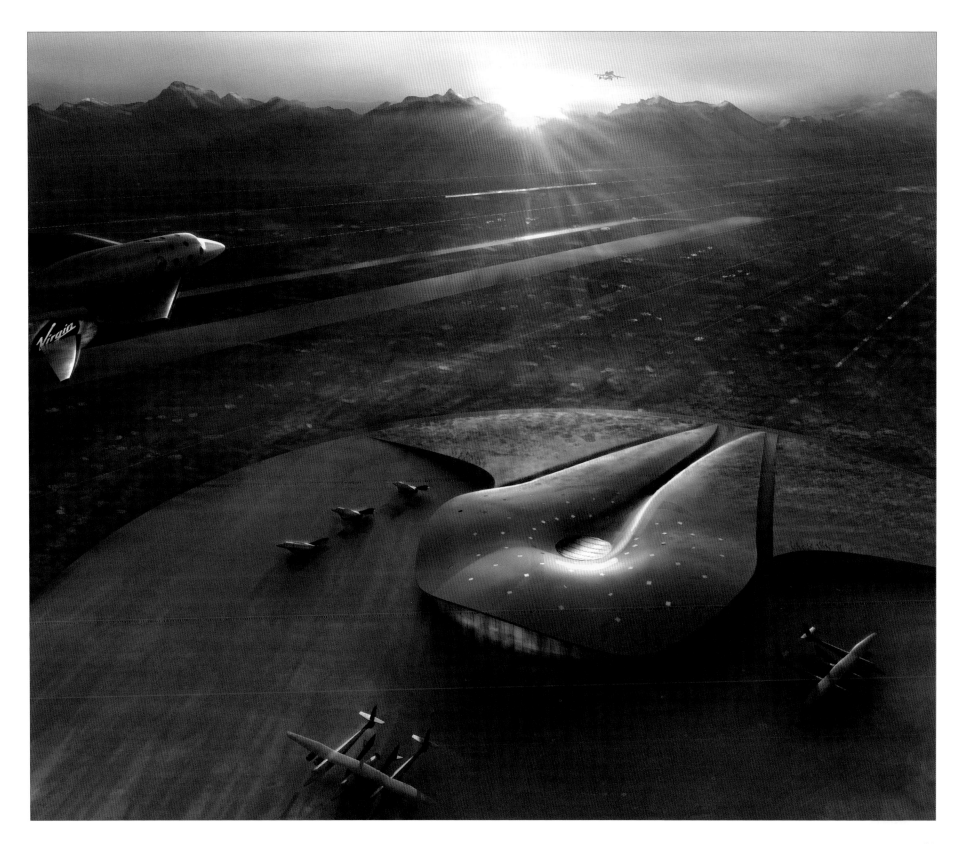

STATE FACTS

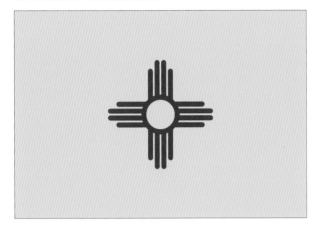

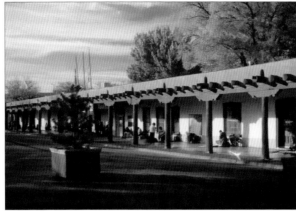

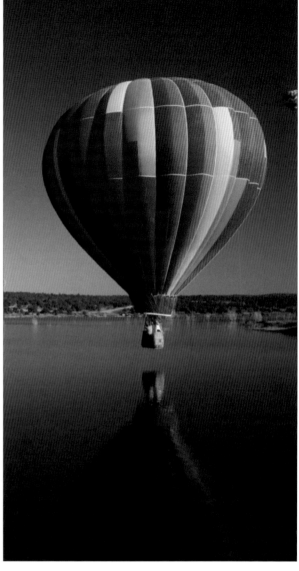

STATE FLAG
Originally designed in 1923, the flag is in the yellow and red colors of Isabella of Castile. The yellow background (or field) sports a central red sun symbol, or "zia." The zia comes from Zia Pueblo and reflects tribal philosophy and pantheistic spiritualism teaching the basic harmony of everything in the universe. It became the official flag in 1925.

STATE CAPITOL
New Mexico has two state capitols: The Palace of the Governors (*above*) was built in 1610 and was in use for almost three centuries for Spanish, Mexican, and American governments. It is now a museum. The current capitol building (*below*), dedicated in 1966, is a mix of New Mexican style, with Pueblo adobe elements, and Greek revival embellishments.

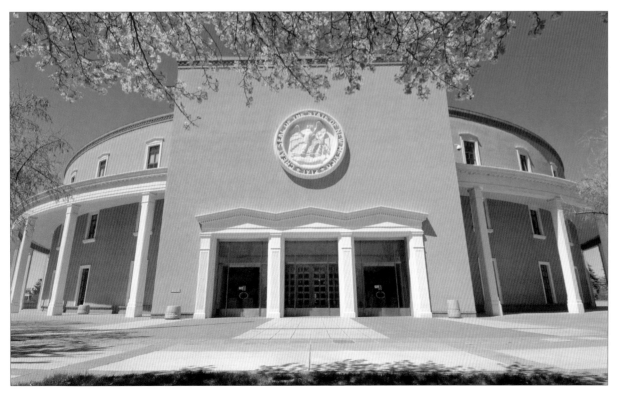

STATE AIRCRAFT
The hot air balloon became the official state aircraft on March 1, 2005. The first balloon rally was held in Roswell in 1973, which was so successful that it developed into the World Balloon Championship. Now Albuquerque is "the balloon capitol of the world" and every October hosts the International Balloon Fiesta filling the skies with hundreds of beautiful, colorful, and unusually shaped balloons from all over the world.

At El Morro National Monument in Ramah, ancestral Puebloans and Spanish—along with American travelers—carved over 2,000 signatures, dates, messages, and petroglyphs for hundreds of years.

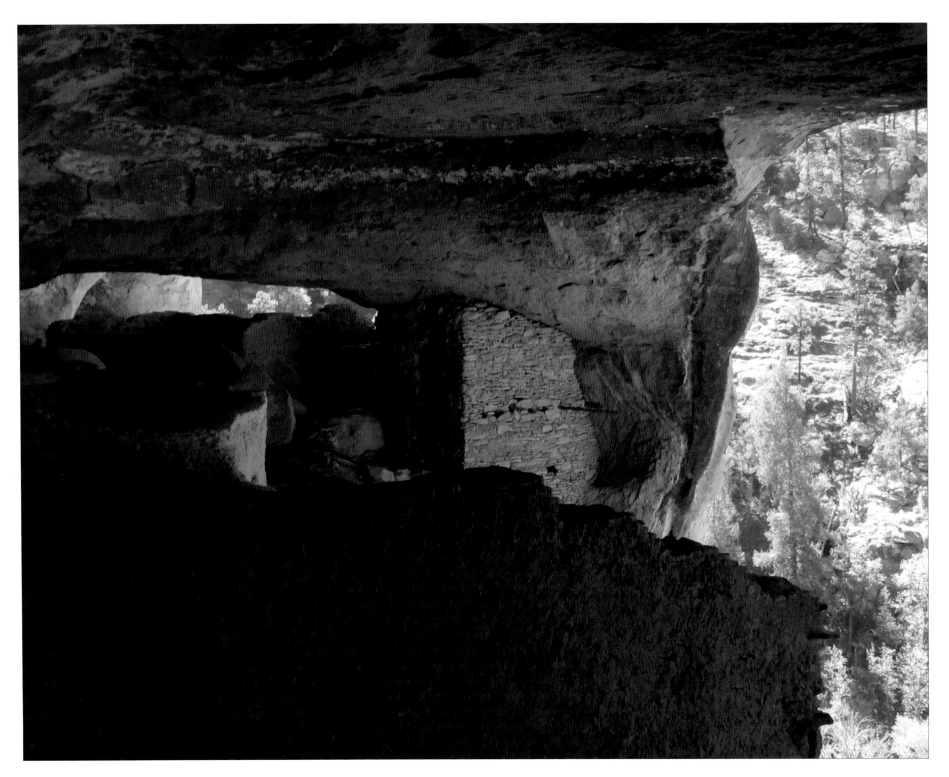

Gila Cliff Dwellings in Silver City are home to the Mogollon people who lived in this area over 700 years ago.

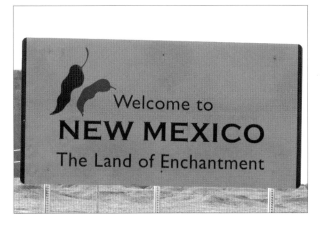

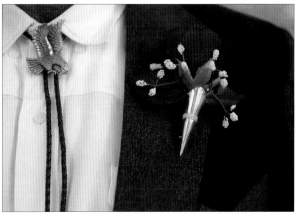

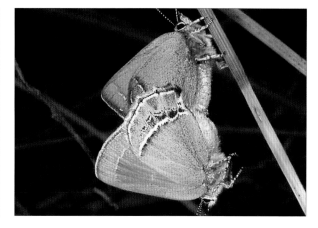

STATE NICKNAME

The phrase "Land of Enchantment" was first coined by Lillian Whiting in 1906 as the title of her book about New Mexico. By 1935 the phrase was being used to encourage tourism to New Mexico and six years later it was being used on license plates. It became the official nickname of New Mexico in 1999.

STATE BOLO TIE

The western-style bolo tie evolved from the neckerchiefs worn by Argentine cowboys and Boy Scouts, as well as from the Navajo men who hung a silver conch from a string around their necks. It can be worn with a closed or loosened collar and became the official state tie in 2007.

STATE BUTTERFLY

The Sandia Hairstreak (*Callophrys mcfarlandi*) appears spring and early summer mornings across the dry Beargrass hillsides in much of New Mexico. The caterpillar is pink, maroon, or green and found on Beargrass where it feeds on flowers and fruits. The male butterfly is predominantly brown, while the female is reddish brown, and both have golden-green underwings.

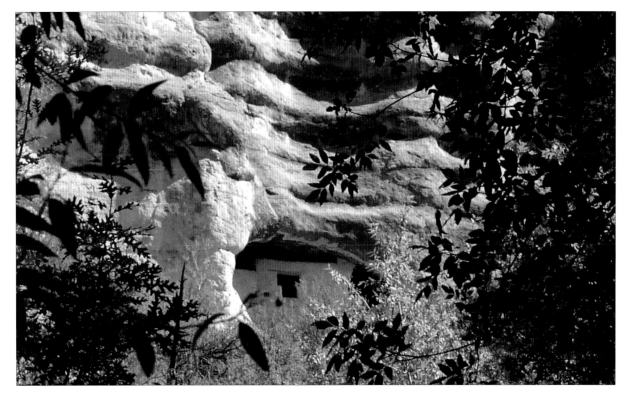

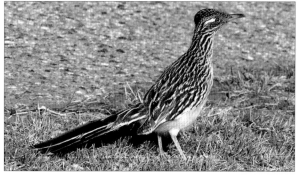

STATE BIRD

The Greater Roadrunner (*Geococcyx californianus*), adopted as official bird in 1949, is a large ground cuckoo found across southwestern America. Many Native Americans believe the roadrunner possesses supernatural powers. Since 1969 "Dusty Roadrunner" has been the official litter control symbol of New Mexico, promoting the importance of preservation and conservation of natural resources.

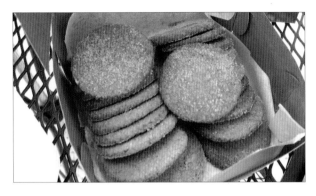

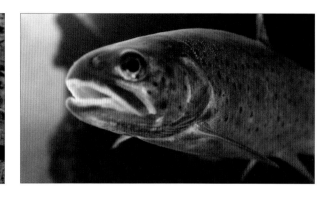

STATE COOKIE

The biscochito is a small, anise-flavored cookie baked since early Spanish times for special celebrations such as weddings, holidays, baptisms, and other important occasions. It became the official state cookie in 1989 and was chosen to encourage and maintain traditional home baking.

Biscochitos Recipe

6 cups flour
¼ tsp. salt
3 tsp. baking powder
1 ½ cups sugar
2 tsp. anise seeds
2 eggs
2 cups lard or shortening
¼ cup brandy
¼ cup sugar
1 tbsp. cinnamon

Sift together the flour, baking powder, and salt. In another bowl, cream the shortening with sugar and anise seeds until fluffy. Beat in the eggs one at a time, then add the brandy. Add both mixtures together and beat to a dough. Refrigerate for 2-3 hours. Turn dough out on floured board, let it warm slightly, and roll to ¼ or ½ inch thickness. Cut into shapes—fleur-de-lys is traditional. Dust with a mixture of sugar and cinnamon. Bake for 10-12 minutes on an ungreased baking sheet at 350° or until light brown.

STATE AMPHIBIAN

The New Mexico Spadefoot (*Spea multiplicata*) right across New Mexico. Named for the small, hard, wedge-shaped structure on each hind leg for digging into moist soil, the males are around 2.5in long and vary in color around the gray/ brown/green spectrum. The amphibians live underground until the rains fill low-lying areas when the males emerge and start calling the females.

STATE FISH

The Rio Grande Cutthroat Trout (*Oncorhynchus clarki*) aka the New Mexico Cutthroat Trout, is found in cold mountain streams and lakes across northern New Mexico. Up to 10 in long and weighing up to one pound, these yellow-green or gray-brown, black spotted fish can live for up to eight years.

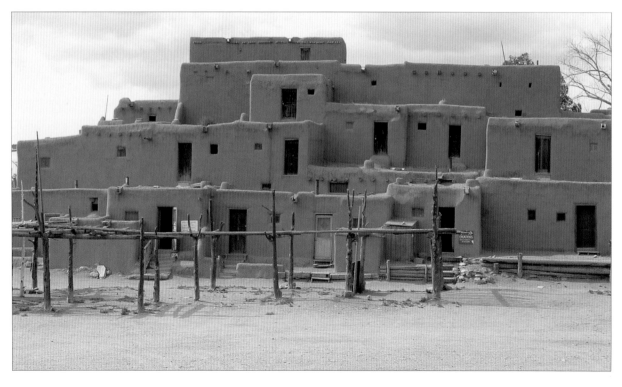

Taos Pueblo is an ancient pueblo belonging to a Tewa-speaking tribe of Pueblo people. It was designated a National Historic Landmark on October 9, 1960, and in 1992 became a World Heritage Site.

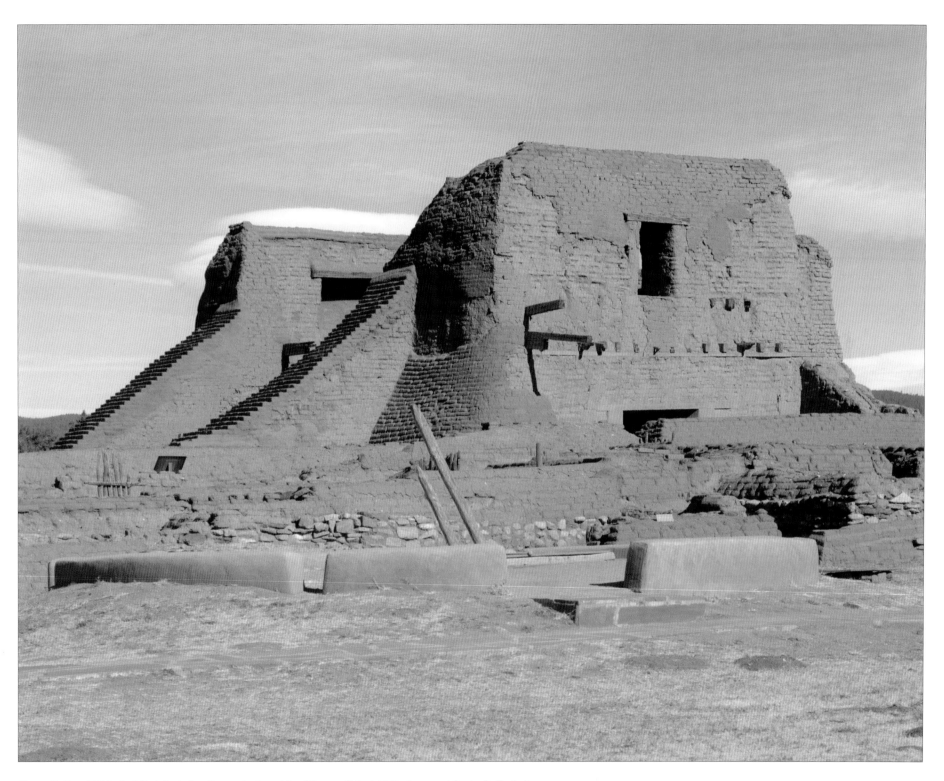

Pecos National Historical Park includes the ancient pueblo of Pecos, Colonial Missions, and Santa Fe Trail sites.

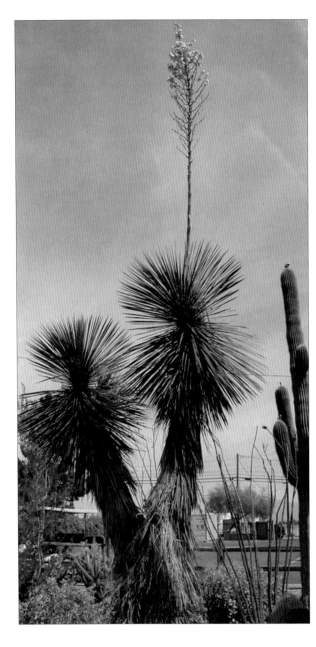

STATE FOSSIL

Coelophysis bauri, a mid-triassic Period (about 228 million years ago) early, small, hollow-boned, dinosaur, was first found at Ghost Ranch in Rio Arriba County, New Mexico in 1947. It was probably a fast-moving, possibly warm-blooded, long-tailed carnivorous dinosaur about 9 feet long and some 50 or so pounds in weight.

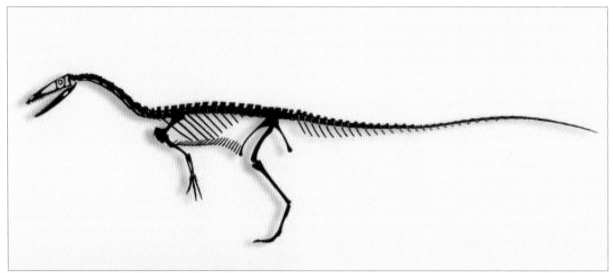

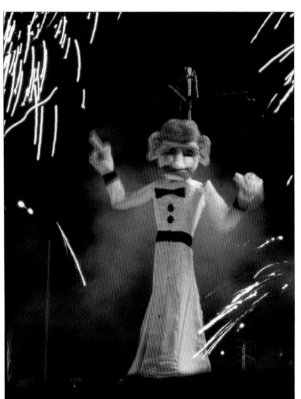

Left: Zozobra ("Old Man Gloom"), a giant marionette effigy that is burned during Fiestas de Santa Fe, usually during the second week of September. Zozobra embodies gloom; by burning him, people destroy the worries and troubles of the previous year in the flames. Attended by 40,000, his burning marks the start of three days of celebration that includes traditional Mass at St. Francis Cathedral; a reenactment of the Entrada, when Don Diego de Vargas returned to the city; a Children's Pet Parade; and the Historical/Hysterical Parade.

Below: New Mexican Cowboys stand in the beautiful sunset.

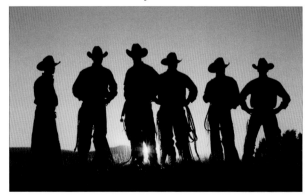

STATE FLOWER

The Soaptree Yucca (*Yucca elata*) grows up to 30 feet high with roots ranging out for at least 100 feet looking for water. It lives in moving sand dunes such as White Sands National Monument, near Alamogordo. The roots and stems were crushed by settlers for a soap substitute and the creamy white flowers eaten by cattle during drought.

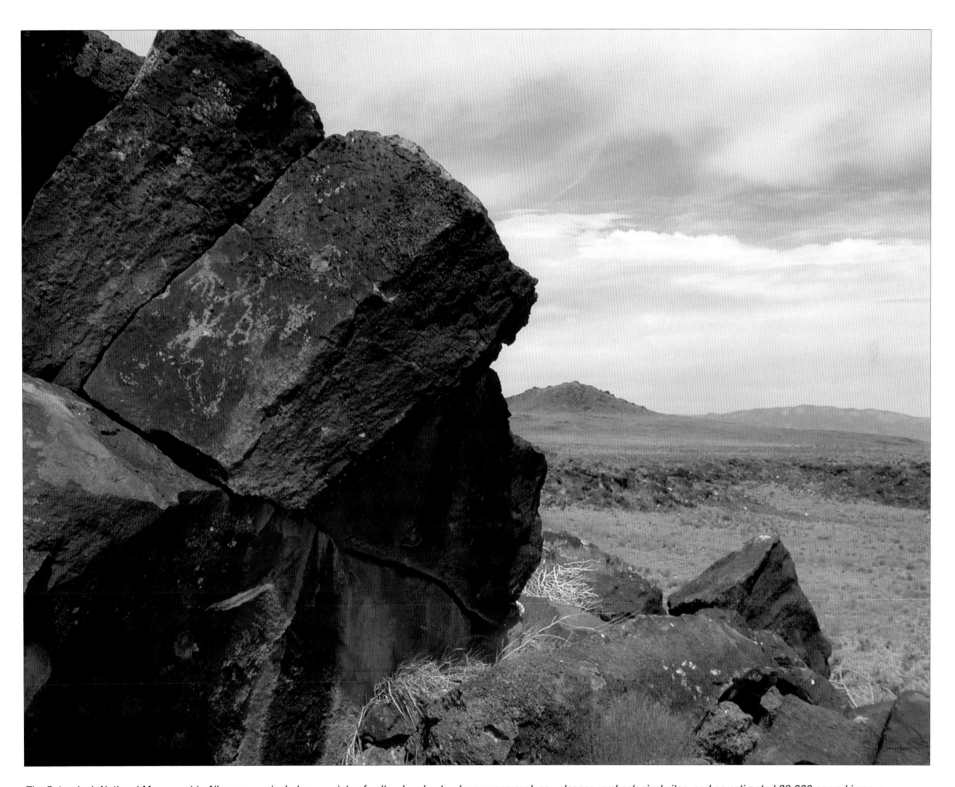

The Petroglyph National Monument in Albuquerque includes a variety of cultural and natural resources such as volcanos, archeological sites, and an estimated 20,000 carved images.

STATE SONG

"O, Fair New Mexico" is the official state song and was written by Elizabeth Garrett in around 1915 and became the official state song two years later. Elizabeth was the blind daughter of the Lincoln County Sheriff Pat Garrett. A qualified voice and piano teacher and popular performer of songs she was known as the "Songbird of the Southwest." "Así Es Nuevo Méjico" is the title for the Spanish version written by contemporary composer Amadeo Lucero.

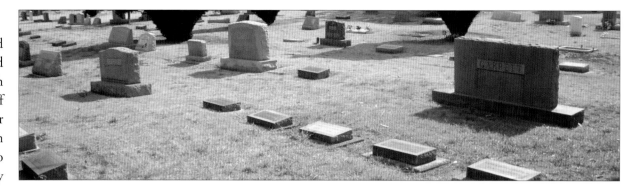

Garrett family burial site at the Masonic Cemetery in Las Cruces

English

Under a sky of azure, where balmy breezes blow;
Kissed by the golden sunshine, is Nuevo Méjico.
Home of the Montezuma, with fiery heart aglow,
State of the deeds historic, is Nuevo Méjico.

Chorus

O, fair New Mexico, we love, we love you so
Our hearts with pride o'erflow, no matter
 where we go,
O, fair New Mexico, we love, we love you so,
The grandest state to know, New Mexico.

Second Verse

Rugged and high sierras, with deep canyons below;
Dotted with fertile valleys, is Nuevo Méjico.
Fields full of sweet alfalfa, richest perfumes bestow,
State of apple blossoms, is Nuevo Méjico.

(Chorus)

Third Verse

Days that are full of heart-dreams, nights
 when the moon hangs low;
Beaming its benediction o'er Nuevo Méjico.
Land with its bright mañana, coming through
 weal and woe;
State of our esperanza, is Nuevo Méjico.

(Chorus)

Spanish

Un canto que traigo muy dentro del alma
Lo canto a mi estado, mi tierra natal.
De flores doradas mi tierra encantada
De lindas mujeres, que no tiene igual.

Chorus

Así es Nuevo Méjico
Así es esta tierra del sol
De sierras y valles de tierras frutales
Así es Nuevo Méjico.

Second Verse

El negro, el hispano, el anglo, el indio
Todos son tus hijos, todos por igual.
Tus pueblos y aldeas, mi tierra encantada
De lindas mujeres que no tiene igual.

(Chorus)

Third Verse

El Río del Norte, que es el Rio Grande,
Sus aguas corrientes fluyen hasta el mar y
riegan tus campos
Mi tierra encantada de lindas mujeres
que no tiene igual.

(Chorus)

Fourth Verse

Tus campos se visten de flores de Mayo
De lindos colores
Que Dios les doto
Tus pájaros cantan mi tierra encantada
Sus trinos de amores
Al ser celestial.

(Chorus)

Fifth Verse

Mi tierra encantada de historia bañada
Tan linda, tan bella, sin comparación.
Te rindo homenaje, te rindo cariño
Soldado valiente, te rinde su amor.

(Chorus)

STATE SLOGAN

"Everybody is somebody in New Mexico" is the official slogan for business, industry, and commerce in New Mexico. It was adopted as the official slogan in 1975.

STATE POEM

"A Nuevo Mexico" by Luis Tafoya was published for the first time in 1911. It became the official state poem in 1991. Written in Spanish, it is a hymn of praise to the wonders and glories of New Mexico and its peoples, both historic and present.

Spanish

Levanta, Nuevo México,
esa abatida frente
que anubla los encantos
de tu serena faz,
y alborozado acoge
corona refulgente,
Símbolo de gloria y de ventura
y paz.

Después de tantos años de
lucha y de porfía,
tu suerte se ha cambiado
y ganas la victoria,
llegando a ver por fin
el venturoso día
que es colmo de tu
dicha y fuente
de tu gloria.

Has sido un gran
imperio, colmado de riqueza,
y grandes contratiempos
tuviste, que sufrir,
mas ahora triunfo pleno
alcanza tu entereza,
y el premio a tu constancia
pudiste conseguir.

Tu pueblo por tres
siglos aislado y solitario,
de nadie tuvo ayuda,
de nadie protección,
lucho por su
existencia osado y temerario,

sellando con su sangre
dominio y posesión.

Tras tan heroico esfuerzo
por fin has merecido
el bien que procurabas

con insistencia tanta
de que en la Unión de Estados
fueses admitido
con la soberania que
al hombre libre encanta.

Obstáculos y estorbos del
todo desaparecen,
y entrada libre tienes
a la gloriosa Unión, En
donde los ciudadanos prosperan
y florecen,
con tantas garantías
y tanta protección.

Por tan pasmosa dicha
el parabién te damos,
a ti como a tus hijos,
de honor tan señalado,
y que en tu nueva esfera
de veras esperamos
que a fuerza de gran
imperio serás
un gran estado.

English

Lift, New Mexico,
your tired forehead
That clouds the enchantment
of your peaceful face,
And joyfully receive
the bright crown,
Symbol of glory, venture,
and peace.

After so many years of
fight and persistence
Your luck has changed
and you gain victory,
Reaching up to see your
fortunate day at last
That is an overflow of
happiness and the fountain
of your glory.

You have been a great
empire filled with riches,
And many mishaps you
had to suffer,
But now complete triumph
reach up to your integrity,
and reward for your consistency,
you were able to achieve.

Your people for three
centuries, isolated and lonely,
With help or protection
from nobody,
They fought for their
existence, reckless and daring.

Sealing with their blood
their dominion and possession.

After such heroic effort
finally you deserve
The goodness with such
an insistence you procure,
To be admitted in the state
of the union
With the sovereignty that
is a free man's enchantment.

Obstacles and hindrance for
good they disappear,
And free admittance you have
to the glorious union,
Where the people prosper
and flourish
With so many guarantees
and great protection.

For that marvelous
satisfaction we welcome you,
You and your children
such a deserved honor,
And in your new sphere
we truly hope
That by dint of
imperiousness a great state
you will become.

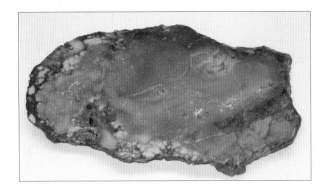

STATE GEM

Turquoise, known as chalchihuitl to the Navajo and Pueblo Indians, is a phosphate of aluminum containing small amounts of copper, iron, and green variscite. Native Americans highly prize the stone, used for trade and for personal adornment often set with silver in jewelery pieces. It became the state gem in 1967.

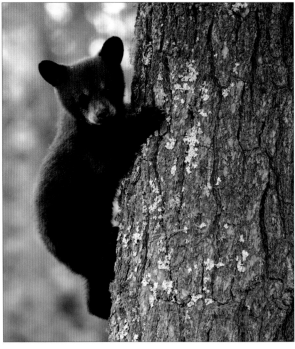

STATE MAMMAL

The American Black Bear (*Ursus americanus*) ranges in woodland from Alaska to northern Mexico. Smokey Bear, probably the most famous bear in the history of the United States, was a cub first found cowering in a tree after a 17,000-acre forest fire in the Lincoln National Forest near Capitàn. In 1950 Smokey was selected by the U.S. Forest Service and the Advertising Council as a spokesman and symbol for fire prevention campaigns all across the country. Smokey served in this capacity for the rest of his life, even after his death in 1975. He is buried in Smokey Bear State Park in Capitàn.

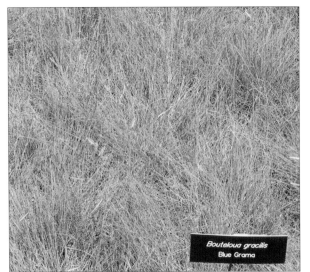

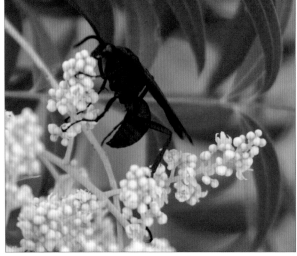

STATE GRASS

Blue Grama (*Bouteloua gracilis*) is found in all thirty-three New Mexico counties. As a perennial grass it provides invaluable forage for cattle and grows in a variety of habitats up to 8,000 feet. Native Americans used its seed to make a flour for bread and Blackfoot Indians used the grass to predict the weather.

STATE INSECT

Tarantula Hawk Wasp (*Pepsis formosa*), or "Tarantula Hawk," is a black-bodied, orange-winged solitary wasp up to 1.2 inches long, making it probably the largest in the U.S. It lives in the flowers of trees and shrubs where it hunts large spiders that it paralyzes then lays an egg on.

STATE QUESTION

"Red or Green?" This refers to chili peppers when ordering New Mexican cuisine. This measure was passed to signify the importance that the chili industry has on the economy of the state. New Mexico produced 99,000 tons of chile in 2000, valued at nearly $49 million.

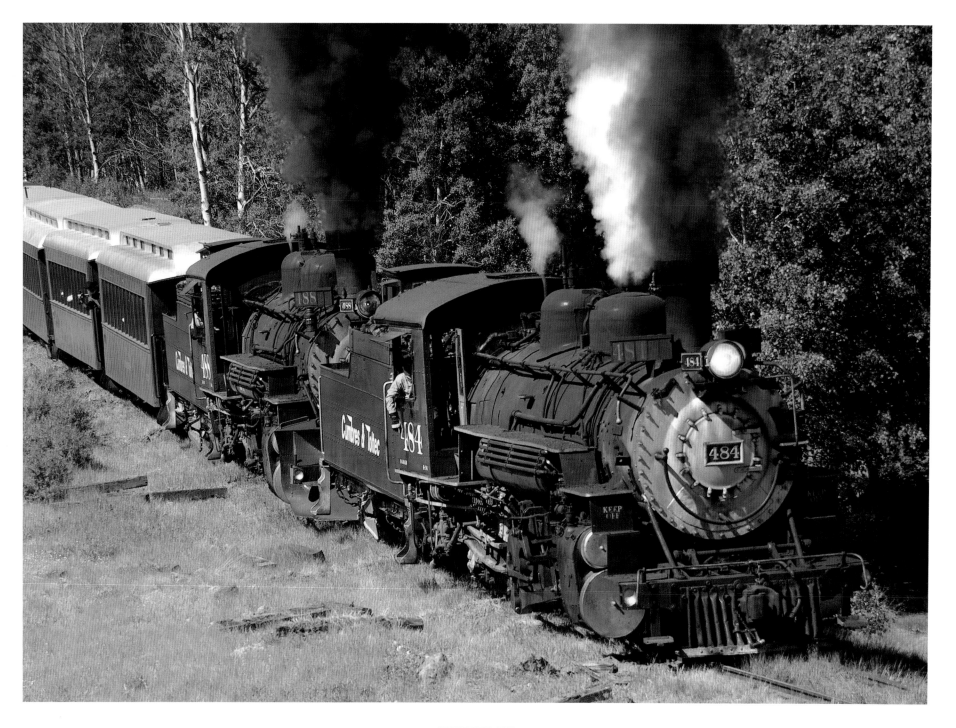

STATE TRAIN

The Cumbres & Toltec Railroad was built in the 1880s and ran for 64 miles between Chama, New Mexico, and Antinito, Colorado, through tunnels and over narrow trestle bridges through stunning mountainous terrain. Now this preserved railroad is a major tourist attraction known as "America's longest and highest narrow-gauge steam railroad."

STATE REPTILE

The New Mexico Whiptail (*Cnemidophorus neomexicanus*) was first collected and recognized in 1947. It lives in desert grasslands and riverside habitats where during the cooler daylight hours it hunts moths, butterflies, beetles, ants, larvae, and grasshoppers. The whiptail is greenish-gray and sports wavy vertebral stripes and lighter spots.

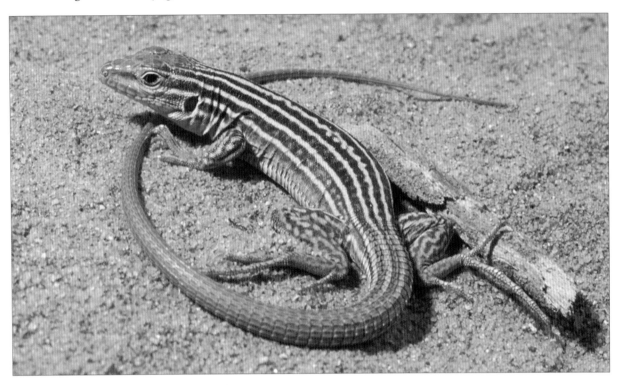

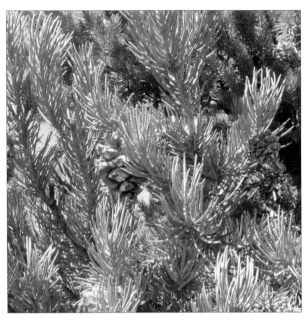

STATE TREE

The Piñon Pine (*Pinus edulis*), known as Two Needle Piñon, is a slow-growing, dry habitat, smallish (only up to 35 feet tall) tree found widely across the southwestern states. Native Americans have eaten its pine nuts for centuries—competing with birds, especially the Piñon Jay, bears, and other wildlife for the pleasure.

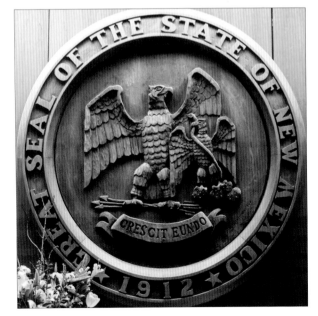

STATE SEAL

The Great Seal of the State of New Mexico is dated 1912—when New Mexico became a state—and features the American Bald Eagle with outstretched wings protectively sheltering a smaller Mexican eagle. On a banner below the eagles is the motto *Crescit Eundo*, which was added in 1882.

STATE MOTTO

"*Crescit Eundo*" translates as "it grows as it goes" and was added to the Great Seal in 1882 by Territorial Secretary W. G. Ritch. It is a quotation from Lucretius, the first-century Latin poet, and refers to a thunderbolt gaining strength as it moved across the sky—a symbol of dynamic progress.

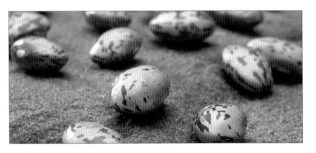

STATE VEGETABLES

Frijoles (*Phaseolus vulgaris*), aka pinto bean, and the chili (*Capsicum annum*) are inseparable ingredients in Native New Mexican cuisine, and in 1965 jointly became the state vegetables. The pinto bean is a staple of Pueblo Indian diet; chilies were introduced by the Spanish from Mexico.

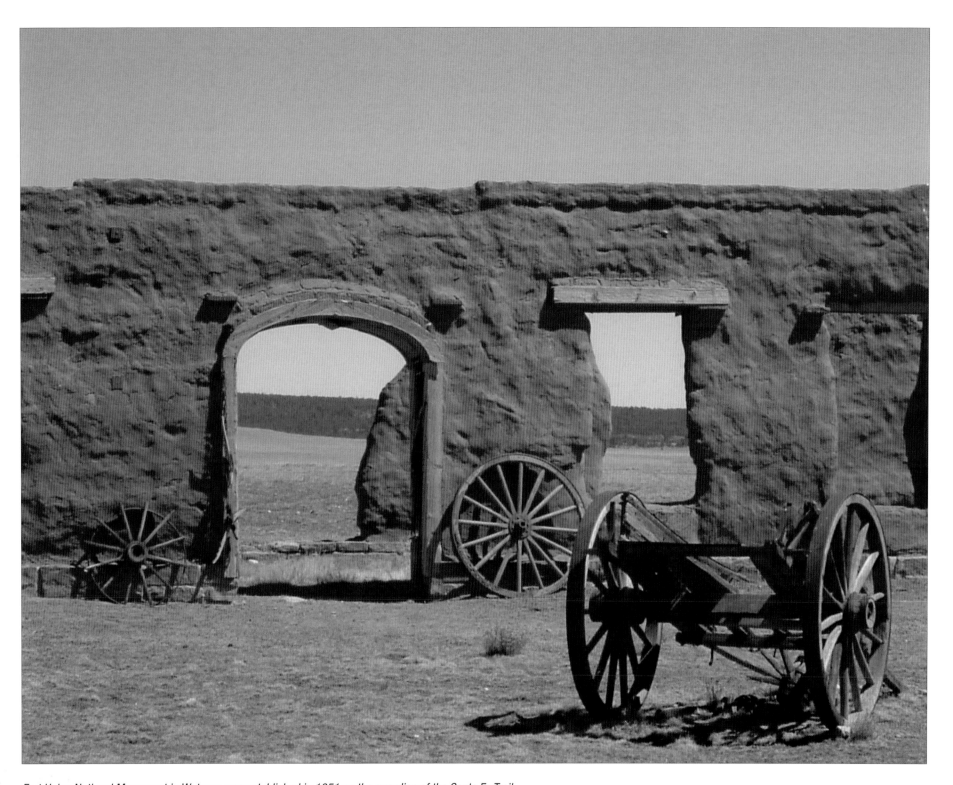

Fort Union National Monument in Watrous was established in 1851 as the guardian of the Santa Fe Trail.

SPRINGER

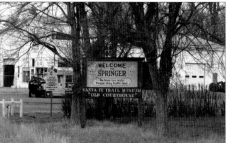

Springer is located in Colefax County, originally the territory of Utes and Apaches, then later trappers, hunters, cattlemen, prospectors, pioneers, and the inevitable outlaws. Thanks to its high altitude (5,857 feet) Springer has a more equable climate, as does much of New Mexico, attracting people suffering from respiratory ailments.

Most of the land of modern day Colefax County was originally given in 1870 to Lucien B. Maxwell, in what became known as the Maxwell Land Grant. The original town was called Maxwell after him but changed to Springer after the famous lawyer and paleontologist Frank Springer.

In 1879 the Santa Fe railroad passed through Springer and brought in many new people and businesses. The town grew fast and quickly became the center of trade in northern New Mexico.

Fort Union, 48 miles south of Springer, was established in 1851 to protect travelers along the Santa Fe Trail from Indian attacks. There was a range war in Springer in 1881, when Maxwell sold his land grant to a group of investors. Typically fought over for water rights or grazing rights to unfenced/unowned land, it could pit competing farmers or ranchers against each other. Range wars were known to occur in the American West, especially prior to the Taylor Grazing Act of 1934, which regulated grazing allotments on public land. It was the headquarters of the Military Department of New Mexico and one of the largest forts in the Southwest.

This is a favorite stop-off point for many tourists in northern New Mexico, especially history buffs and fans of the Old West.

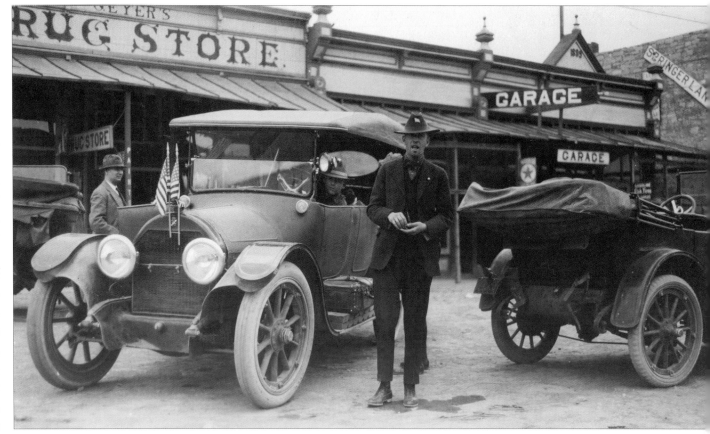

An early photograph shows the Springer Drug Store, c. 1900.

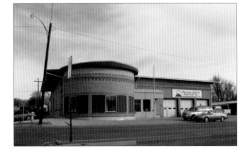

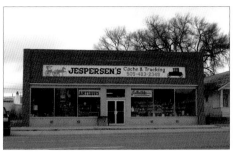

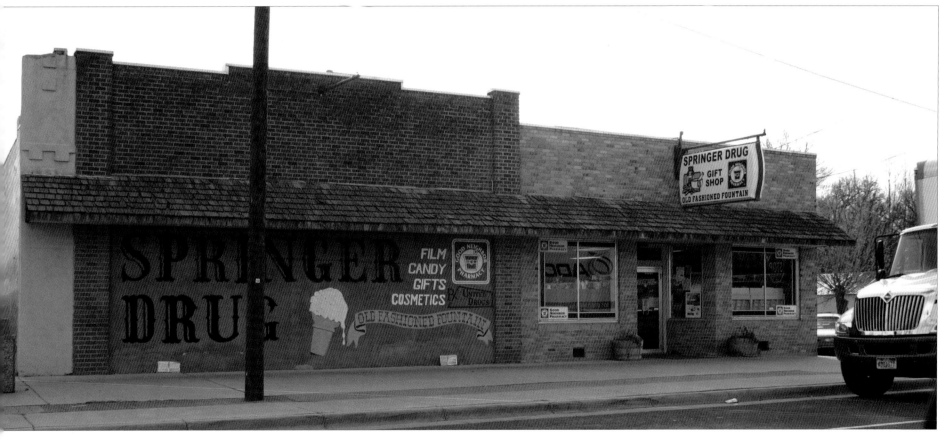

The Springer Drug Store now stands a few streets away from the original location.

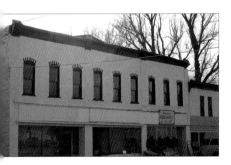
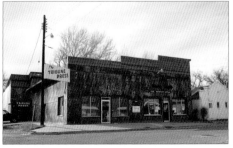

TAOS

Early Pueblo peoples built Taos Pueblo and Picuris Pueblo. Taos was the center of the Pueblo Rebellion of 1680 when Spanish settlers were driven away from the region only to return in 1669 when Don Diego de Vargas resettled the area. As the Southwest was opened up and other strangers arrived, Taos became the main center for mountain men such as Kit Carson whose third wife was local woman Maria Josefa Jaramillo. During the Mexican-American War, some Taos people rebelled and killed the U.S. Territorial Governor Charles Bent in his Taos home as he tried in vain to escape.

When peace returned to the land, artists discovered the beauty of Taos and ever since then a succession of artists and other cultural luminaries have made Taos their home and inspiration—people such as Ansel Adams, Carl Jung, D.H. Lawrence, and Georgia O'Keeffe, to name just a few. Perhaps inevitably the attractions of Taos also appealed to the hippies of the 1960s and early 1970s, indeed many of them stayed on to live here still.

Local landmark "Bridge to Nowhere" was built in 1965. This suspension bridge across the Rio Grande is the second-highest bridge in the U.S. and was so called at the time because the funds did not exist to continue the road on the other side. In 1970, in a landmark decision by the U.S. government, the sacred Blue Lake was returned to Taos Pueblo. Today, Taos has a population in excess of 12,000, drawing tourists from all over the country to visit this town steeped in history. The Taos ski valley occupying over 1,300 acres of terrain is a popular winter resort. In the summer it offers numerous recreational activities.

A 1920s photograph of Kit Carson's original home.

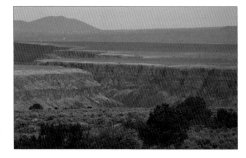 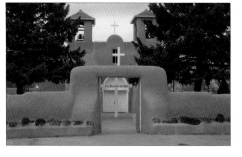

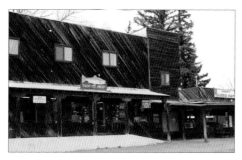

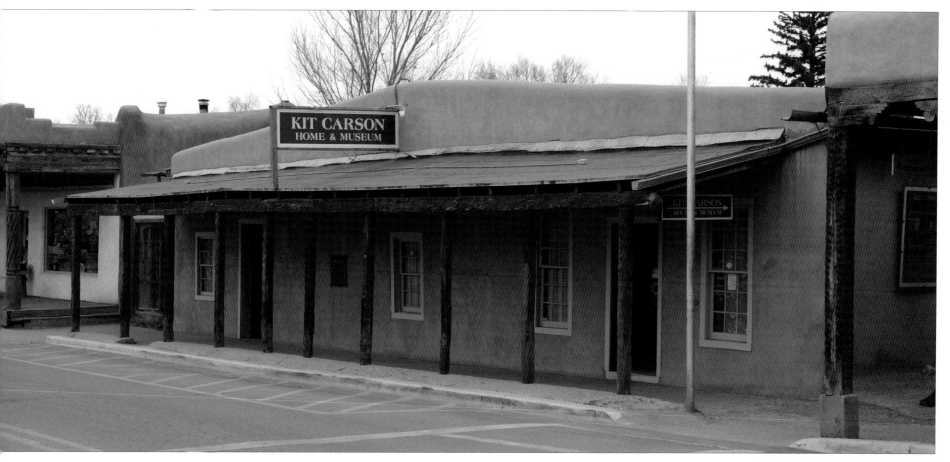

e same building now preserved as a museum to the memory of this famous mountain man.

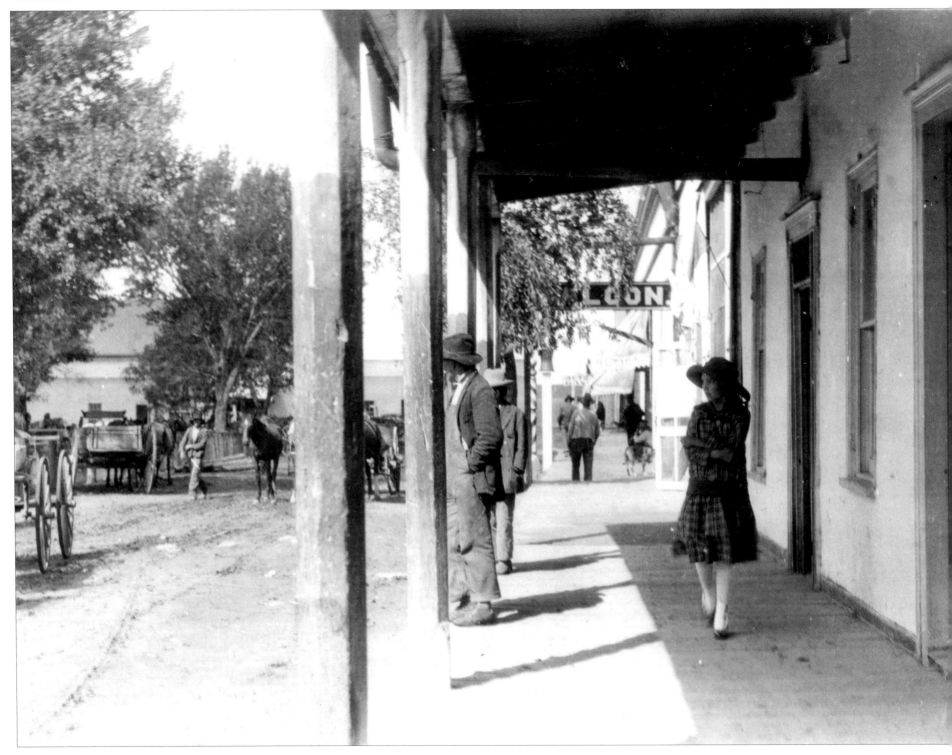

Old Taos Plaza, c. 1880, originally served as a central meeting place for local residents.

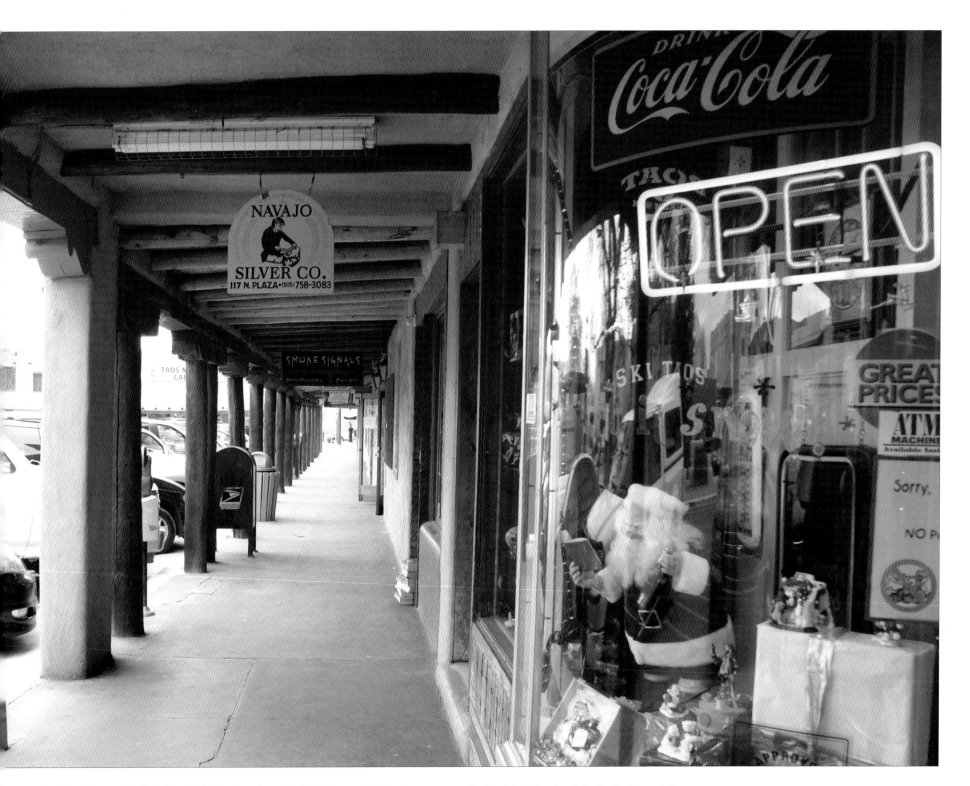

Present-day Taos Plaza—the first place to fly the American flag both day and night—is now a popular tourist destination full of galleries and shops.

Taos

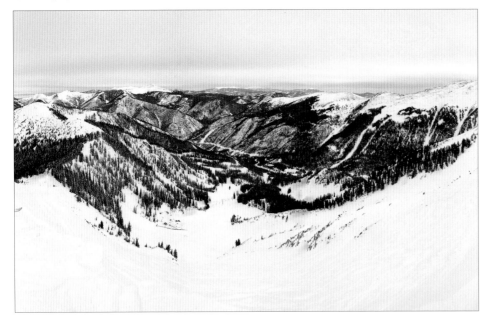

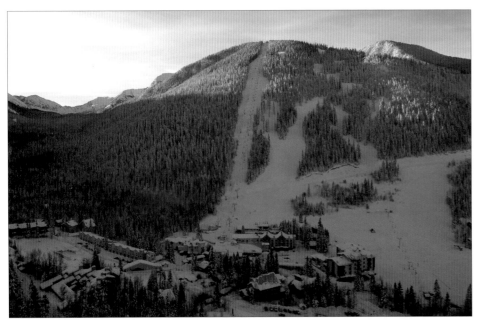

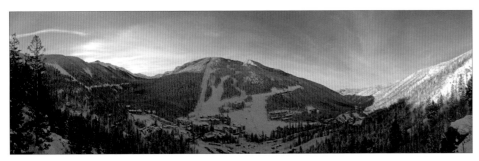

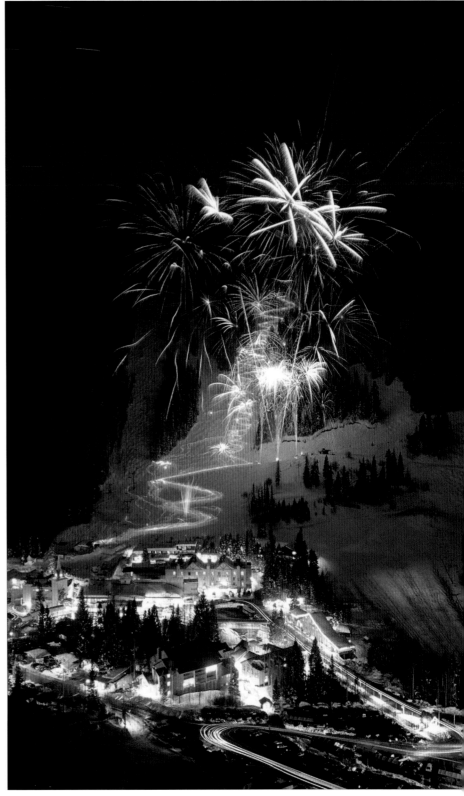

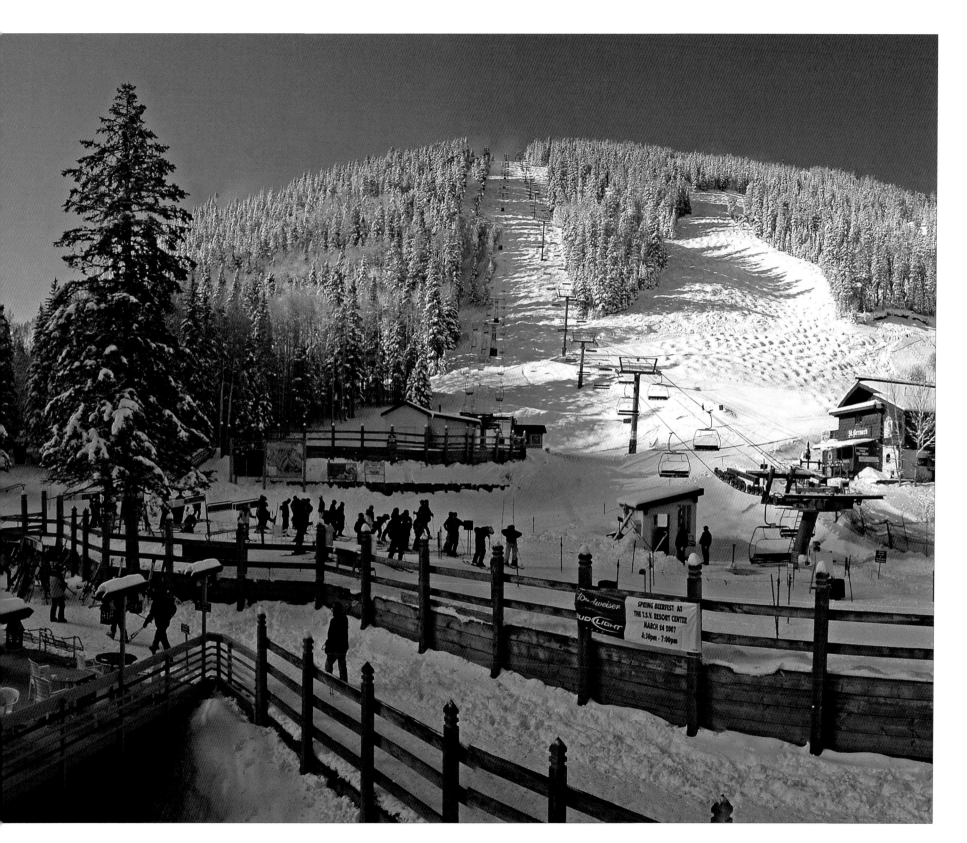

POJOAQUE

Pojoaque pueblo was settled around 500 AD and is one of the six Tewa-speaking Rio Grande Pueblos and a member of the Eight Northern Pueblos. Pojoaque had its largest population way back in the fifteenth and sixteenth centuries.

The first mission in Pojoaque was the San Francisco de Pojoaque Mission in the early 1600s.

During the Pueblo Revolt of 1680, Pojoaque was abandoned and left empty until around 1706. Resettlement was slow but by 1712 the census shows the population had risen to seventy-nine people. Much later, around 1900, a severe smallpox epidemic ravaged Pojoaque and twelve years later the pueblo was once again abandoned. Long years of abandonment passed until the pueblo was again resettled in 1934 and became a federally recognized Indian reservation two years later.

Pojoaque and Pojoaque Pueblo are neighboring communities in Santa Fe County.

Pojoaque Pueblo is an Indian reservation, and the town of Pojoaque is a collection of communities near the Pueblo with people from various ethnic backgrounds.

The largest and most expensive resort in New Mexico—Buffalo Thunder, a 61,000-square-foot casino themed in pueblo-style architecure—was opened in Pojoaque in August 2008 to join the Cities of Gold Casino.

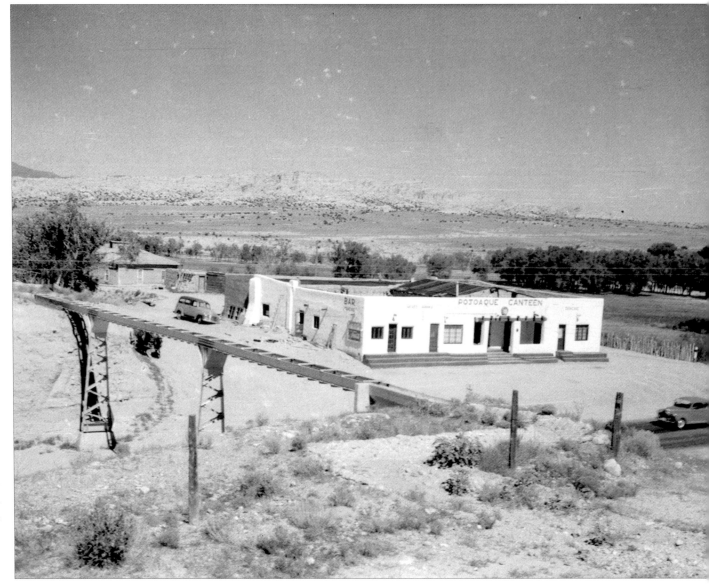

Pojoaque Canteen, as seen in 1949.

e local church and cemetary serves the population of over a thousand people, many of whom are now employed in the two casinos on the reservation.

SANTA FE

 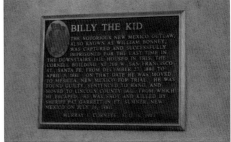

Santa Fe is the oldest capital city on the entire continent of North America being originally settled by the Conquistador Don Pedro de Peralta in 1609, more than ten years before the Pilgrims established Plymouth Colony in Massachusetts in 1620. Santa Fe became the center and capital of the Spanish "Kingdom of New Mexico" and became the seat of power for the Spanish Empire north of the Rio Grande, and in the process the oldest European community west if the Mississippi River.

Don Peralta had his men lay out the street plan for his capital city Santa Fe at the base of the Sangre de Cristo Mountains over the ancient remains of the Native American pueblo of Kaupoge—meaning "place of shell beads near the water." The first Governor-General of New Mexico, Don Juan de Oñate, made San Juan Pueblo the first capital of New Mexico, but his successor, Don Pedro de Peralta, moved his capital 25 miles south to a cluster of villages abandoned some 200 years earlier by their Pueblo Indian inhabitants. He named the place Santa Fe and it has remained the capital of New Mexico ever since.

The Spanish oppression of the Native Americans and their culture is well documented. In the Pueblo Revolt of 1680 an estimated 400 colonists were killed (many of them Catholic missionaries and priests) and the remainder was driven back into Mexico. The victorious Pueblo Indians attacked Santa Fe and burned most of the town, with the exception of the Palace of the Governors.

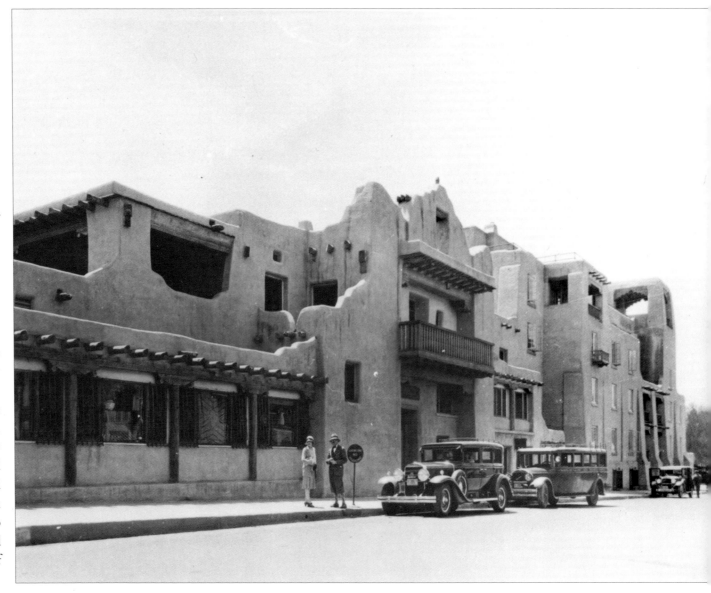

Bus at west side of La Fonda Hotel, Santa Fe, c. 1929.

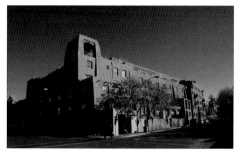

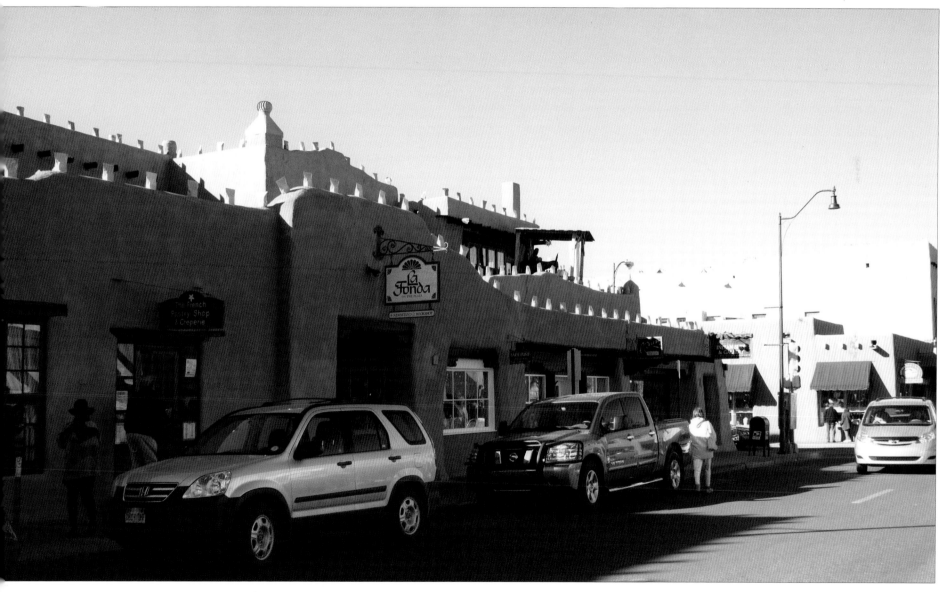

e Hotel La Fonda is still at the heart of the city.

SANTA FE

The rebels occupied Santa Fe until 1692 when Don de Vargas reconquered New Mexico and marched on Santa Fe. With a small group of Spanish soldiers he surrounded the city for two months until the event known as the "Bloodless Reconquest" when inhabitants surrendered and swore loyalty to the King of Spain and the Catholic Church. However, only six months passed before the Pueblo Indians recaptured Santa Fe, this time Don de Vargas did not hold back. He retook the city by force and in the process many Indians lost their lives.

From then on Santa Fe prospered and grew bigger and more influential. New Mexico was far from peaceful with many communities regularly attacked by Comanche, Apache, and Navajo war parties, but the Spanish authorities formed an alliance with the more peaceful Pueblo Indians and gradually the territory was developed. As for trade, with the settled political climate Santa Fe was able to grow into an important trading center but the Spanish policy of closed empire meant that colonists could trade with only the British, American, and French.

When Mexico became independent of Spain, Santa Fe became the capital of the province of New Mexico. The policy of closed empire ended and American traders and trappers moved in to take advantage of new business. The Santa Fe Trail was opened in 1821 by William Bucknell and ran for 1,000 miles from Franklin, Missouri to Santa Fe following either a mountain route or a route following the Cimarron River.

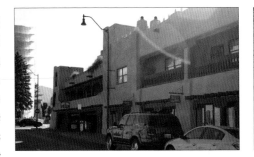
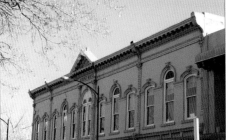

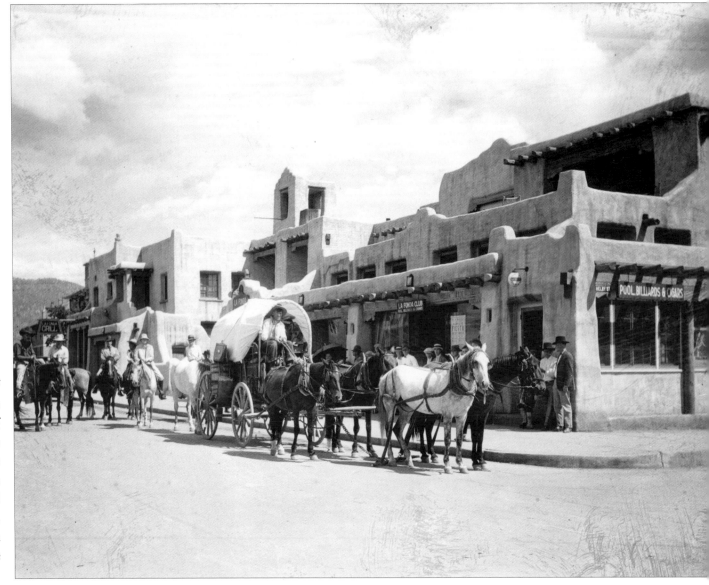

Cowboys outside the La Fonda Hotel around the turn of the century.

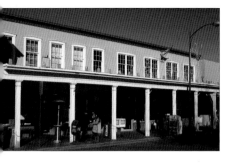
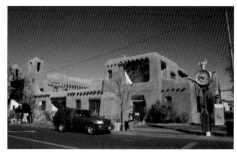

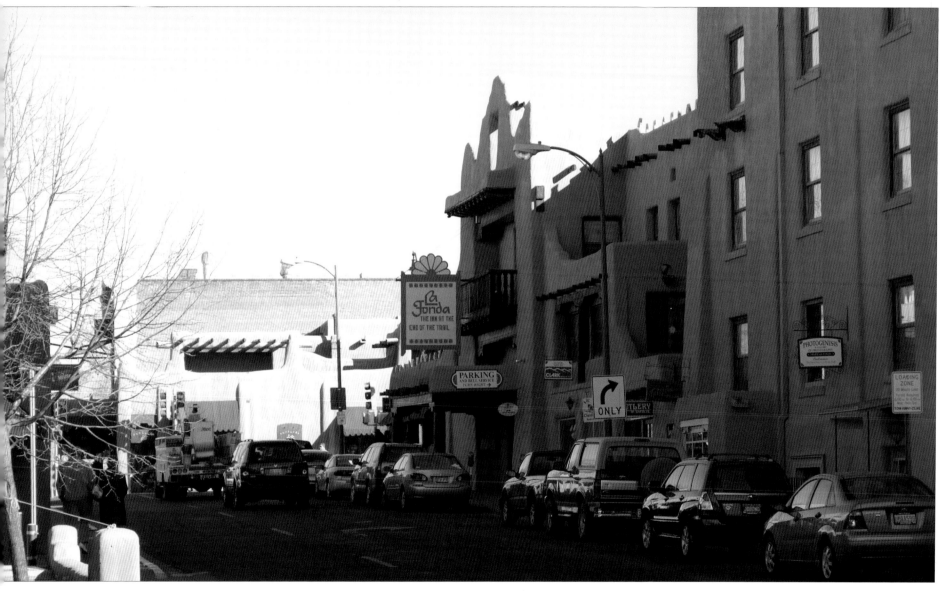

...e current La Fonda was built in 1922 on the site of the previous inns. In 1925 it was acquired by the Atchison, Topeka & Santa Fe Railroad, which leased it to Fred Harvey.

SANTA FE

In 1837 Santa Fe was briefly occupied by rebelling northern New Mexico farmers during the Chimayó Rebellion, but they were quickly supressed. The next excitement came in August 1846 when, during the Mexican-American War, United States Army General Stephen Watts Kearny took Santa Fe for the U.S. by raising the flag in the plaza. Then, two years later, Mexico and the U.S. signed the Treaty of Guadalupe Hidalgo, which ceded New Mexico and California to the United States. Santa Fe became the official capital in 1851.

During the Civil War, General Henry Sibley's Confederate flag flew over Santa Fe for a few days until he was defeated by Unionist forces. In 1868 the telegraph arrived in Santa Fe connecting the city to the outside world as never before. This was truly accomplished a few years later in 1880 when the Atchison, Topeka and Santa Fe Railway arrived. Although the railway was named in part for the capital of New Mexico, its main line never reached there as the terrain made it too difficult to lay the necessary tracks (Santa Fe was ultimately served by a branch line from Lamy).

Today the city remains a significant historic city in the American southwest, full of culture and historic significance with a rich architectural and cultural heritage.

Home to the largest selection of museums and galleries in the south, key events include, the Fiestas de Santa Fe in the autumn, the Great Santa Fe Trail Horse Race Endurance Ride takes place over the first two weeks of September, and the Santa Fe Wine and Chili festival.

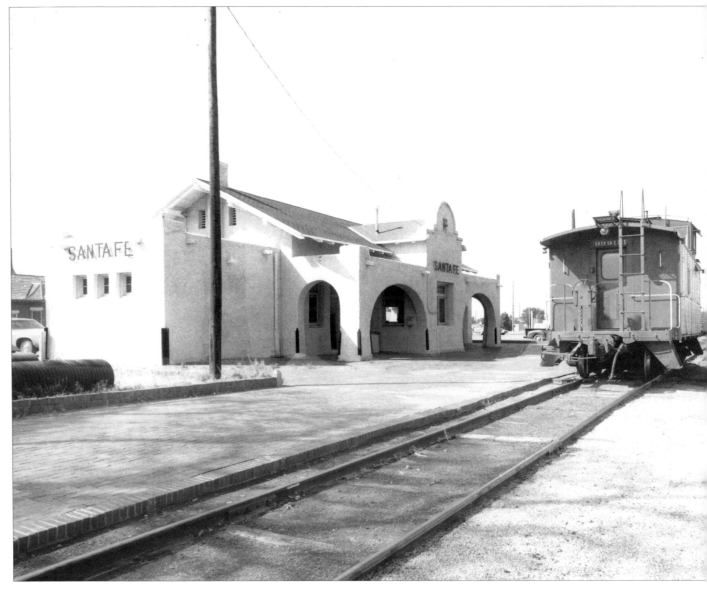

Atchison, Topeka and Santa Fe railway depot in Santa Fe.

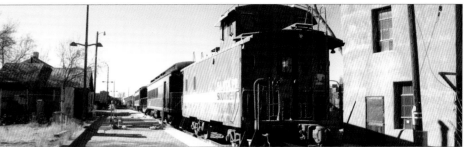

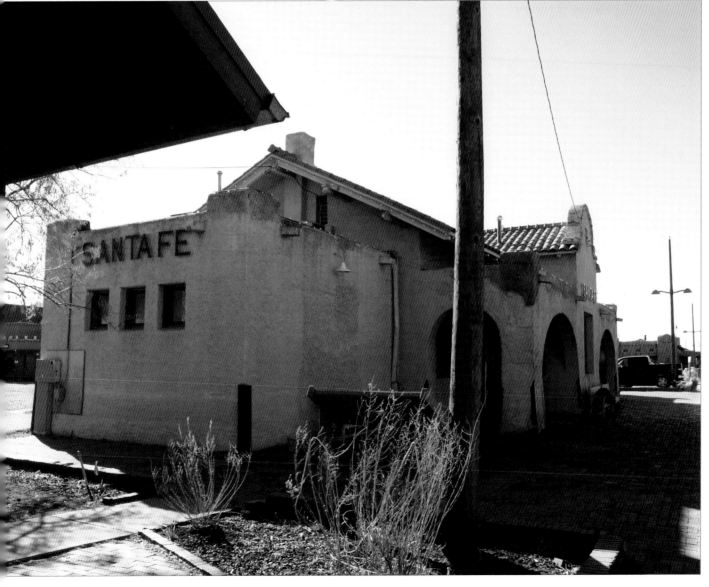

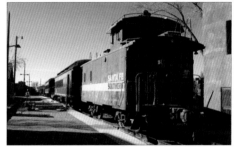

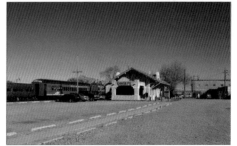

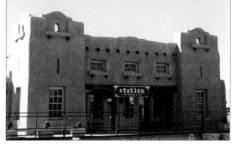

...he depot building and railyard still stand and contain wonderful examples of the trains previously used on this line.

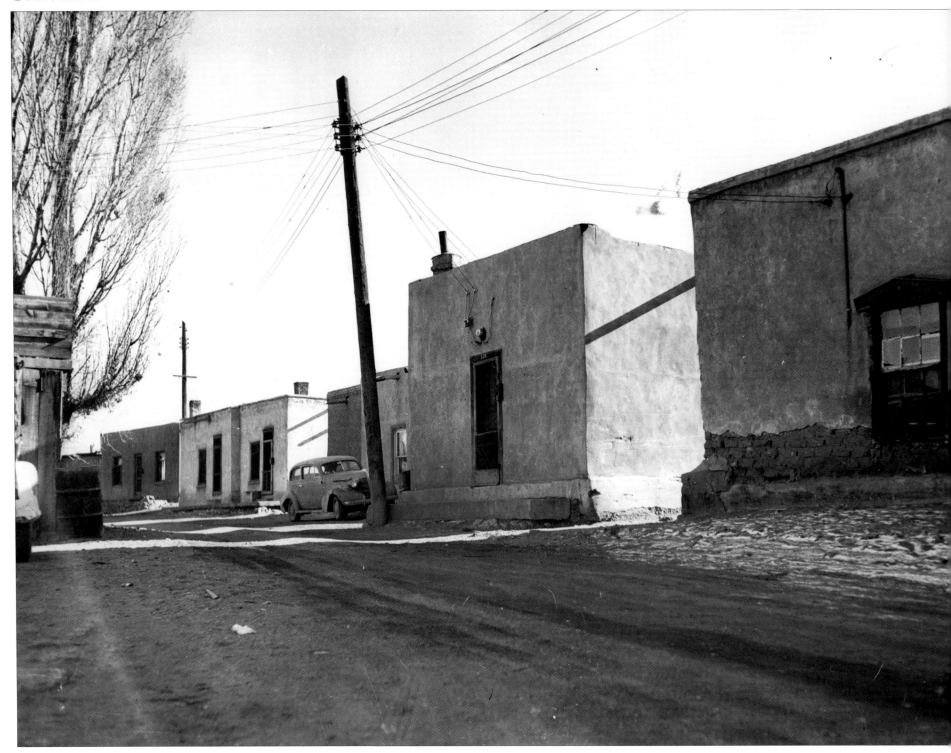

Adobe homes on DeVargas Street near Jefferson Street in Santa Fe.

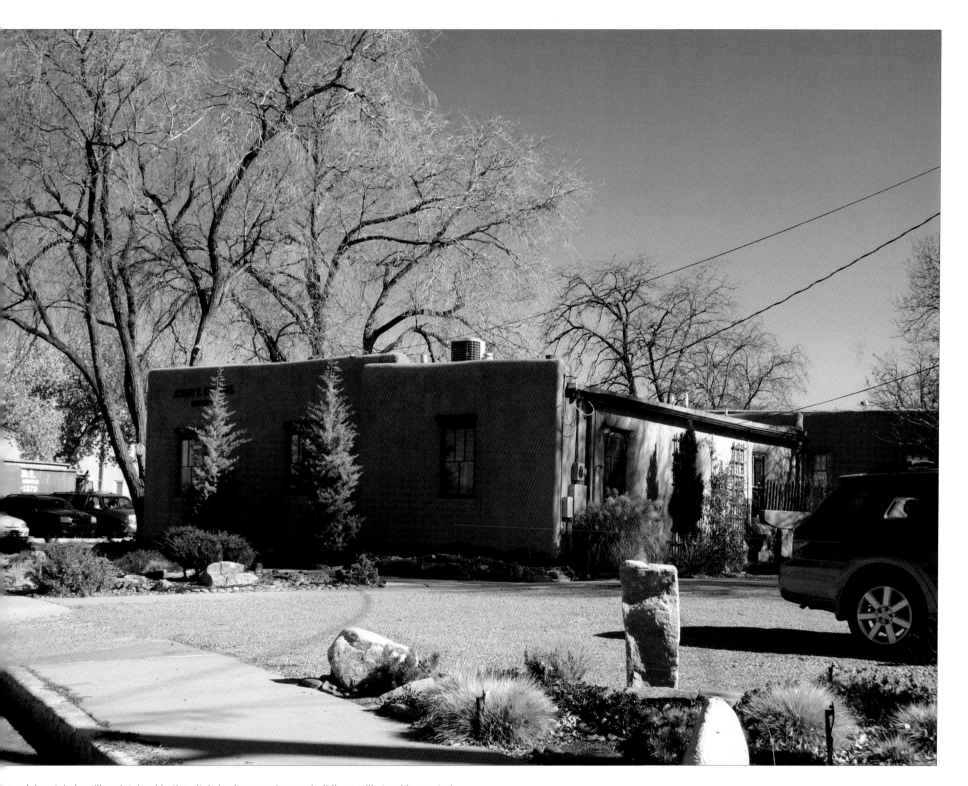

The adobe style is still maintained in the city's heritage and many buildings still stand in use today.

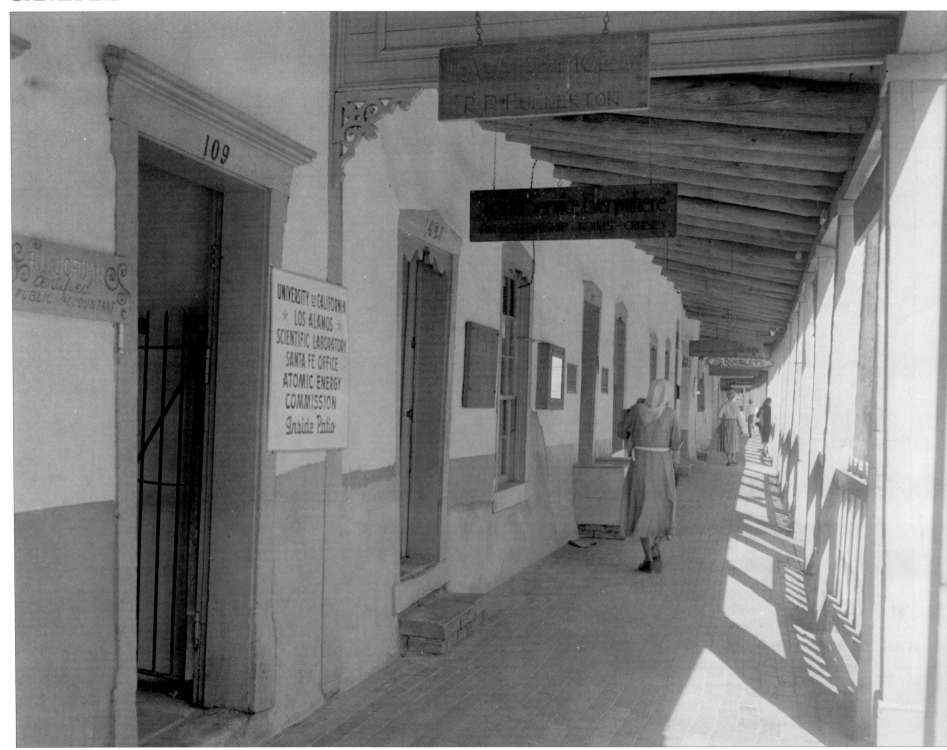

109 Palace Avenue, Prince Plaza portal, Santa Fe, 1958.

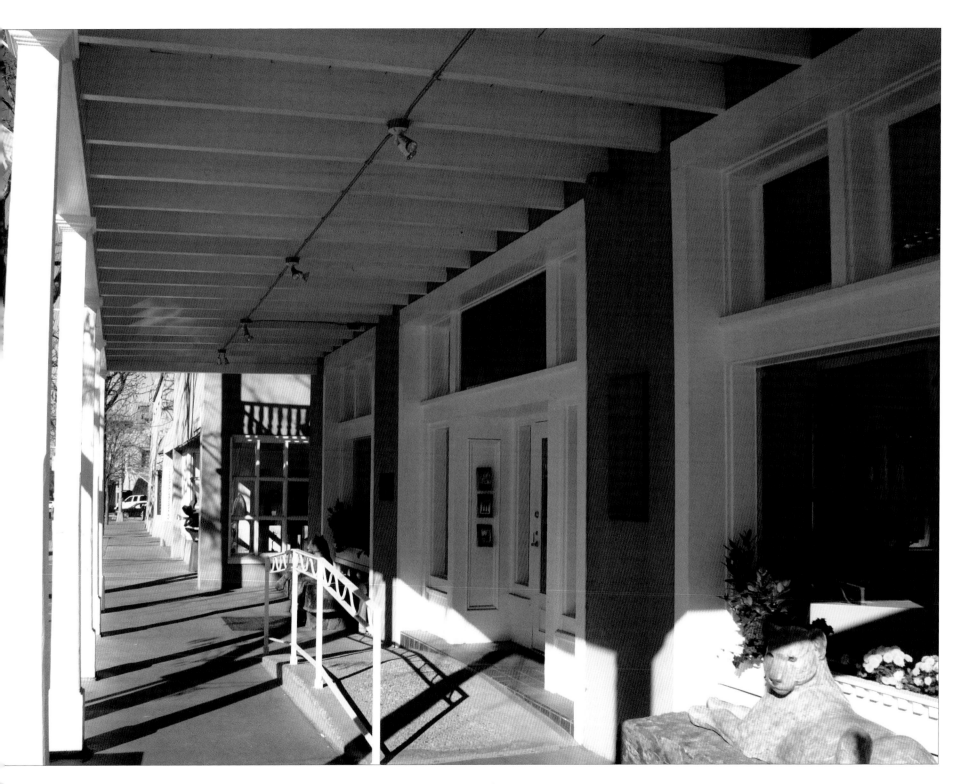

The streets are now lined with wonderful shops and restaurants.

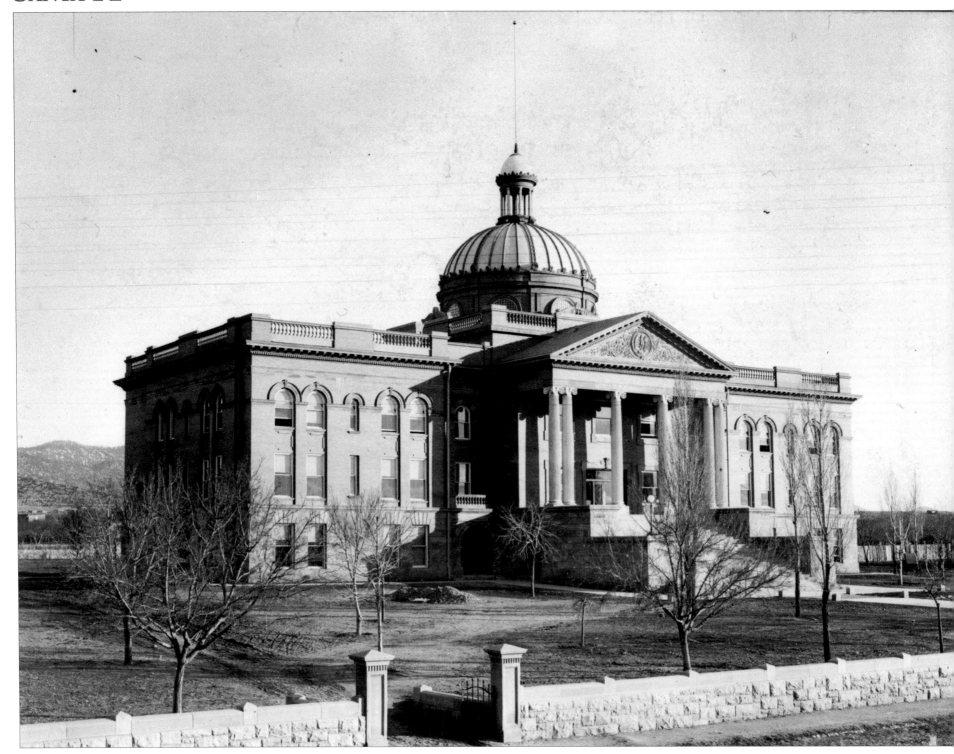

The Capitol Building, Santa Fe, c. 1900.

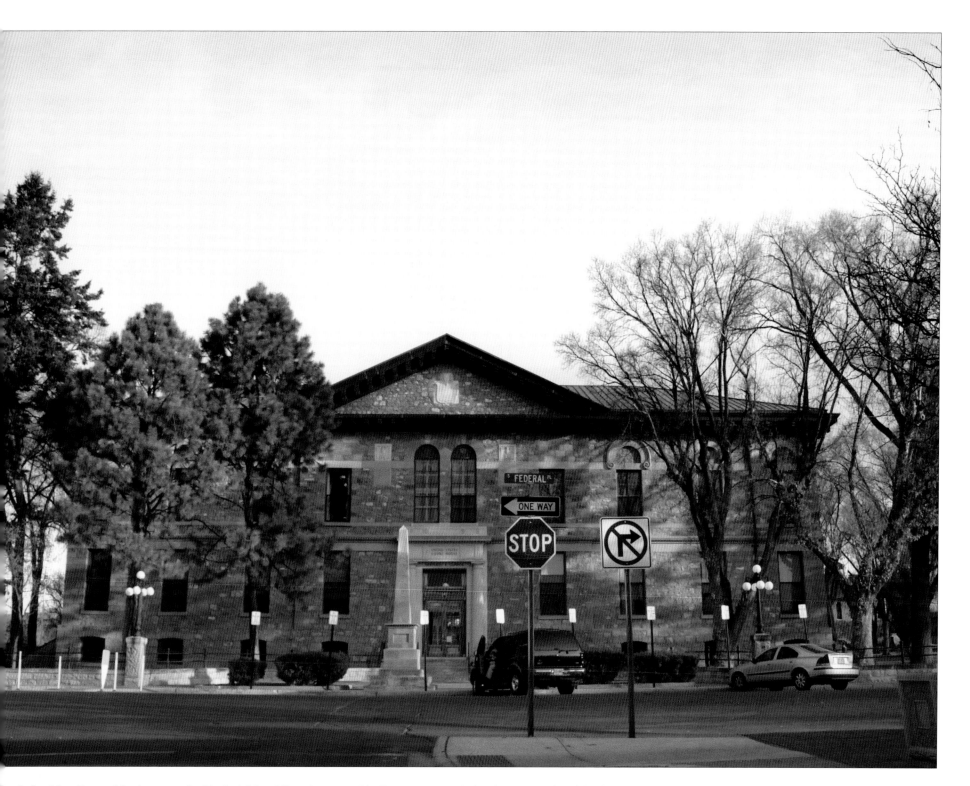

The Federal Courthouse (also known as the Territorial Court House) was used by the government during the construction of the Capitol Building (left).

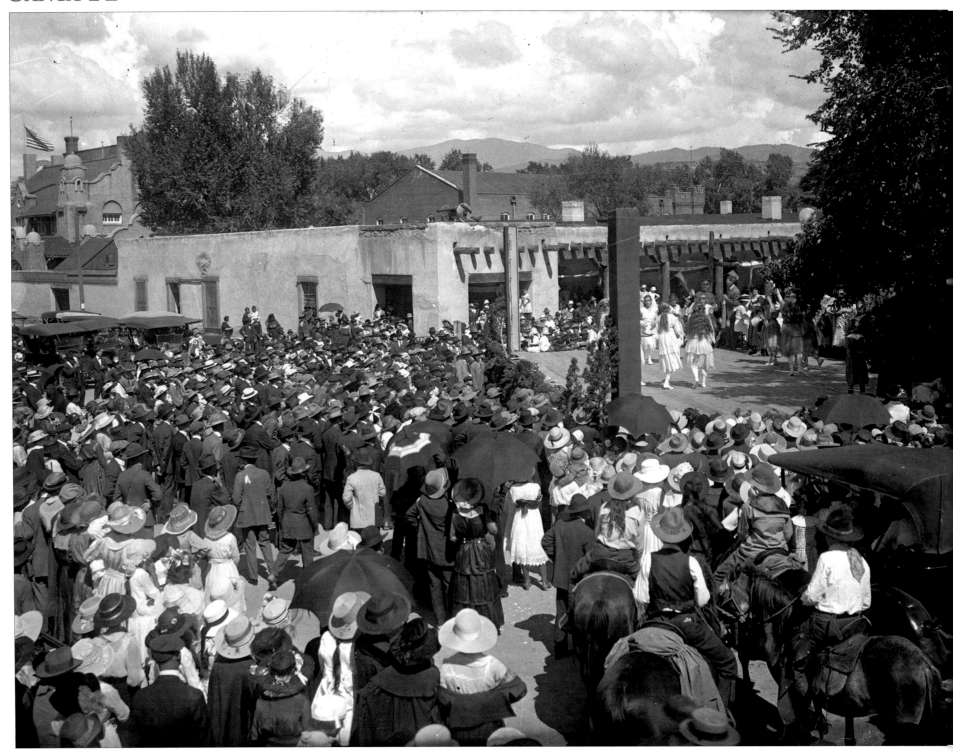

Crowd on the Plaza, Fiestas de Santa Fe, 1915.

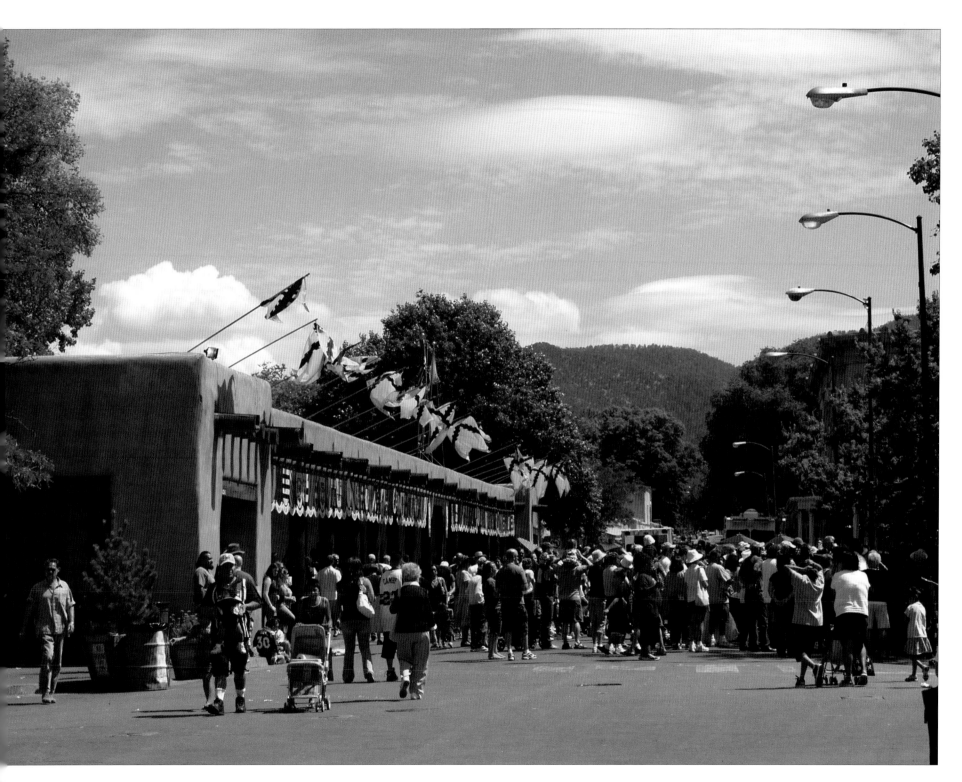

...e fiesta to celebrate the bloodless reconquest has been celebrated since 1712 by proclamation of the then-governor Jose Chacon Medina Salazar y Villaseor, the marquis of Penuela. It is the oldest ...ic celebration of its kind in North America. Zozobra, which has gone up in flames every year since Will Shuster created it in 1924, became one of the symbols of Santa Fe.

La Armeria de Santa Fe, 1050 Old Pecos Trail, Santa Fe, 1949. Men of the 200th Coast Artillery Regiment (processed here in 1941) were sent to the Philippine Islands early in WWII. The Regiment wa divided to form the 515th Coast Artillery Regiment while in the Philippines. Both of the Regiments were lost to enemy action on Bataan when the Japanese overran the Philippines in 1942. The 200t consisted of 1,800 men when deployed. After three and six months of captivity, less than half were to return to the United States.

...ese buildings now house "The Bataan Memorial Military Museum," "Armory For the Arts Theatre," and "The Santa Fe Children's Museum."

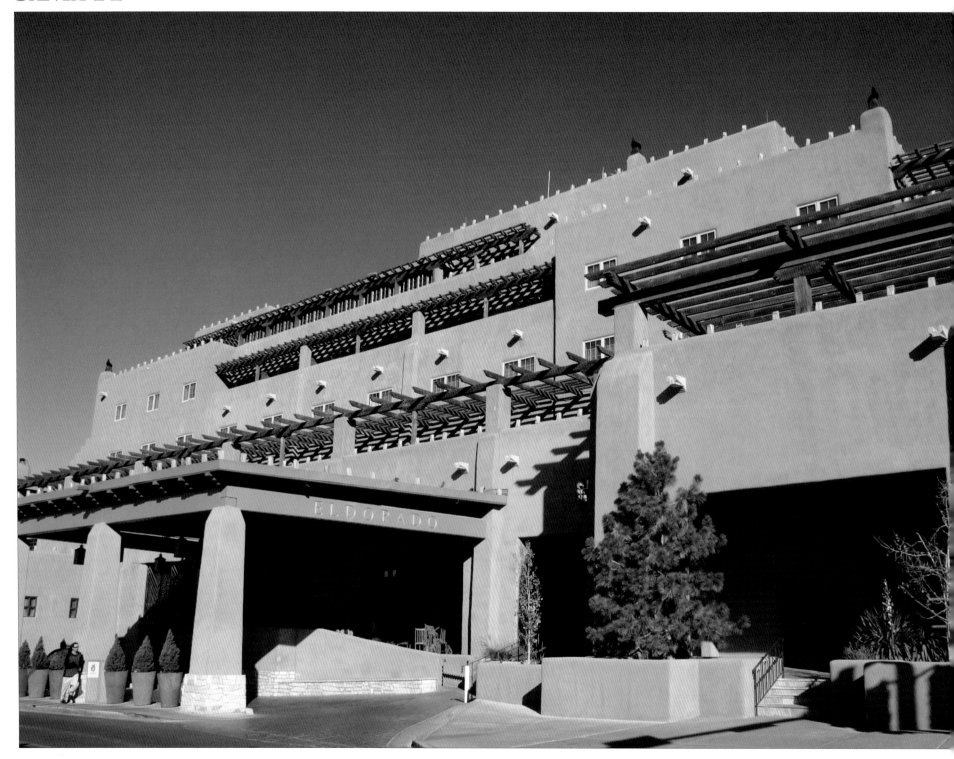

The Eldorado Hotel and Nidah Spa is Santa Fe's premier four-diamond hotel.

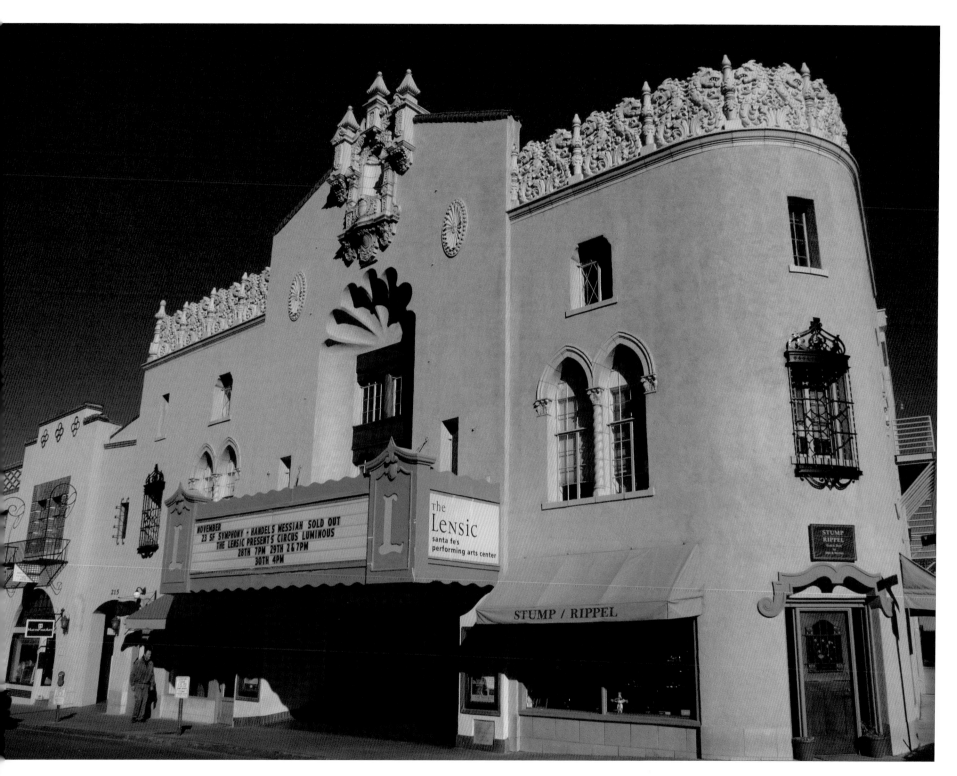

e Lensic Performing Arts Center is an 821-seat theater designed by Boller Brothers of Kansas City, well-known movie theater and vaudeville house architects. The pseudo-Moorish, Spanish naissance–style Lensic was built by Nathan Salmon and E. John Greer, and opened on June 24, 1931.

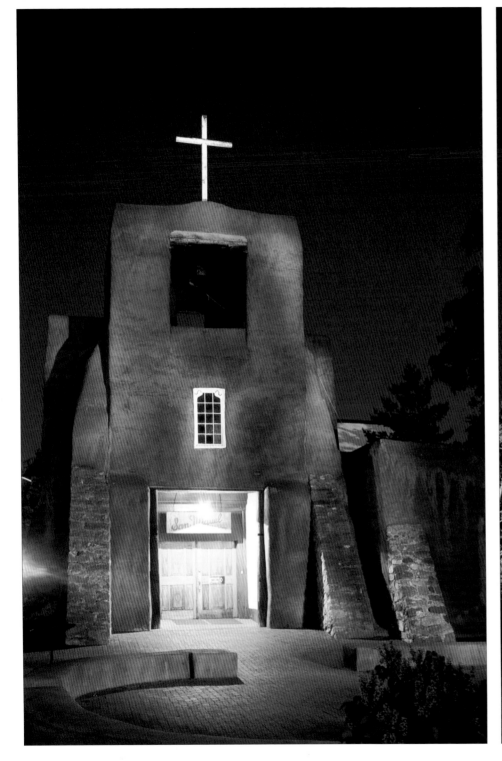

The San Miguel Mission.

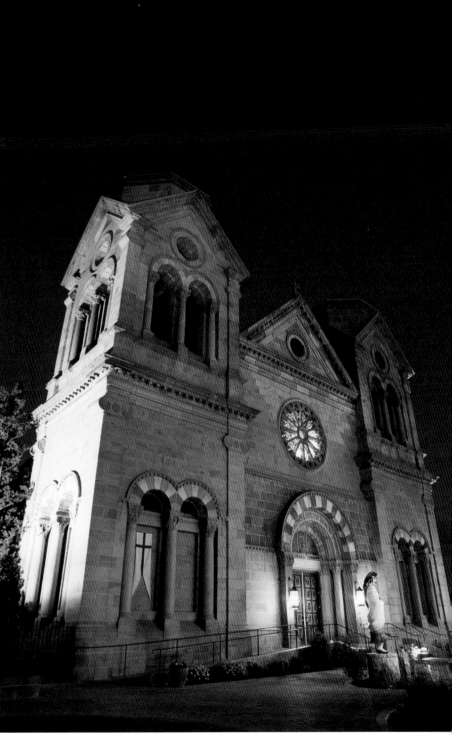

The Cathedral Basilica of St. Francis of Assisi.

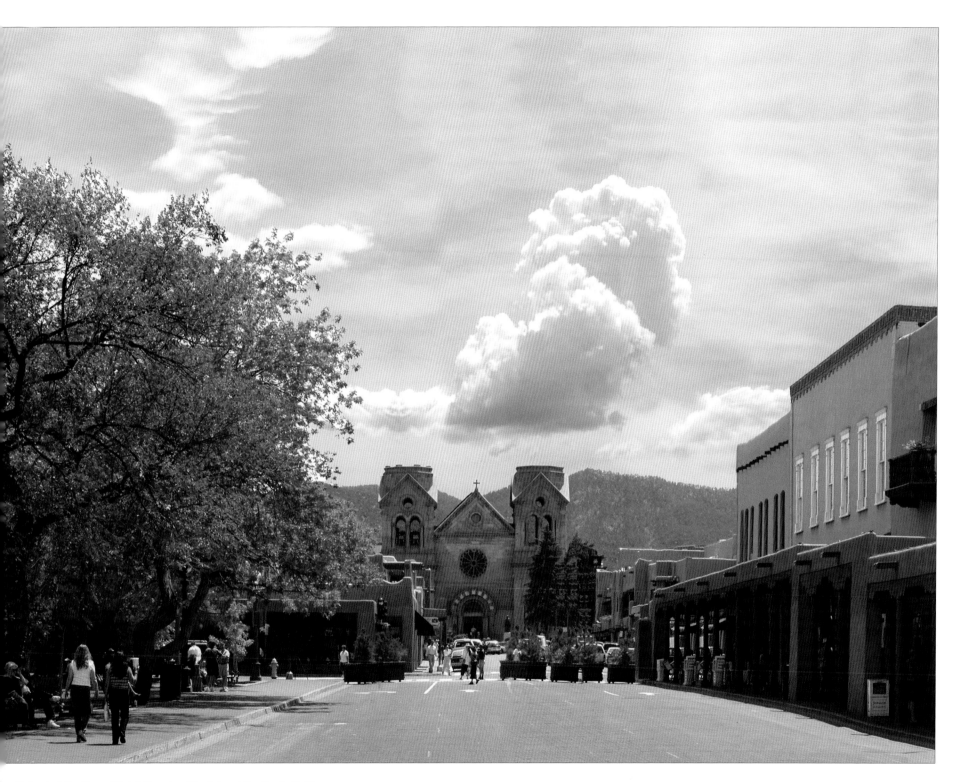

The Cathedral Basilica of Saint Francis of Assisi and the Santa Fe Plaza.

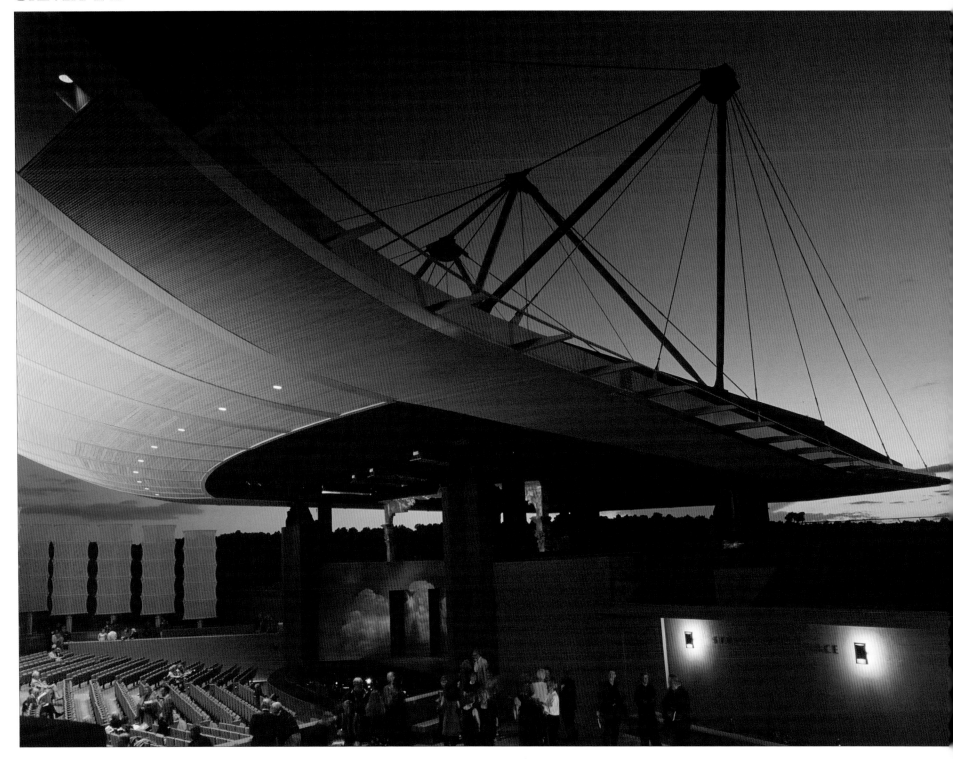

The Santa Fe Opera House. There have been three theaters on the present site of the Santa Fe Opera. Each has been located on a mesa, with the audience facing west toward an ever-changing horizon of sunsets and thunderstorms, frequently visible throughout many productions when no backdrops are used.

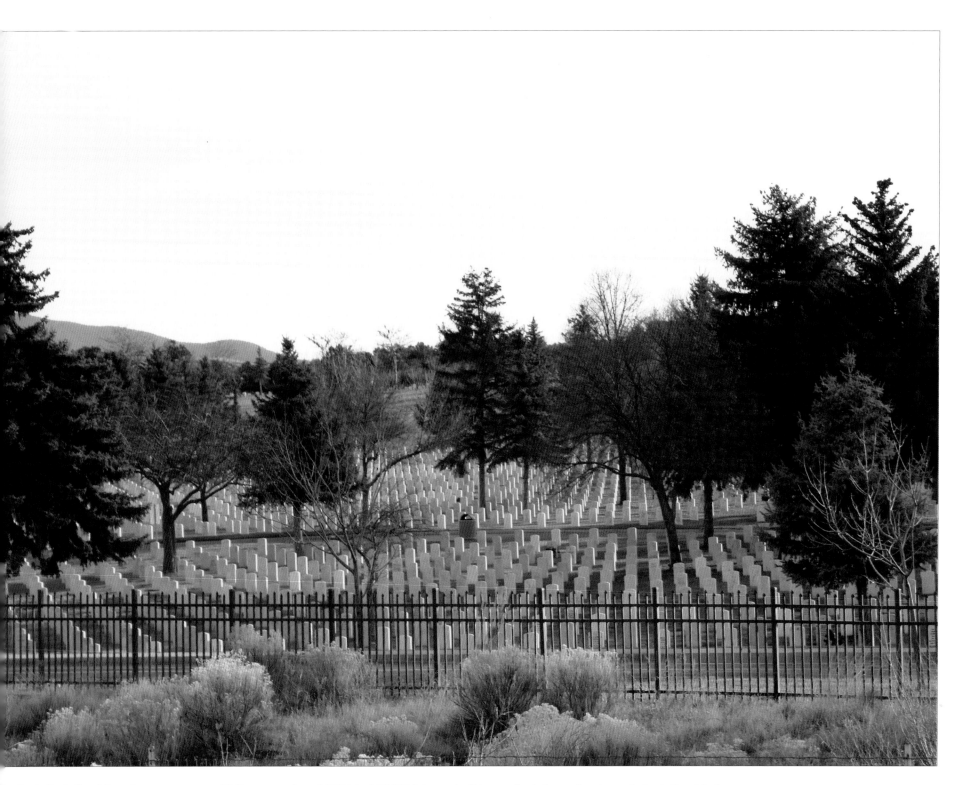

The Santa Fe National Cemetary encompasses 78.6 acres, and as of 2005, had 39,695 interments. It is one of only two national cemeteries in New Mexico.

GLORIETA

Glorieta was the scene of a crucial encounter between Confederate and Union forces during the Civil War a good decade before the town existed. In March 1862, the two sides met at Pigeon's Reach near La Glorieta Pass with the Unionists emerging so completely victorious that the Confederate attempt to take New Mexico was decisively ended.

The Atchison, Topeka and Santa Fe Railway made its way over the La Glorieta Pass a few miles west of Pigeon's Ranch in 1879, and remarkably quickly a small village emerged at the stop and was soon named Glorieta.

Glorieta remains a quiet spot with a few businesses and a small community. Shortly after World War II the Southern Baptist Assembly chose Glorieta as its headquarters for their western leadership center, LifeWay Glorieta Conference Center. Here, people can enjoy cool afternoon walks on winding trails with family or friends. Conference participants can rest under a shady porch sharing ideas from that morning's session, while the ministry staff builds a greater sense of teamwork during adventure recreation.

Today the town has a small mercantile store, a restaurant, a gift shop, and a sprinkling of homes.

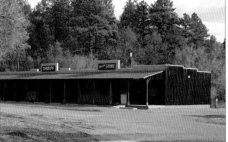
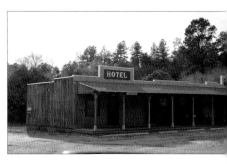

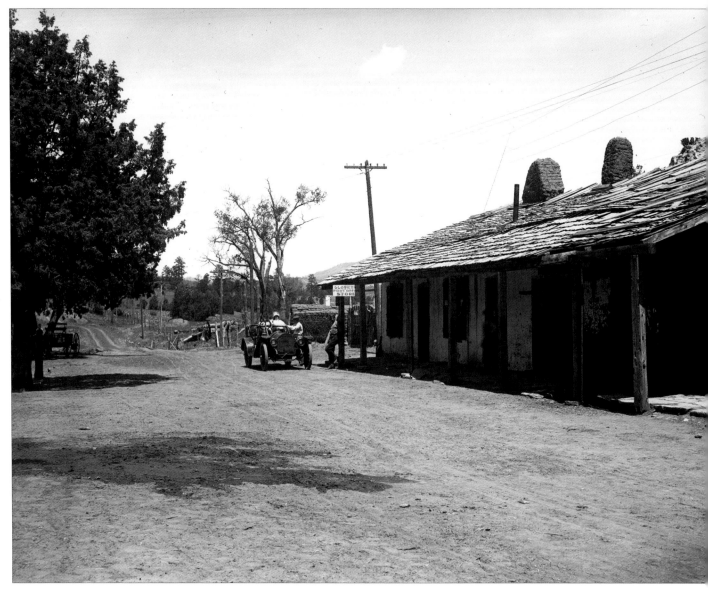

Pigeon Ranch, Glorieta, 1912. During March of 1862 as the Confederates attempted to occupy New Mexico, a decisive engagement between Confederate and Union troops took place at this site.

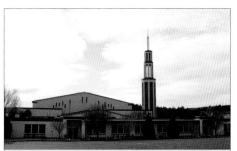
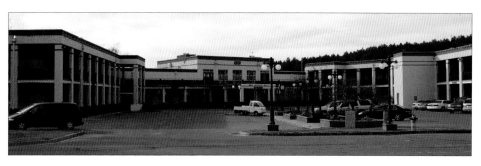

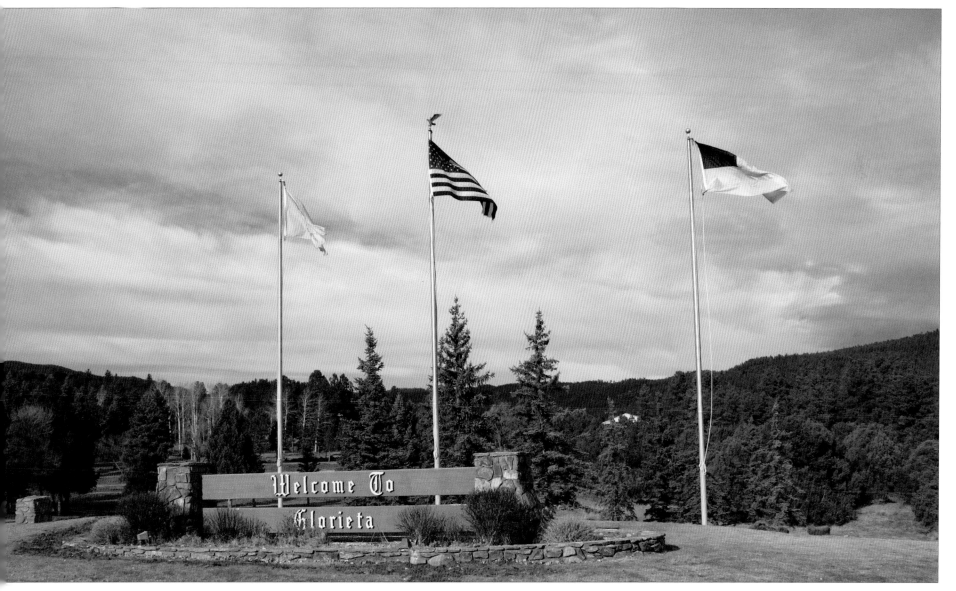

Shortly after World War II, the Southern Baptist Assembly chose Glorieta as headquarters for their western leadership center.

LAS VEGAS

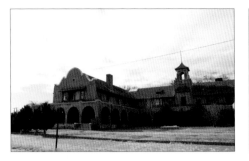 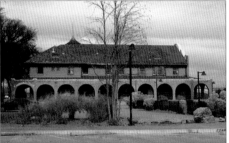

In 1835 a group of settlers were granted land by the Mexican government. They built a traditional-style Spanish village with a church and central plaza surrounded by colonial-style buildings and named the town Las Vegas. The town became a useful stopping point along the Santa Fe Trail and the town prospered. During the Mexican-American War of 1846, Stephen W. Kearny delivered a keynote address here claiming New Mexico for the United States.

In 1879 the railroad stopped a mile out of town which prompted the building of a rival settlement called New Town. Nevertheless, the railroad brought plenty of business to Las Vegas and it could soon call itself one of the largest cities in the American Southwest. Unfortunately, the railroad also brought in droves of undesirable criminals and the eastern side of town soon earned a rough and dangerous reputation. Legendary characters and some of the most notorious criminals of the Wild West appeared, such as Doc Holiday and his girlfriend Big Nose Kate, as did Jesse James, Billy the Kid, Wyatt Earp, Hoodoo Brown, and the Durango Kid. Historian Ralph Emerson Twitchell once claimed, "Without exception there was no town which harbored a more disreputable gang of desperadoes and outlaws than did Las Vegas." However, by the turn of the twentieth century the climate had changed and Las Vegas was a respectable town with a library, school, hotel, and an electric street railroad. Since the 1950s, and the diminishing importance of the railroad, life in Las Vegas has remained steady and constant.

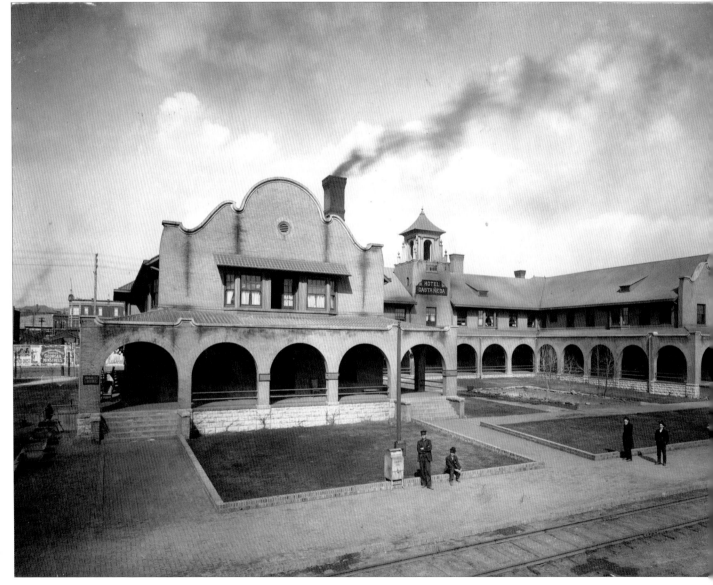

Castañeda Hotel, Las Vegas, c. 1904. It was built in 1898 as part of Fred Harvey's chain of railroad hotels.

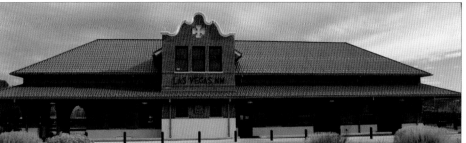

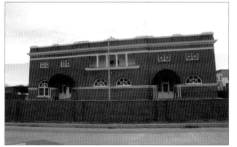
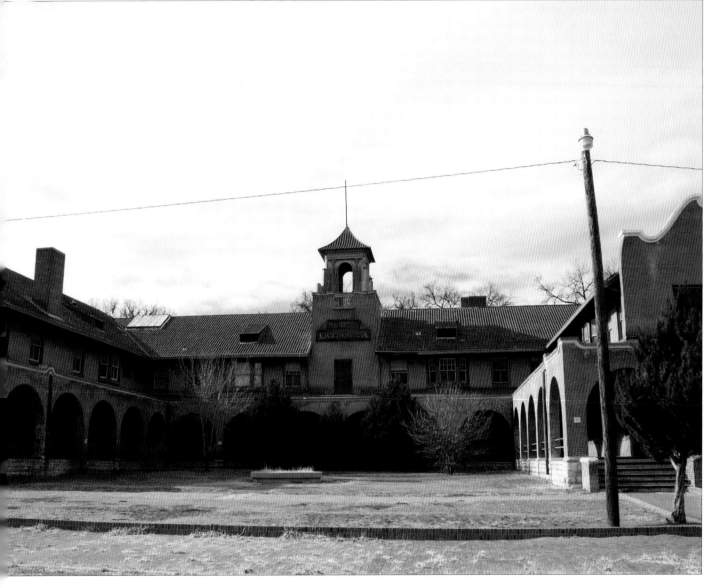

The hotel has been unoccupied for many years as today the majority of rail transports in the United States are based on freight train shipments, and the vast majority of passenger transport is made by automobile, bus, and air.

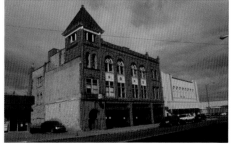

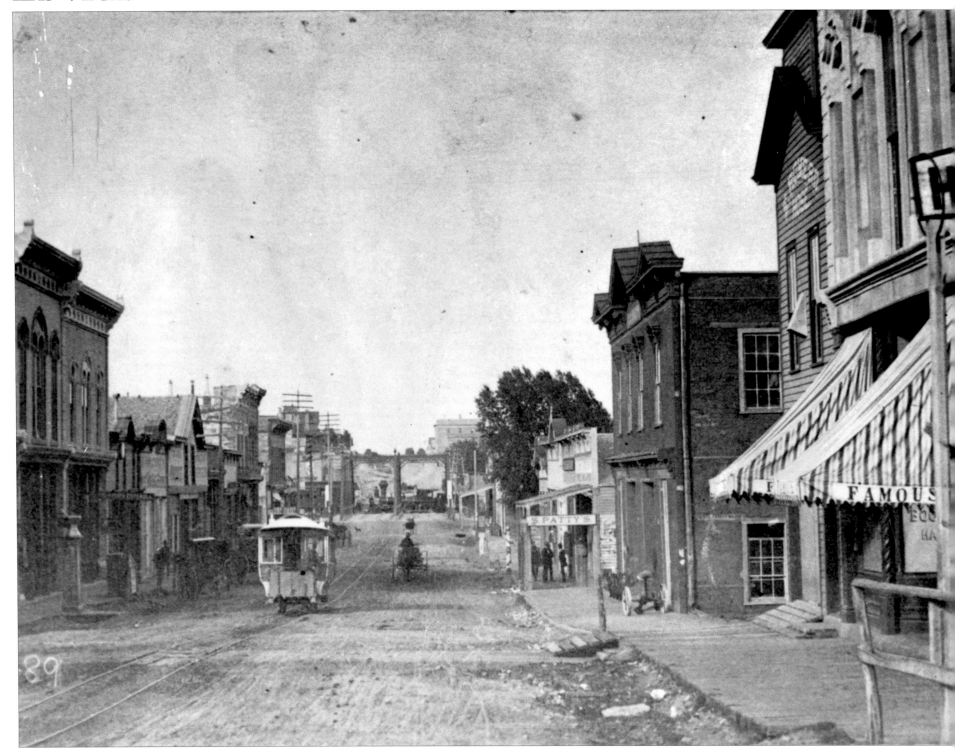

Bridge Street looking east, Las Vegas, 1892.

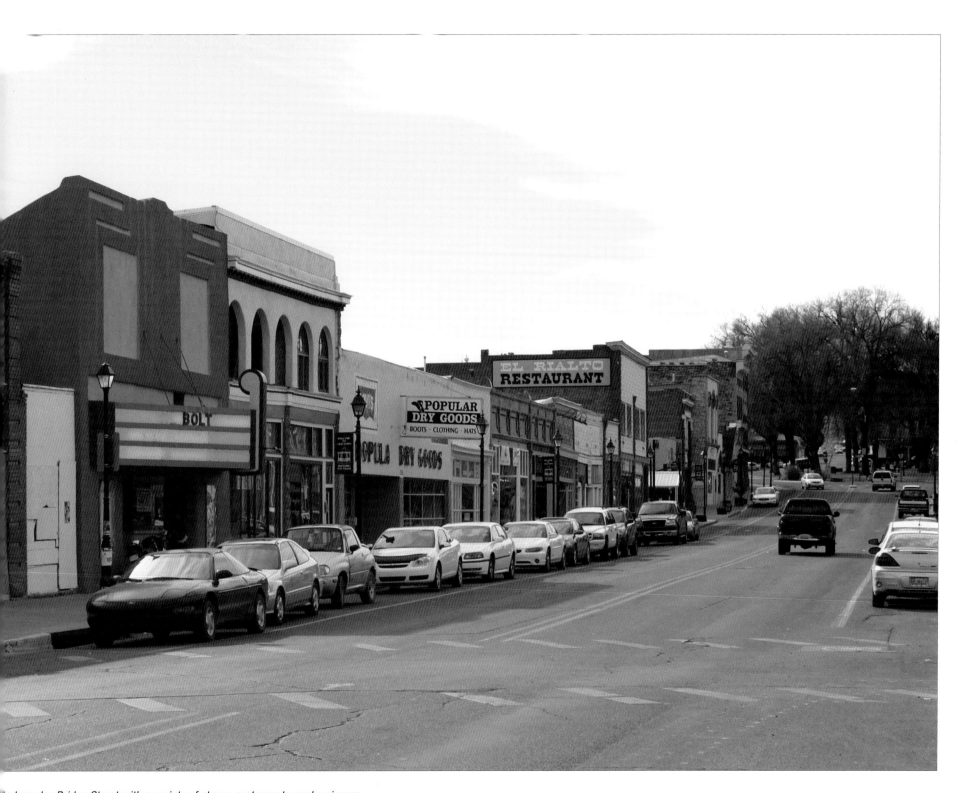

Modern-day Bridge Street with a variety of stores, restaurants, and a cinema.

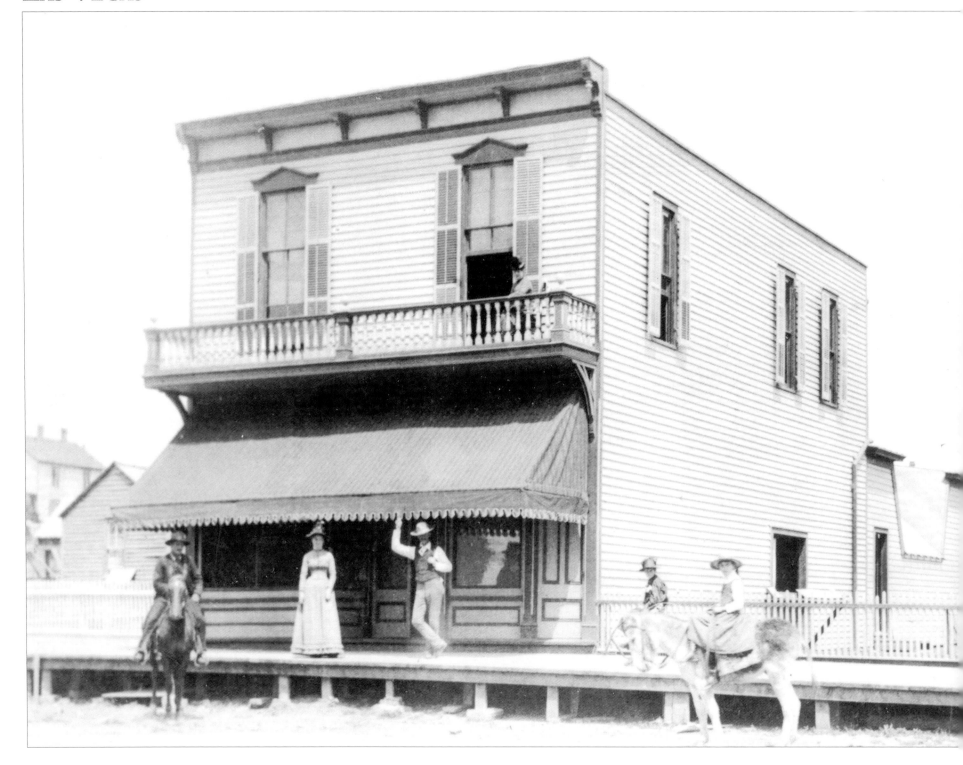

Photo studio of J. N. Furlong and T. Crispell, Douglas Avenue, Las Vegas, c. 1880.

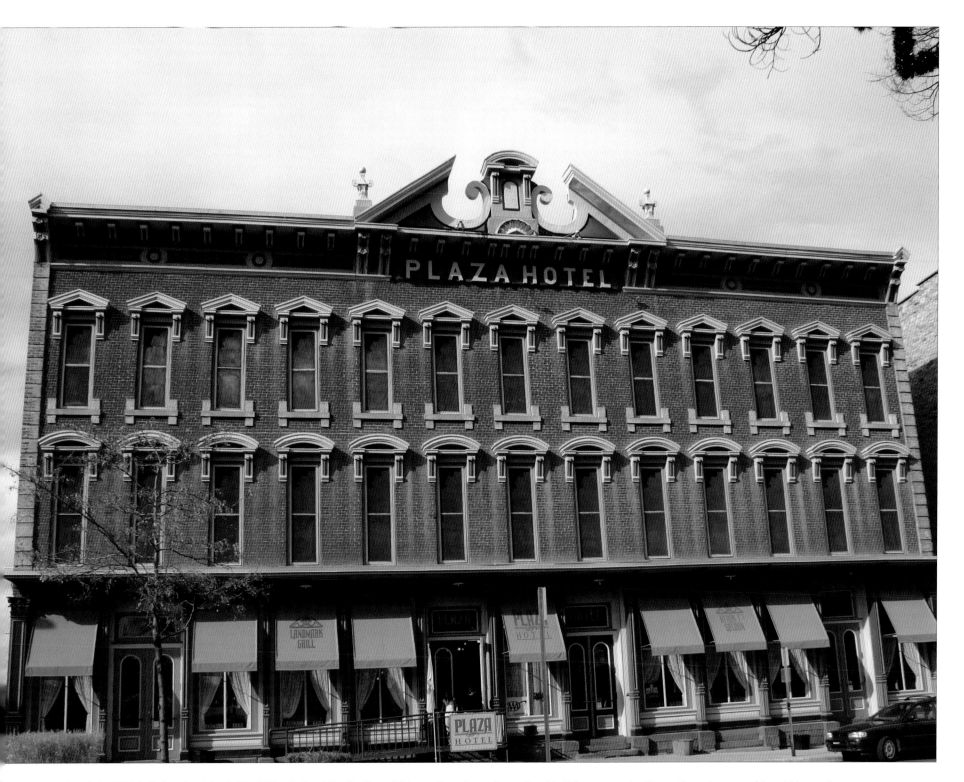

The Plaza Hotel, built in 1882 in Italianate style, dubbed "The Belle of the Southwest," is Las Vegas's most prominent building, occupying the northwest corner of the old town plaza.

TUCUMCARI

Tucumcari comes from the Comanche word *tukanukaru* meaning "to lie in wait for something to approach." Some of the oldest civilizations in North America flourished in this area over 10,000 years ago and they walked land once trodden by prehistoric man.

In the Tucumcari region in the thirteenth century, Anasazi Indians grew their corn, beans, and squashes beside the abundant waterways. Pottery remains and other ancient artifacts prove that this was a thriving trading area. The area was populated by nomadic tribes of principally Comanche and Apaches. The flat-topped Tucumcari Mountain was a rich hunting ground for buffalo and antelope, as well as serving as a tremendous lookout point for Comanche raiders to target cattle droves along the Chisolm and Comanchero trails.

Tucumcari started as a tent city at a whistle stop beside the Chicago, Rock Island and Union Pacific Railroad in 1901 in the western portion of modern-day Quay County when it was known as Six Shooter Siding. By 1908 the camp was a division point and was renamed Tucumcari. The town thrived, railroad business grew, other businesses grew, and by 1910 had become a major railroad center.

In 1926 Route 66 took in Tucumcari and brought lots more business and travelers as it does to this day. A large number of the vintage motels and restaurants built in the 1930s, 40s, and 50s are still in business despite intense competition from newer chain motels and restaurants in the vicinity of Interstate 40, which passes through the city's outskirts on the south side of town.

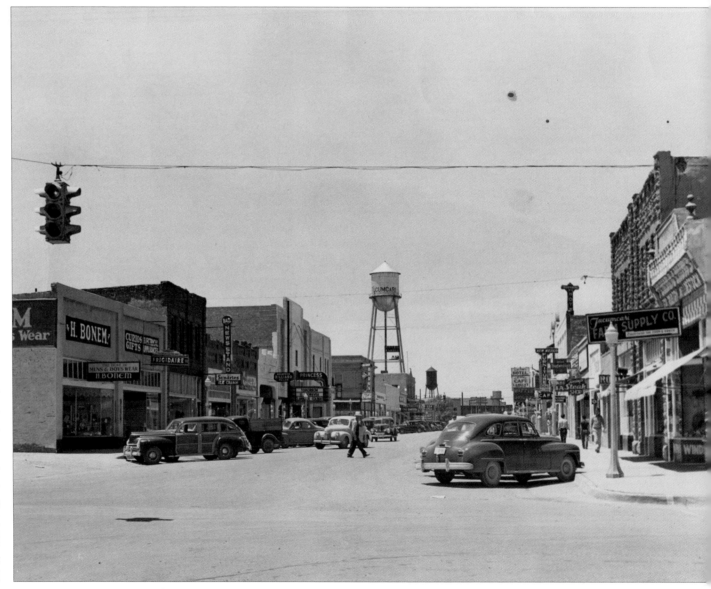

Main Street (Route 66) Tucumcari, 1947.

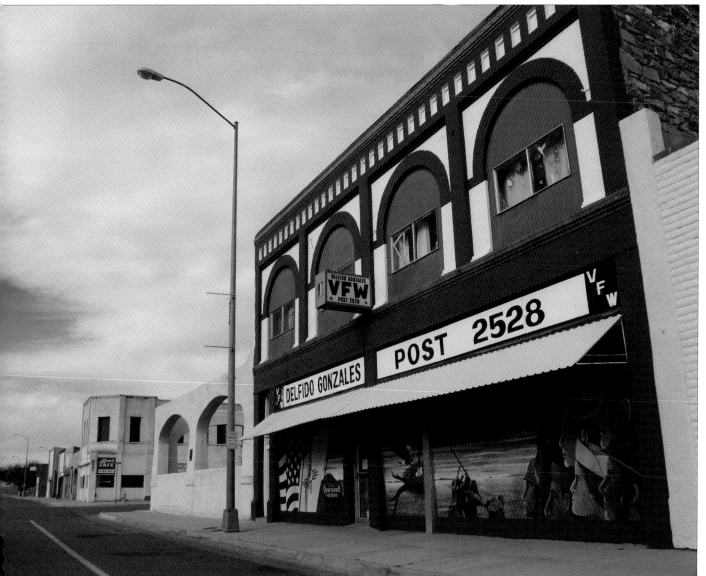

e colorful modern-day main street.

FORT SUMNER

 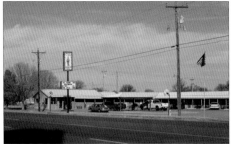

Congress authorized the foundation of Fort Sumner at Bosque Redondo on October 31, 1862. Its purpose was to protect the nearby new Navajo reservation which extended over 40 square miles. In January 1864, the Navajo surrendered to Kit Carson and his troops at Canyon de Chelly in Arizona. Carson ordered the destruction of the remains of all their property and then sent them on the "Long Walk" to Bosque Redondo reservation where some Mescalero Apache already lived. Back at Fort Sumner, peace meant that a small settlement of businessmen, farmers, ranchers, and stockmen started to develop around the fort. However, the Navajo reservation failed to achieve the government's aims as they also housed some of their historic enemies, the Apache, on the same reservation. The local Pecos water was brackish and caused disease and severe intestinal problems among the Natives. The wood supply quickly ran out and the corn crop destroyed by army worm. In 1870 the abandoned fort was sold to Lucien Maxwell and he refurbished the buildings. In July 1881 Billy the Kid was shot here and buried in the military cemetery alongside two fellow outlaws. The railroad arrived nearby in 1905, and the 150 residents moved the seven miles north to the line and rebuilt their businesses and lives there at the pre-existing settlement of Sunnyside. The two settlements existed side by side until 1909 when they merged to become one village called Fort Sumner. Today about 2,000 people live here, cattle and sheep farming and growing crops such as sweet potatoes, apples, alfalfa, melons, and grapes.

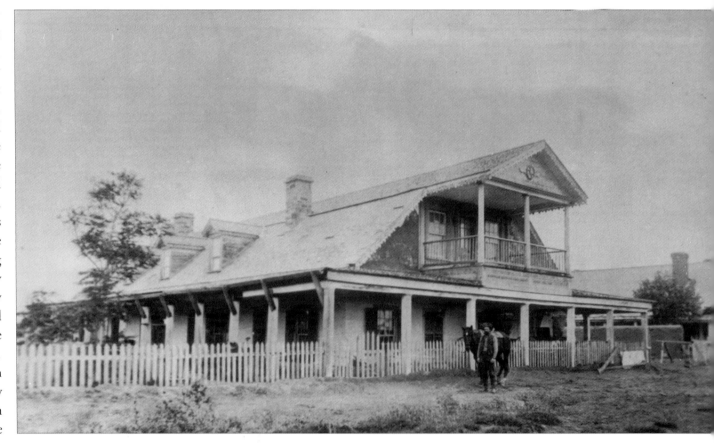

Maxwell house and Officers Quarters in Fort Sumner, where Billy the Kid was shot by Pat Garrett (photo c. 1870).

 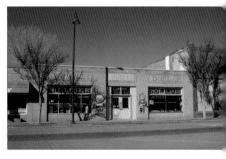

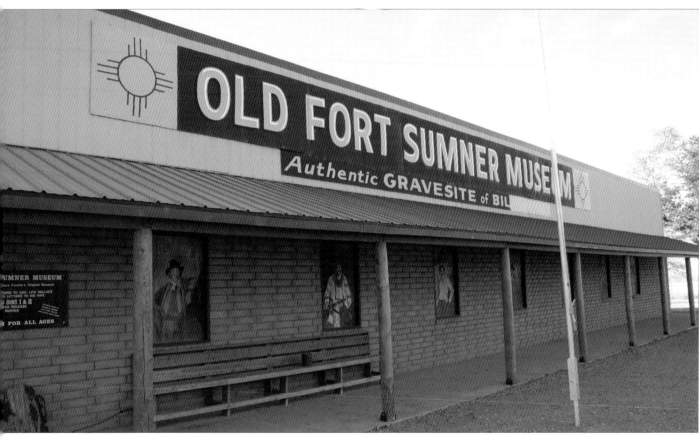

The Old Fort Sumner Museum is located just up the road from Bosque Redondo Memorial (pictured right). Most of the exhibits in the museum are related to Billy the Kid, who is buried in a grave behind the museum, as is also the Maxwell family.

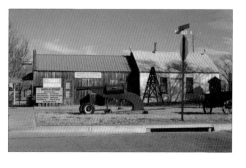

ROSWELL

Roswell is famous as the site of the UFO alien sighting of 1947. Like many small and isolated New Mexico communities, Roswell struggled against frequent and devastating Apache raids. The first buildings were made from adobe in 1869 by two businessmen from Nebraska: these became the general store and post office and occasional paying sleeping quarters. In 1873 the federal government allowed the establishment of the town, which was called Roswell after one of the founders' father. Now in Chaves County, Roswell was originally part of Lincoln County, which proved too vast for easy administration as it administered all of southeastern New Mexico.

In the 1880s and 1890s, Roswell suffered as horses, cattle, and not infrequently people disappeared, taken by the Indians. The raiding substantially stopped after local cattle baron John Chisum decided he had had enough after a number of his horses went missing: he gathered together a posse of locals and trailed the Apache to Fort Stanton where they raided their camp, killed many natives, and retrieved over 100 stolen horses. This brutal action allowed the residents of Roswell to live in comparative peace and establish their businesses, which in turn allowed the town to grow and begin a viable economy. Luck also played a part, when merchant Nathan Jaffa dug a well in his back yard and discovered a major aquifer and source of abundant water in the heart of town in 1890. This valuable resource allowed the area's first major growth spurt, which was supplemented by the arrival of the railroad to Roswell in 1893.

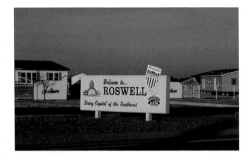

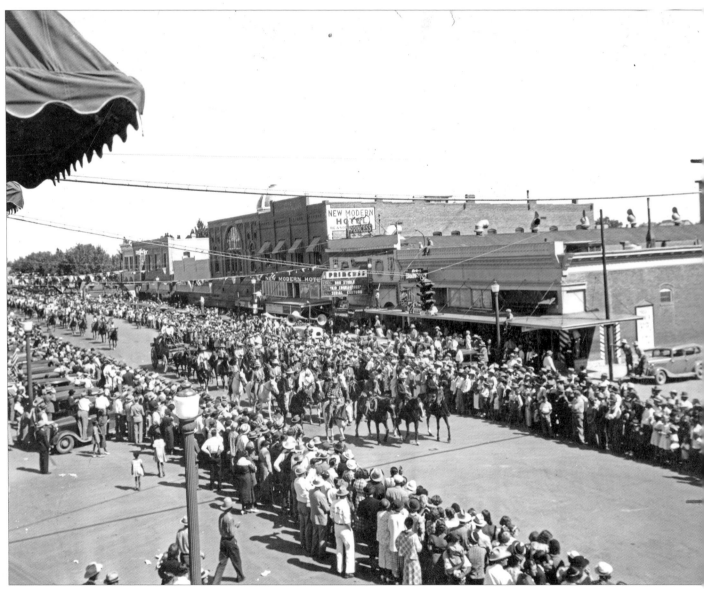

1936 parade in Roswell.

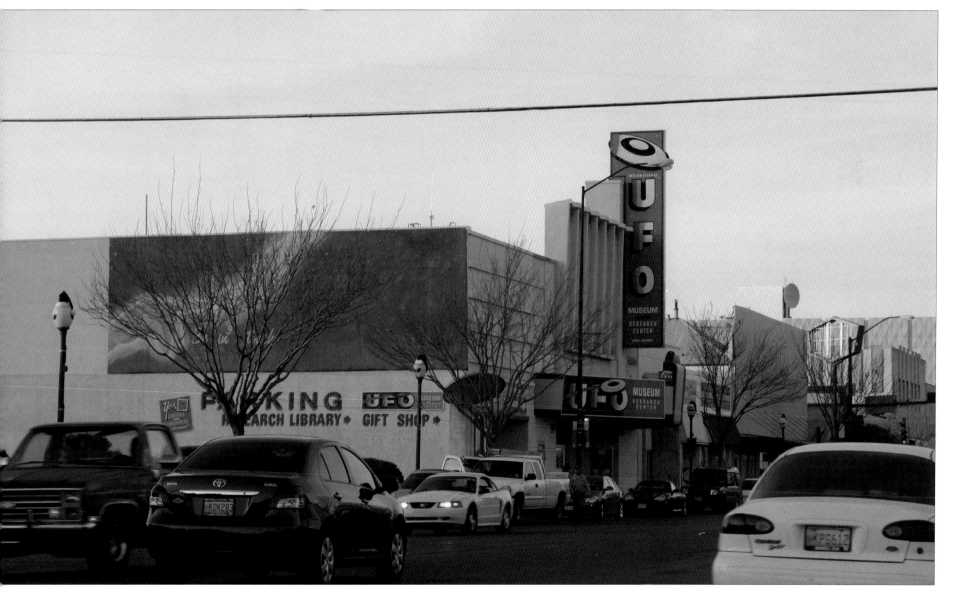

The International UFO Museum and Research Center occupies the old Plains Theater on North Main Street in Roswell.

ROSWELL

In 1891 the New Mexico Military Institute opened in Roswell to instruct young men and women for state and national service. Many of its graduates have gone on to distinguished careers after attending West Point and other military academies.

In 1947, on July 7, a mysterious crash 75 miles north of Roswell made the town a huge tourist attraction. Roswell became associated with the UFO incident because the investigation was led from the town and debris from the site was handled by the local Roswell Army Air Field. Details about the "Roswell Incident" and the local and national government's alleged cover-up of what could be an alien encounter have mystified and intrigued people ever since. Hotels, restaurants, and many associated businesses cater to the continuous stream of thousands of curious visitors. UFO believers are sure the military engineered a cover-up of a crashed alien craft in which alien bodies were discovered. The military, however, maintain that the debris was from an experimental high-altitude surveillance balloon.

In 1967 nearby Walker Air Force Base closed (it had been founded in 1941) and Roswell lost about half its population. Many businesses suffered badly, but following a difficult decade, things have improved. The old base has become an industrial area, particularly in the aviation fields.

The largest annual UFO Festival is held during the first week of July, and the world's biggest "Hike It & Spike It" Four-On-Four Charity Flag Football Tournament on Memorial Day weekend.

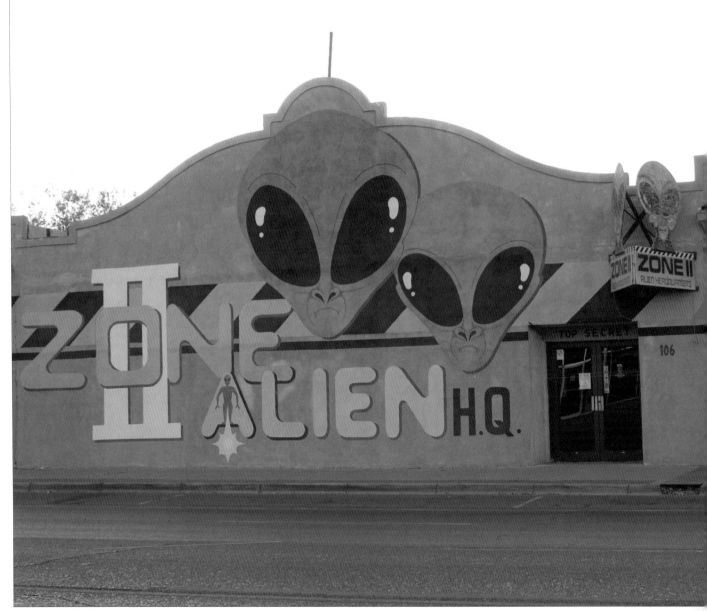

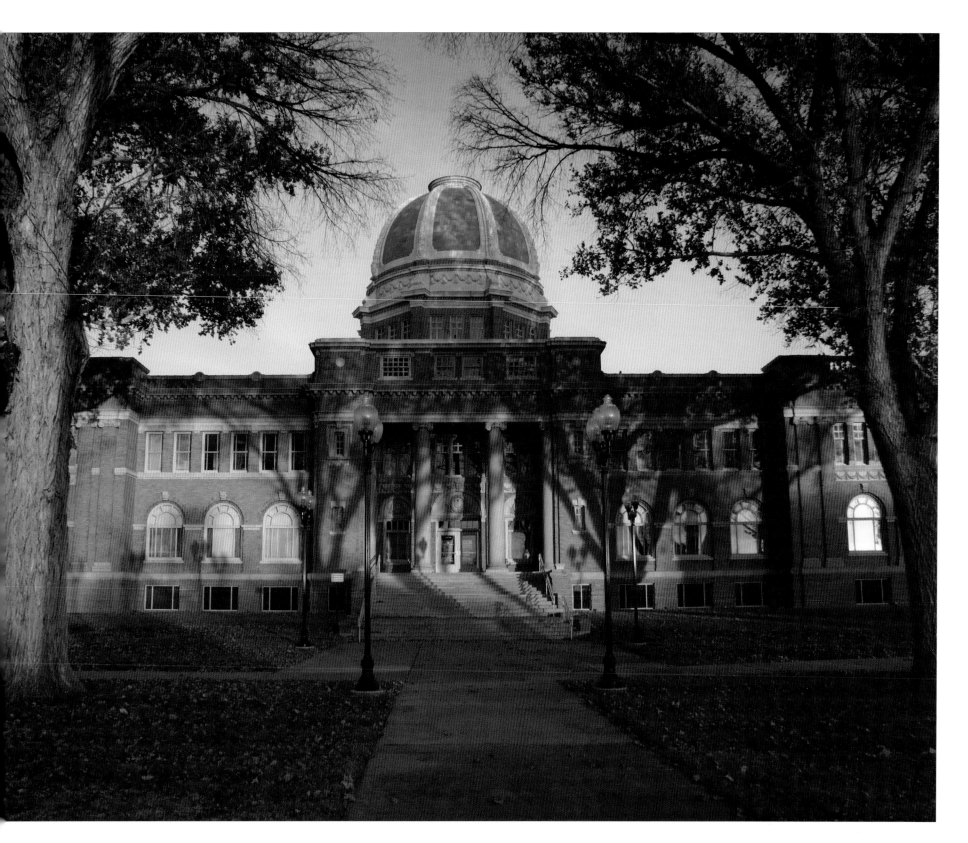

CARLSBAD

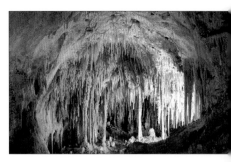

Located along the banks of the Pecos River, Carlsbad was originally christened the town of Eddy on September 15, 1888, and organized as a municipal corporation in 1893. With the commercial development of local mineral springs for medicinal qualities, the town changed its name to Carlsbad, after the famous European spa Carlsbad, Bohemia, (now Karlovy Vary, Czech Republic). On March 25, 1918, the New Mexican governor proclaimed Carlsbad a city.

The rediscovery of Carlsbad Caverns (then known as "Bat Cave") by local cowboys in 1901 and the subsequent establishment of Carlsbad Caverns National Park on May 14, 1930, gained the town of Carlsbad substantial recognition.

In 1925 potash was discovered near Carlsbad and for many years Carlsbad dominated the American potash market. Following the decline of the potash market in the 1960s, the residents and leaders of Carlsbad lobbied for the establishment of the Waste Isolation Pilot Plant (WIPP). Congress authorized the WIPP project in 1979 and construction began in 1980. The Department of Energy Carlsbad Area Office opened in 1993 and the first waste shipment arrived in 1999.

The WIPP is the world's third deep geological repository licensed to permanently dispose of transuranic radioactive waste for 10,000 years that is left from the research and production of nuclear weapons and nuclear power plants. It is located approximately 26 miles east of Carlsbad, New Mexico.

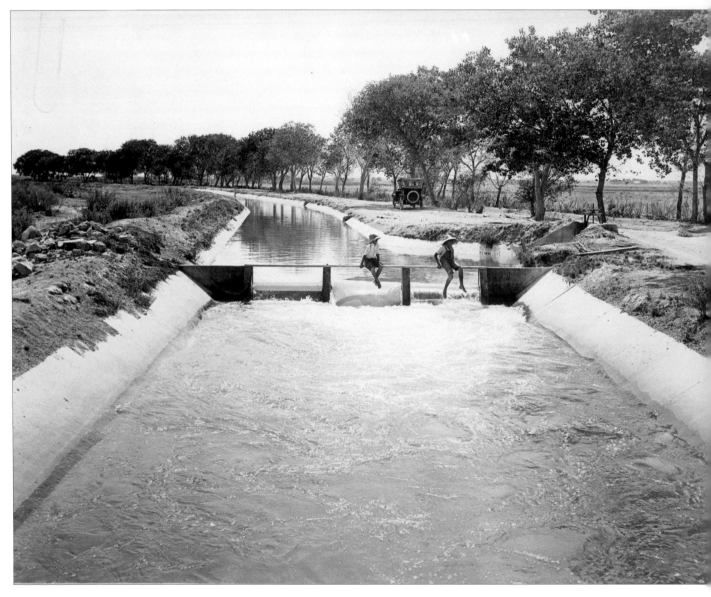

Main canal of Carlsbad Irrigation Project in Carlsbad. Started in 1887, it includes dams, spillways, embankments, and other structures relating to reclamation of water.

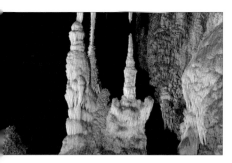 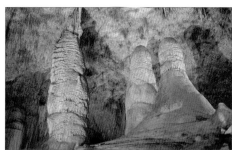

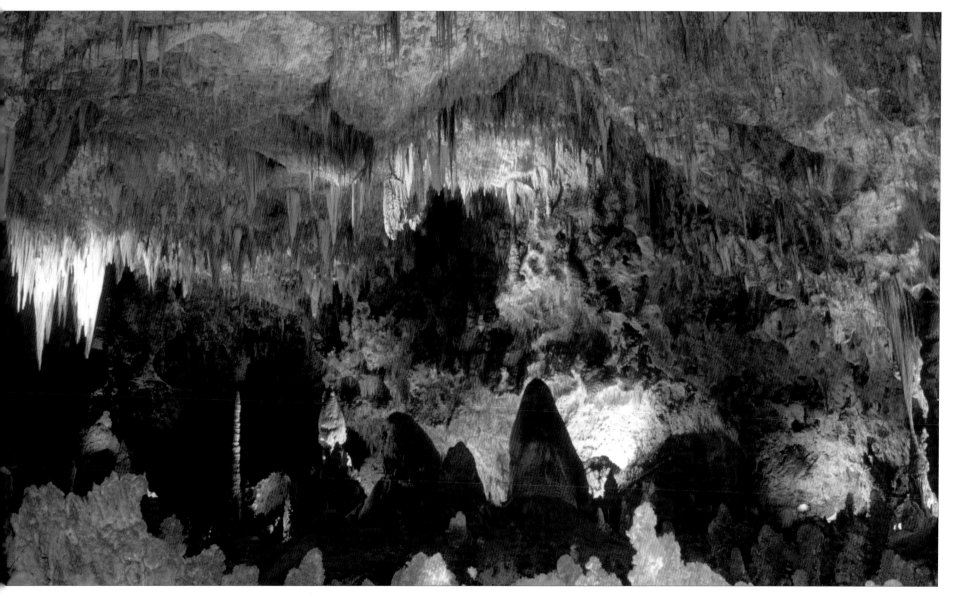

Carlsbad Caverns National Park is one of over 300 limestone caves in a fossil reef laid down by an inland sea 250 to 280 million years ago.

TULAROSA

Tularosa is a village in Otero County, which lies at the base of the Sacramento Mountains and gets its name from the Spanish for the red- or rose-colored reeds which grow along the banks of the Rio Tularosa.

The original settlers built here because it was a valuable water source in the desert. The first settlers came in 1860. This initial community struggled and failed. Two years later Hispanic farmers from the Rio Grande valley managed to make their community permanent, and in 1863 the village of Tularosa was formally laid out with forty-nine blocks, an irrigation system, and specified water rights.

The original ditch system (acequia), which distributed the water, remains almost exactly as it was originally conceived and it supplies the water that nourishes the trees lining the streets and gardens.

In 1979—because Tularosa has managed to retain its unique charm and character—the Tularosa Original Townsite District was recorded in the National Register of Historic Places for its historic 182 buildings and forty-nine block street plan.

Present-day Tularosa is a small and thriving community which retains is historic character. All new building has to conform to the historic vernacular style. Nearby places of interest include the Ruidoso and Mescalero Indian reservation, and the Lincoln National Forest.

The Tularosa vineyards are located just to the north of the town, where picnic tables are available under the shade of the lovely pecan trees.

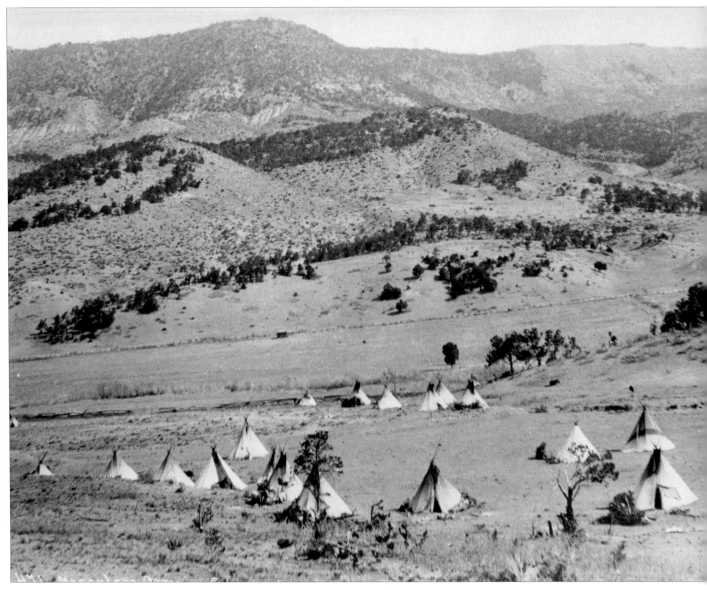

Mescalero Apache camp, Tularosa Valley, 1885.

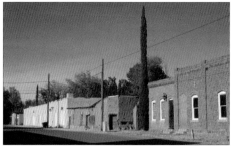

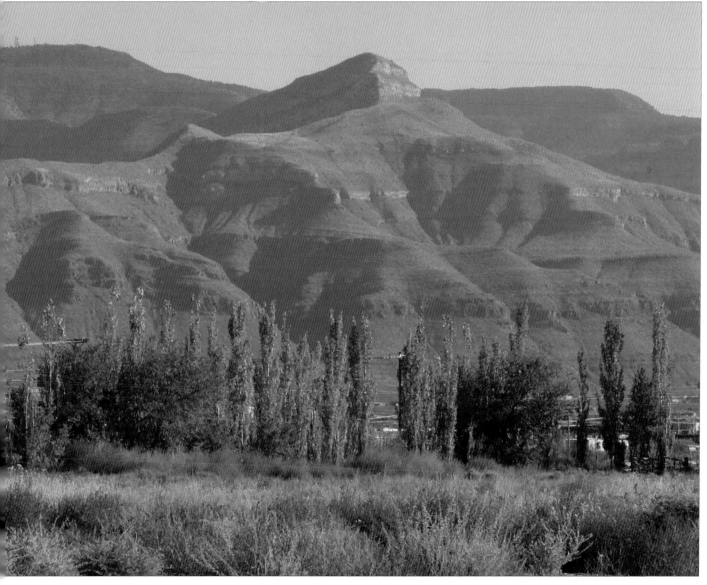

The Tularosa Basin is framed by the imposing Sacremento Mountains that rise to 7,500 feet.

ALAMOGORDO

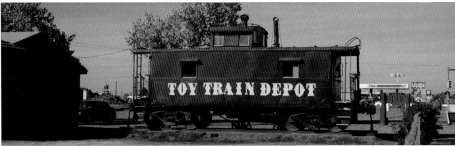

Founded at the railhead in June 1898 when the El Paso and Northwestern Railroad was extended, Alamogordo is located in Otero County. The owner of the railroad, Charles B. Eddy, wanted wide boulevards and cottonwood tree-lined irrigation canals for his new town. Its name, Alamogordo, came from the Spanish *alamo gordo* meaning "fat cottonwood." The original street plan specified that north-south streets have related theme names (presidents, states, etc.), while the east-west streets be numbered.

Alamogordo initially earned money by processing timber for railroad ties, but this was always a short-term job, so the railroad founders formed the Alamogordo Improvement Company to provide the town with an economic future. The original post office was constructed of adobe in 1938 and is listed on the National Register of Historic Places. The post office moved out in 1961 and the building has been used by various federal services since.

Every March Alamogordo hosts the White Sands International Film Festival. Lasting a week, the festival promotes Hispanic and New Mexican filmmakers in particular and shows narrative and documentary films from around the world. Alamogordo is also home to the oldest zoo in the Southwest, Alameda Park Zoo. Nearby lies the Oliver Lee State Park, the historic site of numerous Union Army and Apache battles which includes a fully restored nineteenth-century ranch house.

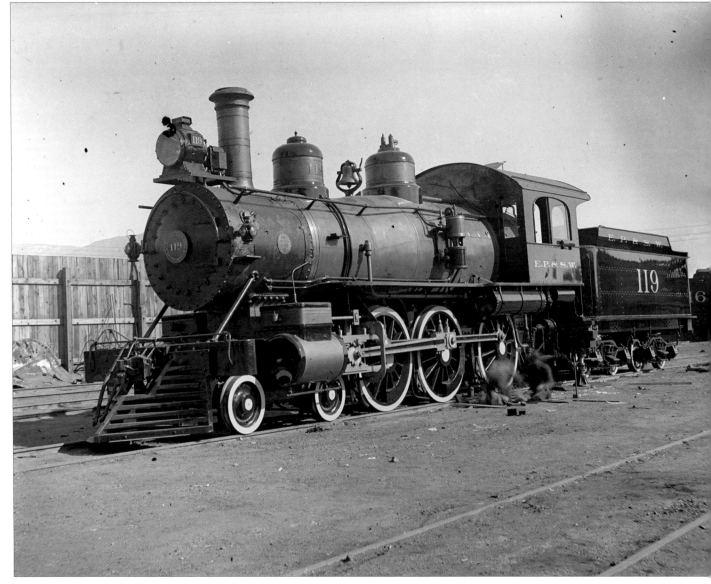

El Paso and Southwestern Railroad locomotive 119 in Alamogordo, 1905.

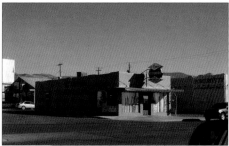

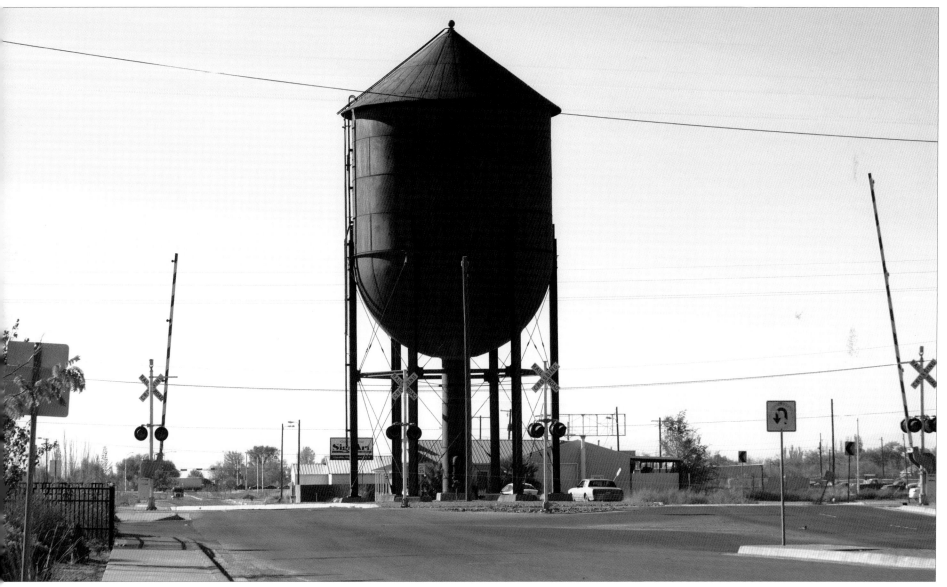

water tower stands as a monument to the great days of the El Paso and Southwestern Railroad, from its origins in 1888 to its demise in 1961.

ALAMOGORDO

Alamogordo holds an important place in the exploration of space. The New Mexico Museum of Space History is located here. In January 1961, Ham became not only the first chimp in space, but also "the first free creature in outer space." He died aged 27 in 1983, and was buried here in the front lawn.

The first atomic bomb was detonated 60 miles from Alamogordo at Trinity Site on the Alamogordo Test Range on July 16, 1945. The explosion site has now become part of the White Sands Missile Range.

In March 1982 nearby White Sands Space Harbor became the only other place than Florida or California for the Space Shuttle Columbia to visit when it landed at the end of the third Shuttle mission.

Six miles southwest of Alamogordo lies Holloman Air Force Base, the home of the 49th Fighter Wing of Air Combat Command, which flies F-117A Nighthawk Stealth Fighters. The wing deploys combat-ready and mission-support forces supporting Air Expeditionary Force operations, Global War on Terrorism, and peacetime contingencies. It trains pilots in the F-117A and the Northrop AT-38B Talon aircraft, and provides support to over 18,000 personnel, to include German Air Force Panavia Tornado and F-4 Phantom II operations.

Also worth visiting is the National Solar Observatory at Sacramento Peak near Cloudcroft. The 76cm Dunn Solar Telescope at an altitude of 9,262 feet above sea level is the premier facility for high-resolution solar physics.

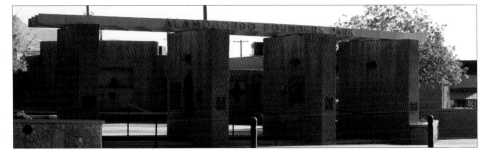

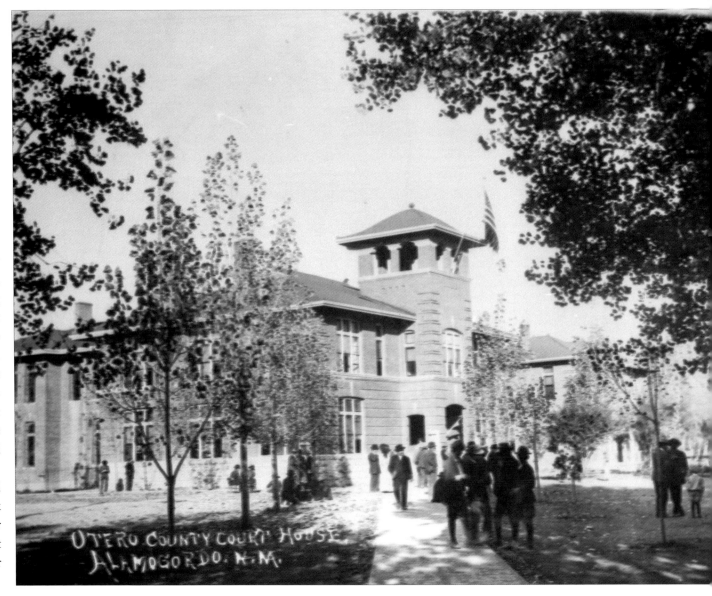

Otero County Courthouse in Alamogordo at the turn of the twentieth century.

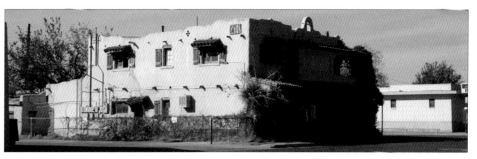

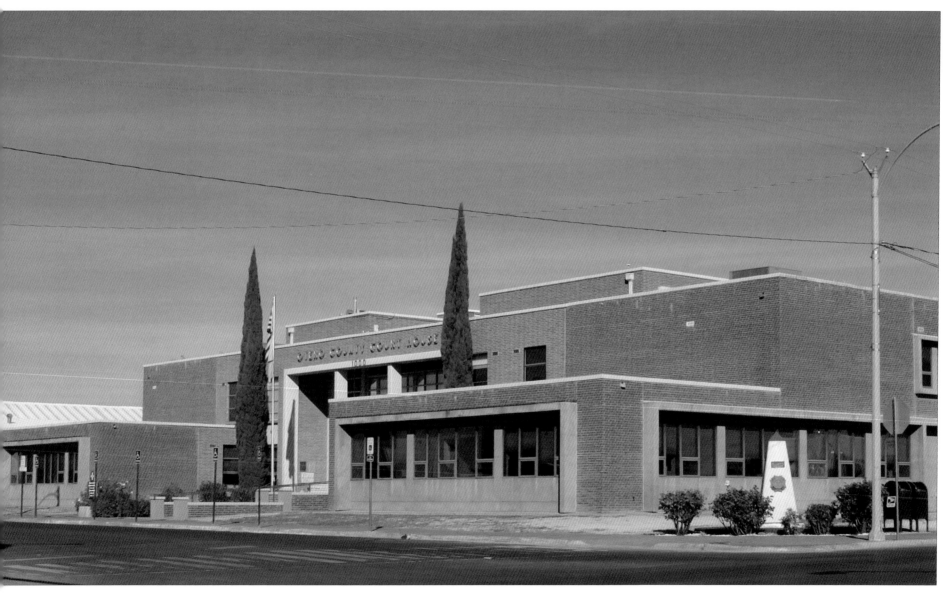

e courthouse as it looks today.

WHITE SANDS

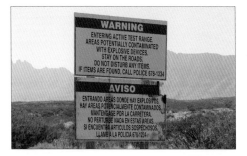
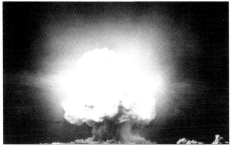

The largest deposit of gypsum in the world is found around White Sands in Tularosa Basin. Unlike other desert sands, the gleaming white desert is cool to the touch because the sand grains reflect rather than absorb the sun's rays, and because of the high rate of evaporation of surface moisture.

The origins of the desert date back about 100 million years to when the land was covered by a shallow sea. When the sea evaporated saline lakes were left behind, and when these also evaporated gypsum was left in thick deposits on the old seabed. Millions of years later, after massive geological movements threw up the Sacramento and San Andreas mountain ranges, weathering, and the passage of time, the gypsum has been ground down to fine powder and piled in steep dunes up to 50 feet high. Thanks to the alkaline nature of the sands and lack of rainfall, very few plants and animals manage to survive in such an extreme environment. The White Sands Missile Range is the largest military installation in the U.S. Trinity Site is where the first atomic bomb was tested at 5:29:45 a.m. Mountain War Time on July 16, 1945. The 19-kiloton explosion not only led to a quick end to the war in the Pacific but also ushered the world into the atomic age. All life on Earth has been touched by the event which took place here.

The 51,500-acre area was declared a national historic landmark in 1975. The landmark includes base camp, where the scientists and support group lived, ground zero, where the bomb was placed for the explosion, and the McDonald ranch house, where the plutonium core to the bomb was assembled.

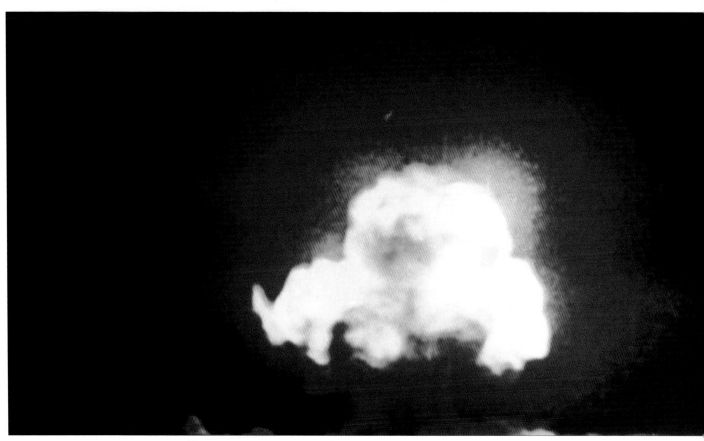

Famous color photograph of the "Trinity" shot, the first nuclear test explosion, July 16, 1945.

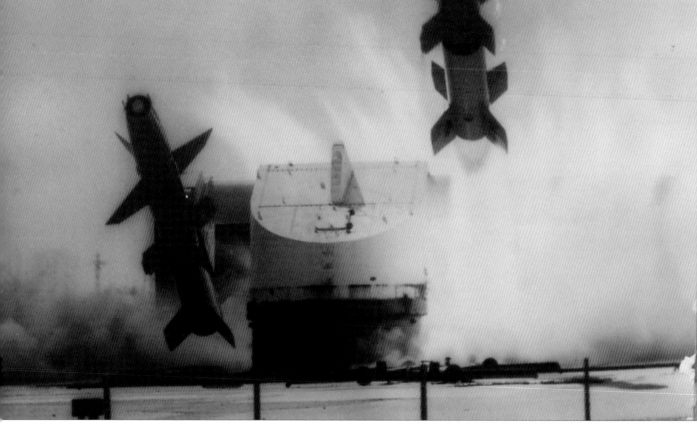

M-8 Talos surface-to-air missile, built by Bendix Corporation during the test launch at White Sands Missile Range, January 2009.

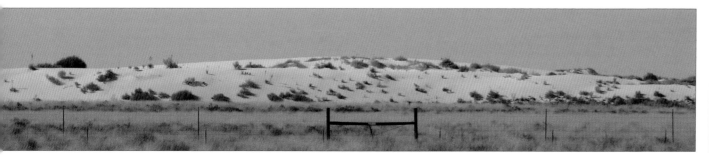

LAS CRUCES

The story of Las Cruces begins 600 million years ago when this area of southern New Mexico was covered by a vast inland sea. When the sea retreated the land was left scattered with amazing fossils, including what the Smithsonian Institute calls "the world's best fossilized footprints from the Permian Period."

The ancient Mogollon Indians lived in this area until around 1450. Little is known of their culture except what can be deduced from the many rock drawings (petroglyphs) they left behind. In later times these were the lands of the Mescalero Apache.

The first Europeans to see the region were with Don Juan de Oñate and his expeditionary group who searched New Mexico for gold in 1598 on behalf of the king of Spain. Moving along what would become known as the Camino Real (now called the Jornada del Muerto) the expedition worked along the Rio Grande before moving through the arid lands where many of the expedition died of dehydration. Juan de Oñate survived the ordeal to become the first colonial governor of New Spain.

Las Cruces lies between the Organ Mountains and the meandering Rio Grande in the Mesilla Valley in Doña Ana County. It was here in 1848 after the Treaty of Guadalupe Hidalgo ceded the land to the United States, that U.S. Army lieutenant Delos Bennett Sackett plotted out eighty-four city blocks, plus plaza and church, to form the outline of Las Cruces with the use of stakes and rawhide ropes. Then the 120 people already living on the land drew lots to see which plot they were allocated. From there the First

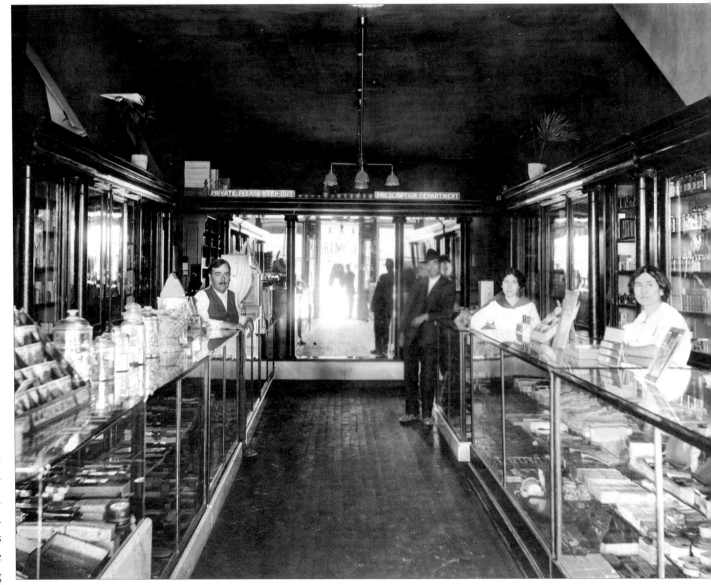

Presliano Moreno, first Spanish person to be a registered pharmacist in New Mexico.

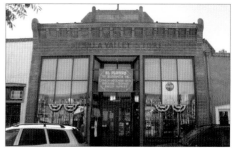

curiosity shop in Old Mesilla town plaza.

Las Cruces

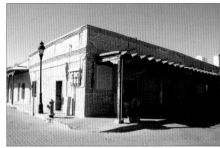

Dragoon of Company H was tasked with protecting the local communities of El Paso and Doña Ana from Apache raiders.

The city is now the second largest in New Mexico with a population of around 90,000. A large part of the original downtown was demolished in the 1960s during an urban renewal project, however the historic center remains as a six-block pedestrianized shopping and cultural area.

Out of town 13 miles north at Radium Springs is the Fort Selden State Monument, which was active as an army post between 1865 and 1891. It was here that the famous Buffalo Soldiers were stationed: they were the U.S. 10th Cavalry Regiment and the first peace-time African American regiment in the regular U.S. Army. While here in New Mexico they participated in the Apache Wars and the Great Plains campaigns earning thirteen Medals of Honor in the process.

The New Mexico State University has its main campus in Las Cruces and has approximately 17,000 students on this 6,000-acre campus. NMSU is the only research-extensive, land-grant institution classified as Hispanic serving by the federal government. The university is home to New Mexico's NASA Space Grant program.

The Border Book Festival is held during the last weekend in April. The Whole Enchilada Festival is held during the last weekend of September with the Southern New Mexico State Fair following it a few days later.

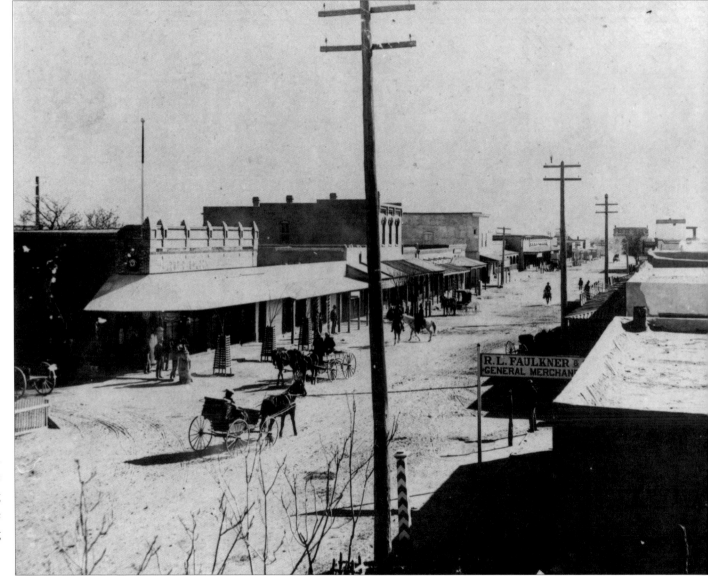

Main Street in Las Cruces, c. 1900.

more modern Main Street as it stands today.

SILVER CITY

Silver City was originally an Apache campsite before becoming San Vincente de la Ciénega (St. Vincent of the Marsh) when silver was found locally in the 1860s and eager prospectors arrived in their hundreds. The silver ode was found by Captain John M.Bullard at Chloride Flats near his family farm. In 1870 Bullard laid out a street plan for Silver City on the family land and a tent city quickly sprang up as would-be prospectors arrived. However, before the year was out, Bullard was killed during an Apache raid in February 1871.

Silver City, like all frontier towns during the 1870s, was a violent and dangerous place. Grant County Sheriff Harvey Whitehill twice arrested William Bonney for theft, the latter became better known as Billy the Kid. In 1878 Silver City authorities—in an attempt to control the town—hired its first marshall, lawman "Dangerous Dan" Tucker who gunned down several troublemakers during his time there. In 1893 the Normal School was established to educate local children, and in 1963 it became the Western New Mexico University. The town had originally been designed with the streets running north to south. The town was also built in the path of normal water runoff. Businesses sprang up and people learned to deal with the inconveniences of the summer rain. Silver City was built with high sidewalks in the downtown area to accommodate high flood waters. Meanwhile, uncontrolled grazing thinned down plant life on hills surrounding the town. During the night of July 21, 1895, a heavy wall of water rushed through the downtown business district leaving a trail of destruction.

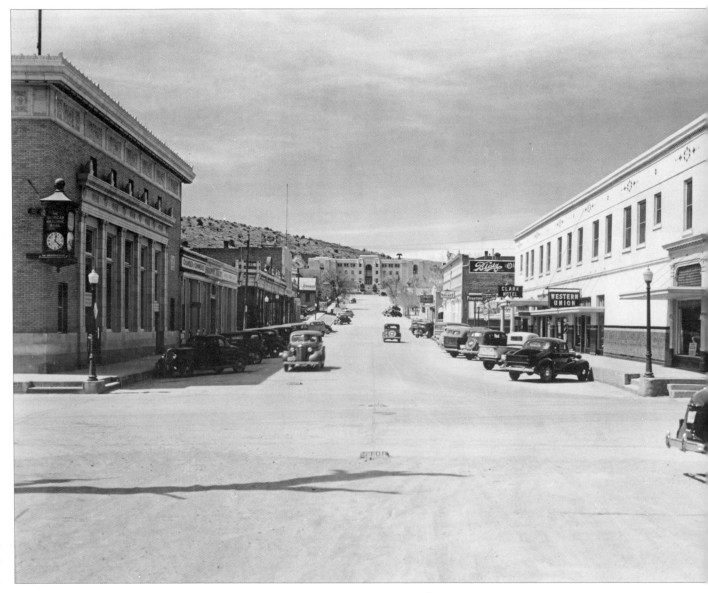

Broadway Street, looking west from Bullard Street in Silver City, c. 1930.

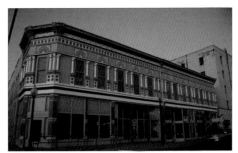

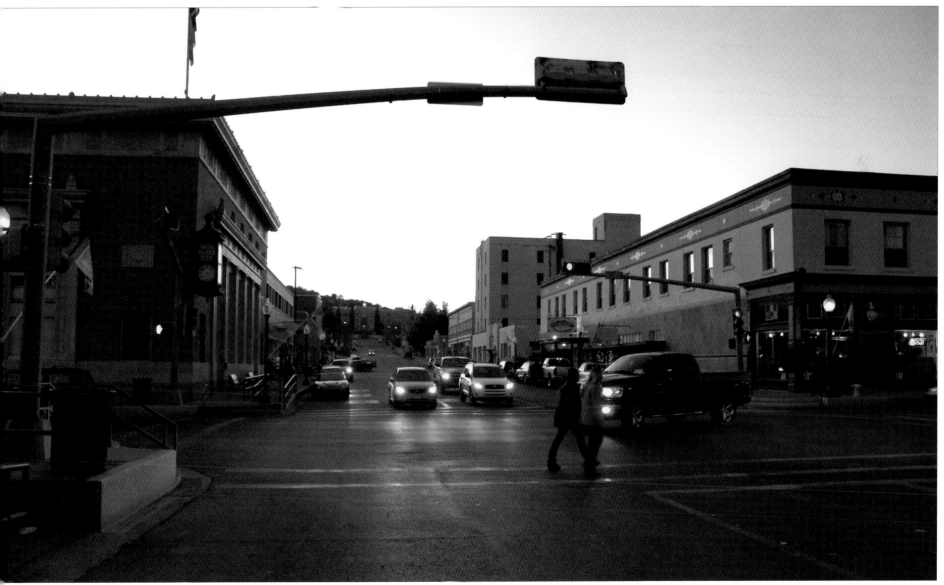

roadway Strreet as it stands today has changed very little.

KINGSTON

Originally called "Percha City" after the local creek, Kingston started as a mining camp when a rich lode of silver ore was discovered in 1882 at a mine that was named the Solitaire. News of the strike spread like wildfire and by the year's end the town population had escalated to 1,800—most of them miners and prospectors and all of them hoping to get rich. During this period Kingston became a boomtown and the largest silver mining town in New Mexico with a population of some 7,000. During the decade spanning the 1880–1890s it has been estimated that around $7 million in silver was dug out of the Black Range Mining District. At this time the town had a reputation for being one of the wildest towns in the West, and contained three hotels, a bank, twenty-two saloons, fourteen general stores, a brewery, numerous gambling dens, three newspapers (the *Shaft,* the *Advocate,* and the *Clipper*), a theater, and many other amenities. In 1888 the Spit & Whittle Club opened and now claims to be the longest continuously active social club in the U.S. and is still open today.

For a long time Kingston did not have a church, and when one was built it was outnumbered by twenty-two saloons. Occasional Native American raids scared the inhabitants but their lives were generally peaceful and Kingston continued to grow. The good times ended when the price of silver dropped, and more crucially, the deposits ran out. Business was so bad that the post office shut in 1957. Present-day Kingston has around thirty permanent residents.

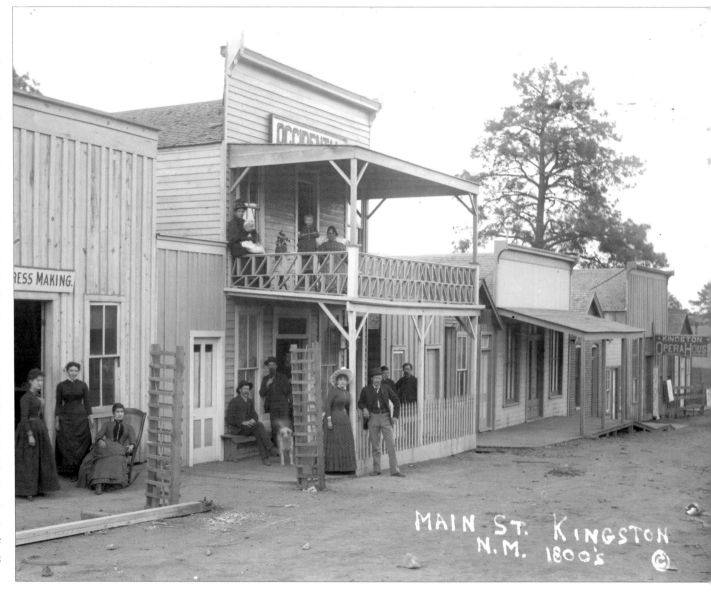

Main Street in Kingston, 1885.

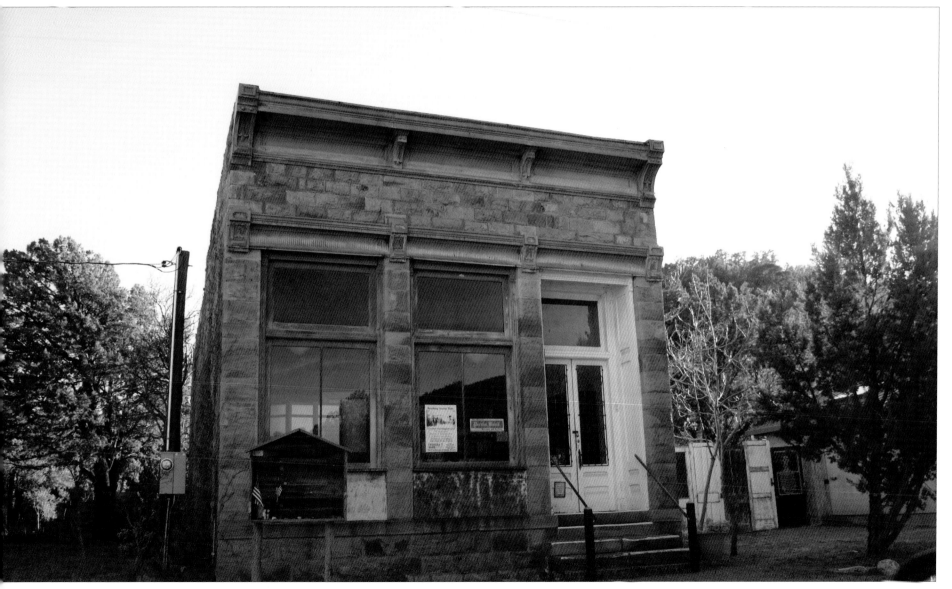

ngston is now a ghost town, with one of the last original buildings still standing, and also home to the haunted Black Range Lodge.

HILLSBORO

Hillsboro began as a tented settlement in Sierra County in 1877 after gold was discovered along Percha Creek by two miners who staked the Opportunity and Ready Pay mines. They were soon joined by many other fortune hunters. Silver was discovered in the surrounding Black Range Mountains in the 1880s and Hillsboro quickly became an important mining and ranching center attracting thousands of prospectors who dug into the mountains hoping to strike lucky. Millions of dollars worth of silver was unearthed, which in turn attracted businessmen and adventurers eager to make a living from the prospectors. Life was dangerous and death and disease common, not least of the problems being regular and fierce Apache raids and attacks from outlaws; accordingly, militiamen and soldiers were stationed in Hillsboro to protect its citizens.

The tented town turned into more durable adobe and wooden dwellings as people settled permanently. A brick courthouse was built in 1892 to deal with the large number of miscreants. In the "panic" of 1893 the price of silver plummeted and the prospectors abandoned Hillsboro. By 1907 Hillsboro had only 1,200 inhabitants. A great drought in 1922 brought disaster to many farmers and ranchers, the main bank collapsed in 1925, and then the Great Depression hit.

Between 1884 and 1939, Hillsboro had been the county seat but then it was moved to the bigger and richer town of Hot Springs (now Truth or Consequences). Present-day Hillsboro has fewer than 250 residents, many of them retired citizens.

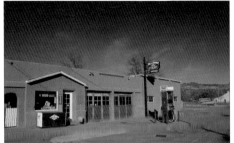

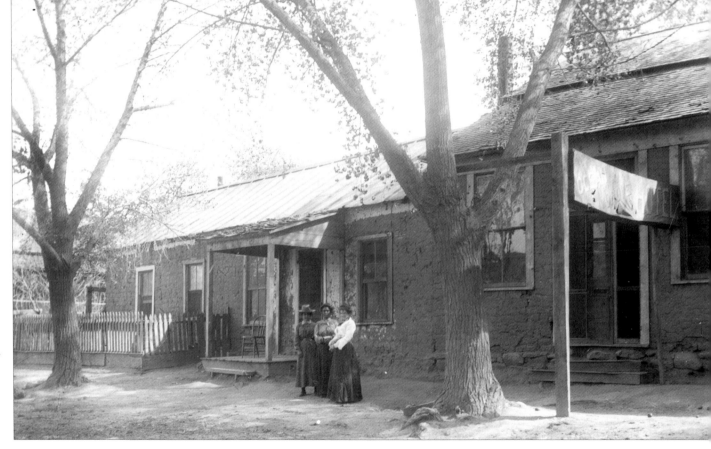

Mrs. Sadie Orchard (who ran a boarding house, two hotels, and the stage coach line) on right, in front of Ocean Grove Hotel, Hillsboro, 1895.

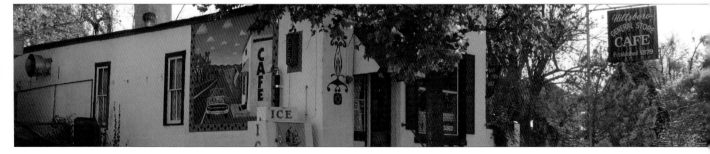

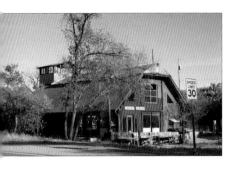

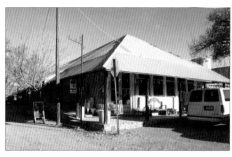

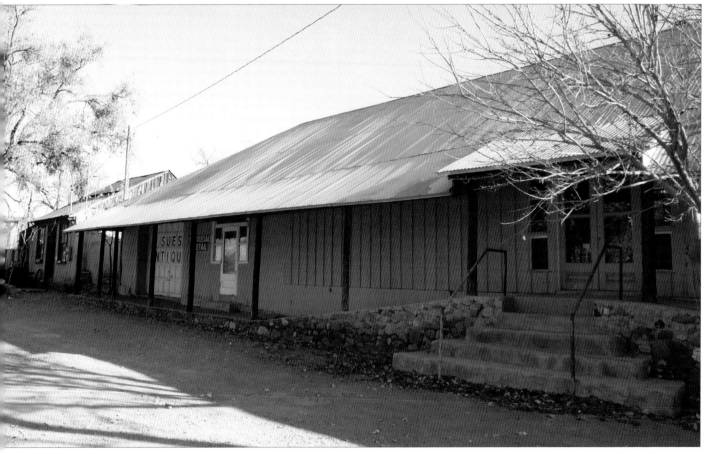

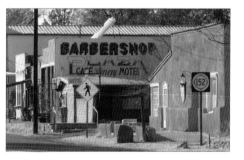

...oday, an antiques shop occupies the building.

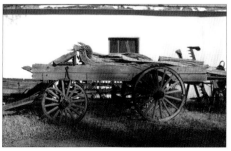

SOCORRO

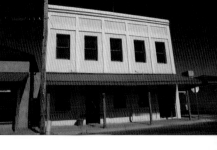

Sitting in Socorro County in central New Mexico near the Rio Grande, Socorro was first seen by the Spanish in June 1598. A group of settlers led by Juan de Oñate crossed the Jornada del Muerto desert and encountered some Piro Indians from Teypana Pueblo who came to their aid with corn and water.

The Spaniards named the place Socorro meaning "help" or "aid." Later, around 1626, the San Miguel Mission was established to minister to the 600 or so Piro Indians living nearby, and soon Spanish farms and ranches sprang up on land given in Spanish grants.

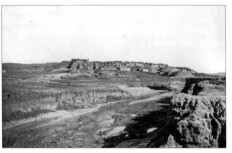

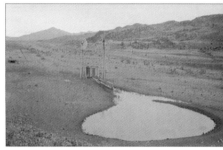

During the 1680 Pueblo Revolt, fleeing Spanish settlers accompanied by some Teypanas Indians took refuge in Socorro. Without protection from Spanish troops the town was destroyed by the Apache and almost everyone killed.

Socorro was abandoned and not rebuilt until long after New Mexico was reconquered. Finally, in 1800, Governor Fernando Chacon ordered the reestablishment of villages in the Rio Grande Valley but Socorro was not resettled until 1815. Around the same time, the mission of San Miguel de Socorro was established and a church was built on the foundations of the former building.

Socorro remained small: the 1833 census shows a little over 400 residents, although a lot more resided in the outlying area; in September 1850 at the time New Mexico became a U.S. territory, the permanent population of Socorro was only 443 people. The following year Fort Conrad—30 miles south—became the first military post to guard against Apache

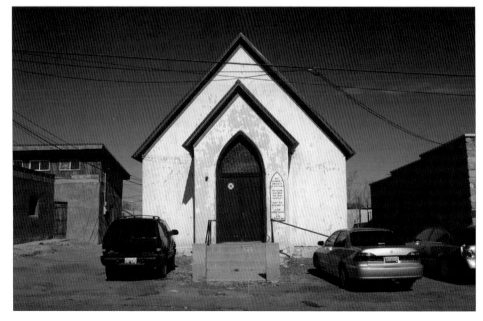

SOCORRO

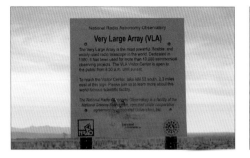

and Navajo raiders; however, by 1854 it was abandoned for nearby Fort Craig instead, which became the base for the Buffalo Soldiers, the regiments of Black soldiers after the Civil War. Socorro grew in the 1880s when the railroad arrived bringing new people and businesses.

The New Mexico Institute of Mining and Technology is located at Socorro and in eastern Socorro Country lie the impressive ruins of the Gran Quivira Pueblo. Also close by lies Cibola National Forest, the Bosque del Apache, Sevilleta National Wildlife Refuges, and the BLM Quebradas Scenic Backcountry Byway. The Very Large Array (VLA) is a radio astronomy observatory located on the Plains of San Augustin, between the towns of Magdalena and Datil, some 50 miles west of Socorro. The VLA stands at an altitude of 6,970 feet above sea level.

The observatory consists of twenty-seven independent antennas, each of which has a dish diameter of 82 feet and weighs 230 tons.

The antennas are arrayed along the three arms of a Y-shape (each of which measures 13 miles long). Using the railroad tracks that follow each of these arms and a specially designed lifting locomotive, the antennas can be physically relocated to a number of prepared positions, allowing aperture synthesis interferometry with a maximum baseline of 22.3 miles: in essence, the array acts as a single antenna with that diameter. The smallest angular resolution that can be reached is about 0.05 arc seconds at a wavelength of 7mm.

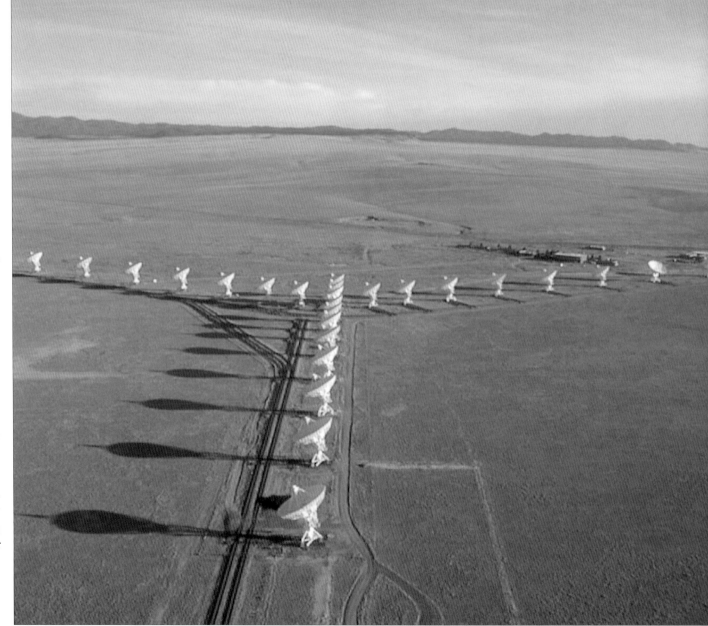

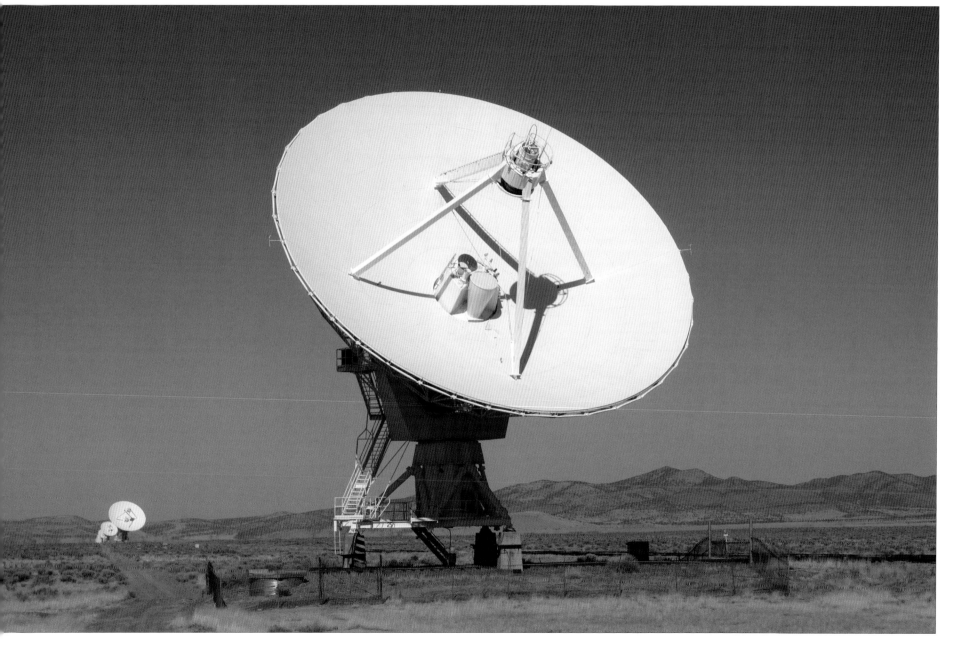

ALBUQUERQUE

Albuquerque was founded in 1706 but its roots date back to ancient times through the Native Americans who have lived here in the Rio Grande Valley since prehistory. The Spanish conquistadors arrived at the settlements which became Albuquerque around 1540, although the Spanish did not immediately settle in the area.

The first Spanish settlers were missionaries who built small adobe churches in the early 1600s; unfortunately they also brought strange and devastating European diseases with them and the Indian population declined alarmingly. By the 1650s a number of Spanish farmers had established around twenty-four farms across the valley. In 1680 after years of suppression and religious intolerance, the Native Americans of Albuquerque rose in rebellion and killed many of their oppressors, and drove the remaining settlers out of their homes and down the Rio Grande to Paso del Norte (now Juarez). For twelve years the Indians held Albuquerque until Diego de Vargas, the new governor of New Mexico, brought his army into the Rio Grande Valley and reestablished Spanish control.

In 1706 king Philip of Spain granted the local colonists permission to establish a new city alongside the banks of the Rio Grande. They chose to build the new Villa de Albuquerque—named after the Duke of Albuquerque—around El Bosque de doña Luisa where the river made a wide curve at the foot of the mountains in an area surrounded by willow trees, cottonwoods, and olives (known locally as "bosque"). The new governor Francisco Cuervo y Valdés told the king that the town already had thirty-

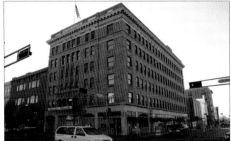

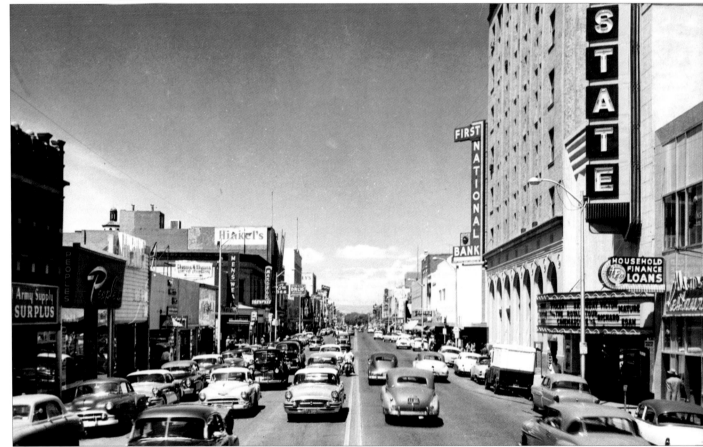

Central Avenue (Route 66) looking west, Albuquerque, 1956.

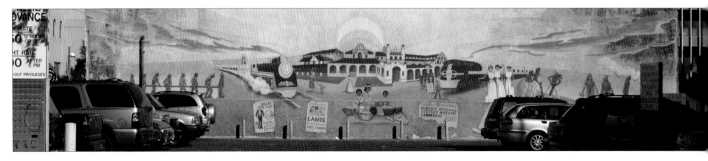

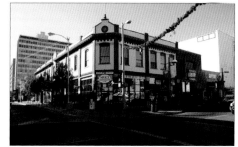

...he same street today remains largely unchanged.

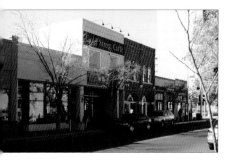

ALBUQUERQUE

five settled families containing some 252 members. The colonists started to build in typical Spanish village fashion with a central church and plaza surrounded by government buildings and clusters of houses. The first building was a church (where San Felipe de Neri stands today) at the center of what would become Old Town. In the very wet summer of 1792 the chapel collapsed, was quickly rebuilt, and subsequently altered and enlarged over the centuries.

In February 1862, during the Civil War, Albuquerque was occupied by Confederate troops led by General Henry Sibley. In April, he made his stand at Albuquerque against Union soldiers commanded by Colonel Edward Canby. The encounter lasted for a day and produced remarkably few casualties before Sibley withdrew. In 1880 the Atchison, Topeka and Santa Fe Railway built its railyards two miles east out of town in what became known as New Albuquerque: it became part of Albuquerque in the 1920s. The University of New Mexico was founded in Albuquerque in 1889. In 1926 U.S. Route 66 arrived at Albuquerque and soon gas stations, motels, restaurants, and other travelers' amenities were built to accommodate the new arrivals. In 1939 Kirtland Air Force Base opened and became a major employer in the region as it became a center for expertise in nuclear weapons. Modern Albuquerque is a high tech center for research containing, among others, the Sandia National Laboratories, and has grown to become the largest city in New Mexico. Every April the city hosts the Gathering of Nations Powwow, which features over 3,000 dancers and singers from over 500 North American tribes.

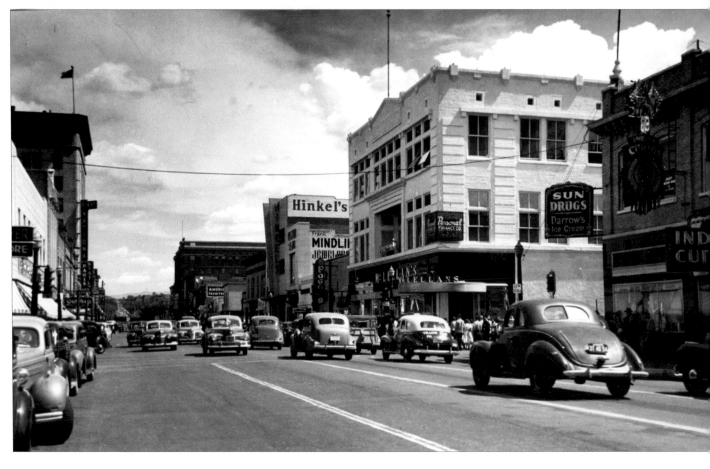

Central Avenue (Route 66) looking east, Albuquerque, c. 1946.

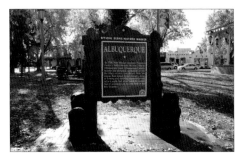
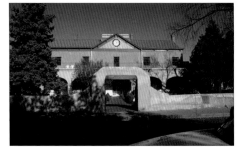

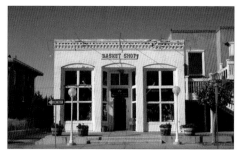

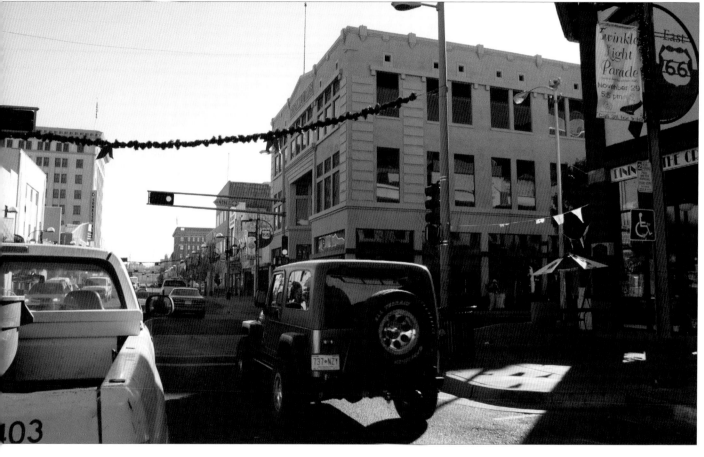

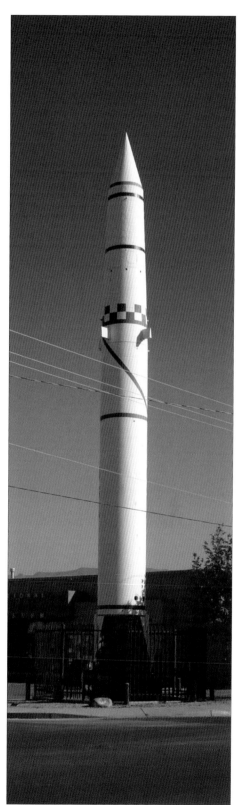

The same street today is now a bustling hive of activity.

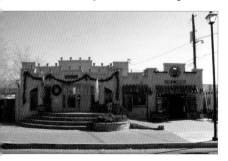

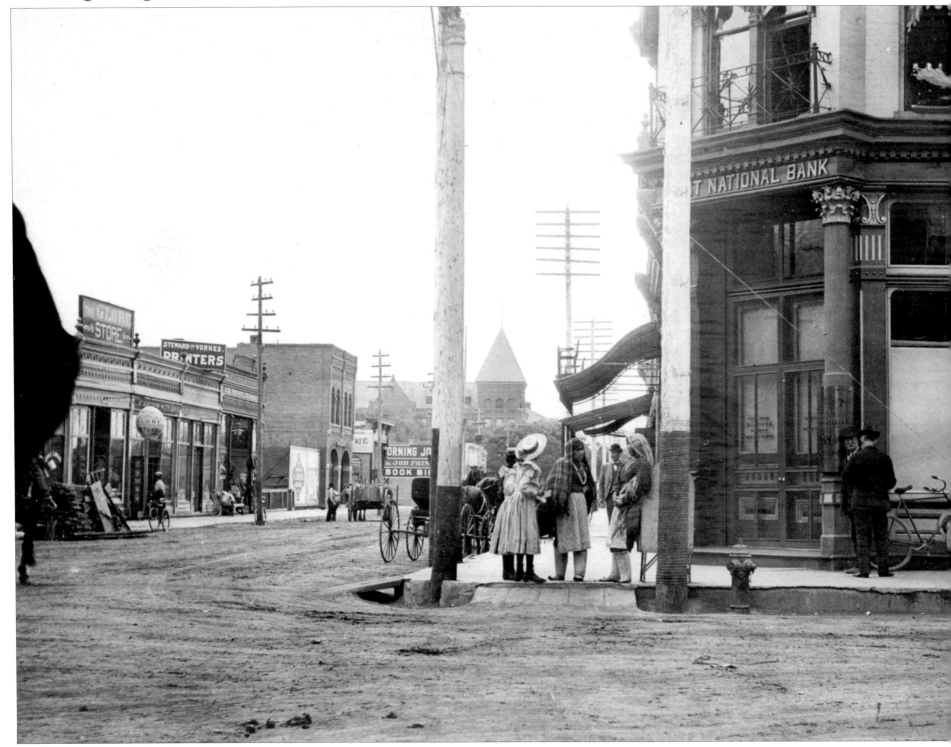

Corner of Gold Avenue and Second Street, Albuquerque, c. 1918.

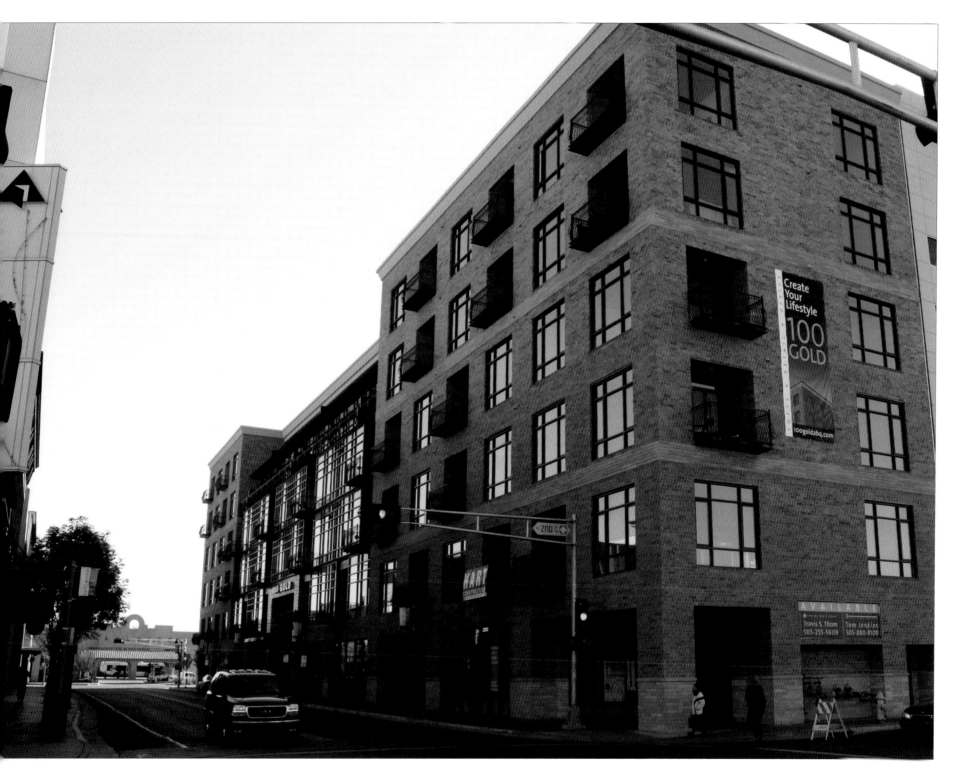

e same street corner today is now home to luxury apartments.

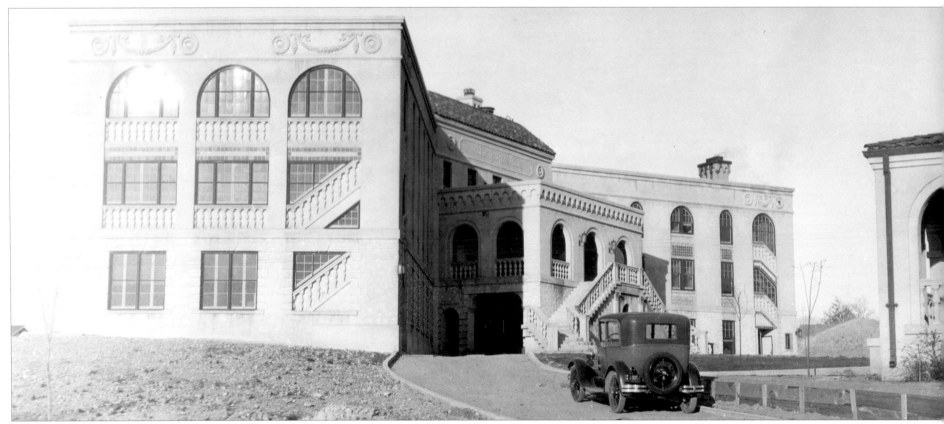

Atchison, Topeka and Santa Fe Association Hospital, Albuquerque, c. 1925.

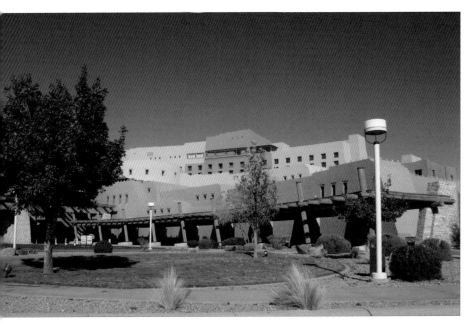

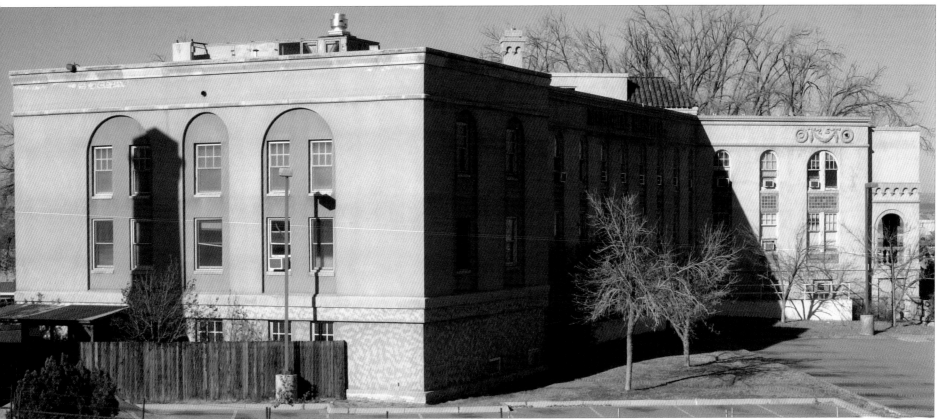

he hospital today, sadly no longer in use, awaits new owners.

The Sandia Peak Tramway overlooks Albuquerque. It is the world's longest passenger aerial tramway and has the world's third-longest single span. It stretches from the northeastern edge of the city to the crestline of the Sandia Mountains.

The Indian Pueblo Cultural Center is owned and operated by the nineteen Indian pueblos of New Mexico and dedicated to the preservation and perpetuation of Pueblo Indian culture, history, and art. The Indian Pueblo Cultural Center is a nonprofit that opened in August 1976 to showcase the history and accomplishments of the Pueblo people, from pre-Columbian to today.

ISLETA PUEBLO

Located in Bernalillo County in the Rio Grande Valley, Isleta Pueblo—meaning "Little Island"—is principally a southern Tewa community and was probably established around 1300. The Tewan name for the pueblo is Tue-I. The Franciscan Spaniards built the San Agustin de la Isleta mission here in 1612 and it still dominates the town plaza in the center of the pueblo. Adobe-built, it is one of the oldest missions in the United States, and although it was badly damaged during the Pueblo Revolt, it was rebuilt in 1716 and renamed St. Augustine Church, after the patron saint of Isleta.

Isleta Pueblo people did not join the 1680 Pueblo Revolt; instead most of the Native population fled for safety to sympathetic Hopi settlements in Arizona or followed the Spanish withdrawal to El Paso del Norte in Texas. When the revolt was over most of the Natives returned home, often accompanied by their new Hopi partners. In the early nineteenth century some people from Laguna and Acoma Pueblos joined the community but disagreements over religion and rituals between the different groups led to the development of the satellite settlement of Oraibi.

The present-day pueblo comprises the main town of Isleta plus the two smaller communities of Oraibi and Chicale. The community is still predominantly Tiwan and most people earn their living from agriculture, although local craftspeople make high-quality pottery, jewelry, and embroidered items. The pueblo contains attractions such as a twenty seven-hole championship golf course, recreational lakes for fishing, and the Isleta Casino and Resort.

Mission Church at Isleta Pueblo, c. 1940.

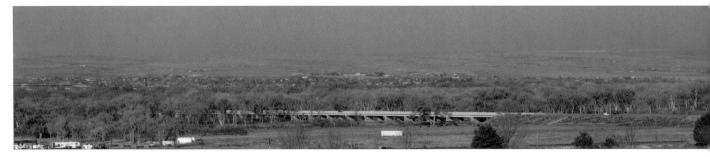

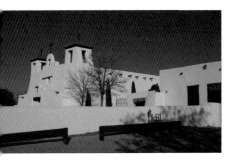

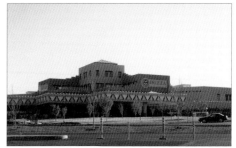
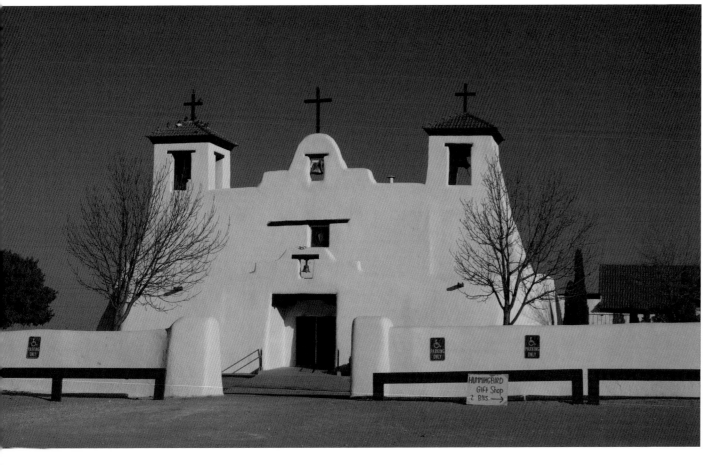

The Mission of San Agustin de Isleta claims to be the oldest mission in New Mexico, established in 1613.

PERALTA

Peralta is located in the northern part Rio Grande Valley of Valencia County on the Lo de Padilla land grant which was granted by the King of Spain in the seventeenth century. The community itself first appears in the records of the Catholic Church in 1835. Between 1848 and 1852 Peralta briefly became the county seat. During the U.S. Civil War a minor engagement known as the Battle of Peralta took place on April 15, 1862: at the time Peralta was described as "a two-mile stretch of adobe houses, thick adobe fences, raised ditches, and groves of large cottonwood trees." The Confederate 5th Texas Mounted Volunteers comprising about 500 men under Colonel Thomas Green had camped in the town while retreating from defeat at the Battle of Glorieta Pass. The Confederates used the low adobe town houses as shelter and from there embarked on an artillery duel with the Union opposition. Suddenly, a dust storm blew in giving the Confederates cover to withdraw; when the air cleared the town had been reduced to rubble. The Peralta was rebuilt but as the railroad bypassed the town it remained a small, rather isolated farming community for the next 100 years or so until in the twentieth century it became one of the main economic centers of Valencia County. On July 1, 2007, the town of Peralta became New Mexico's 103rd municipality. Peralta shares common borders with the Village of Bosque Farms, the Village of Los Lunas, and Isleta Pueblo.

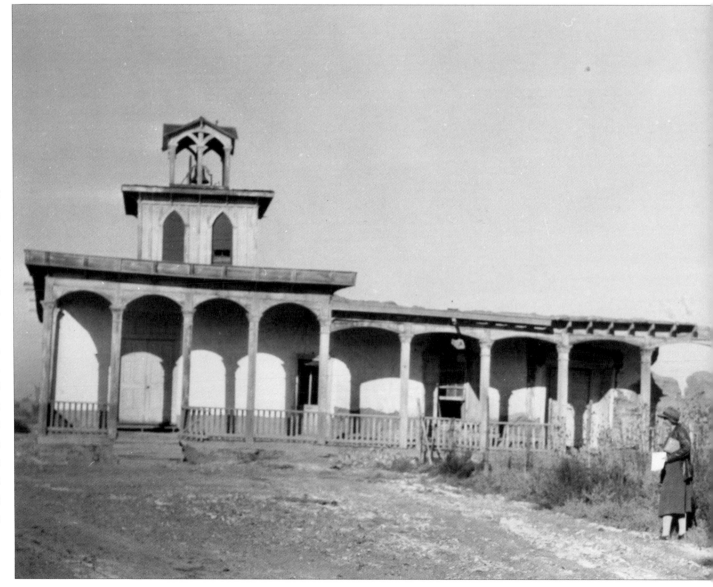

Methodist Mission, Peralta, c. 1930.

he new Peralta Memorial United Methodist Church.

ACOMA PUEBLO SKY CITY

The oldest inhabited community in the entire United States, Acoma Pueblo—"Haak'u" in Acoma—covers about 75 acres on top of a sheer 367-foot-high sandstone mesa. Also called Sky City, the settlement was built by Native Americans around the twelfth century. It was chosen for its fantastic defensive position against other Native raiders as it could only originally be reached via a vertiginous hand-cut stairway carved into the face of the mesa. When the Spanish conquistador army arrived in 1540 led by Francisco Vásquez de Coronado, they conquered Acoma and imposed their repressive rule and culture over the pueblo.

The San Esteban Del Rey Mission was built between 1629 and 1640. The pine roof beams were carried from Mount Taylor on the shoulders of Acoma men, who were not allowed to let them touch the ground during the entire journey.

Only a few families live year-round on the mesa itself while most people live in one of a number of nearby small villages, notably Acomita, McCarty's, Anzac, and Sky Line. Most people gather in the city only for feast days and many of the inhabitants dry farm corn in the valley below or work for the tourist industry. The pueblo is famous for white, thin-walled, hand-coiled clay pots, and Acoma potters still make their distinctive pottery painted with black and red-brown geometric designs. Acoma Pueblo is a registered National Historic Monument and also a National Trust Historic Site; it sits on federal trust land which is administered by the federal government. The Sky City Casino Hotel has become a recent source of income.

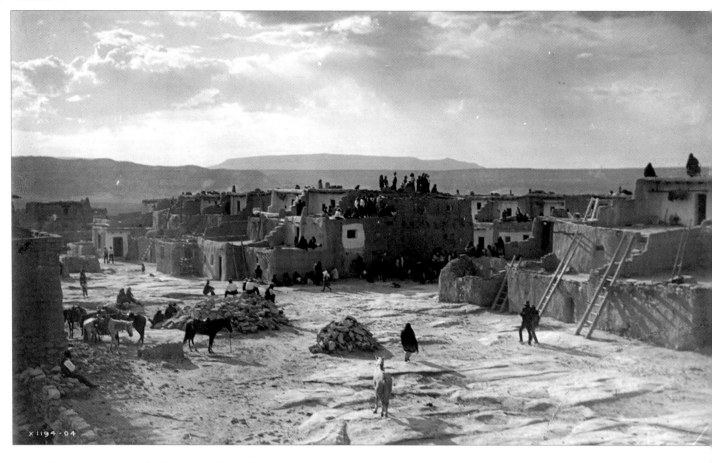

Acoma Pueblo as photographed by Edward S. Curtis in 1904.

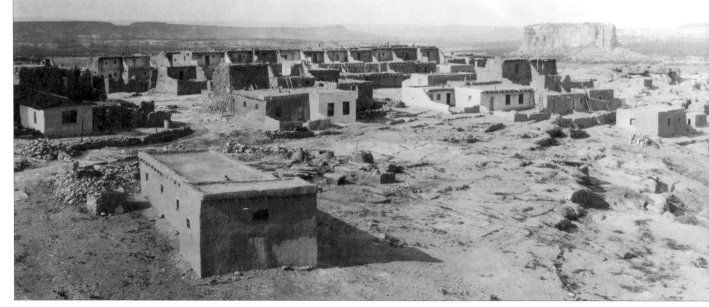

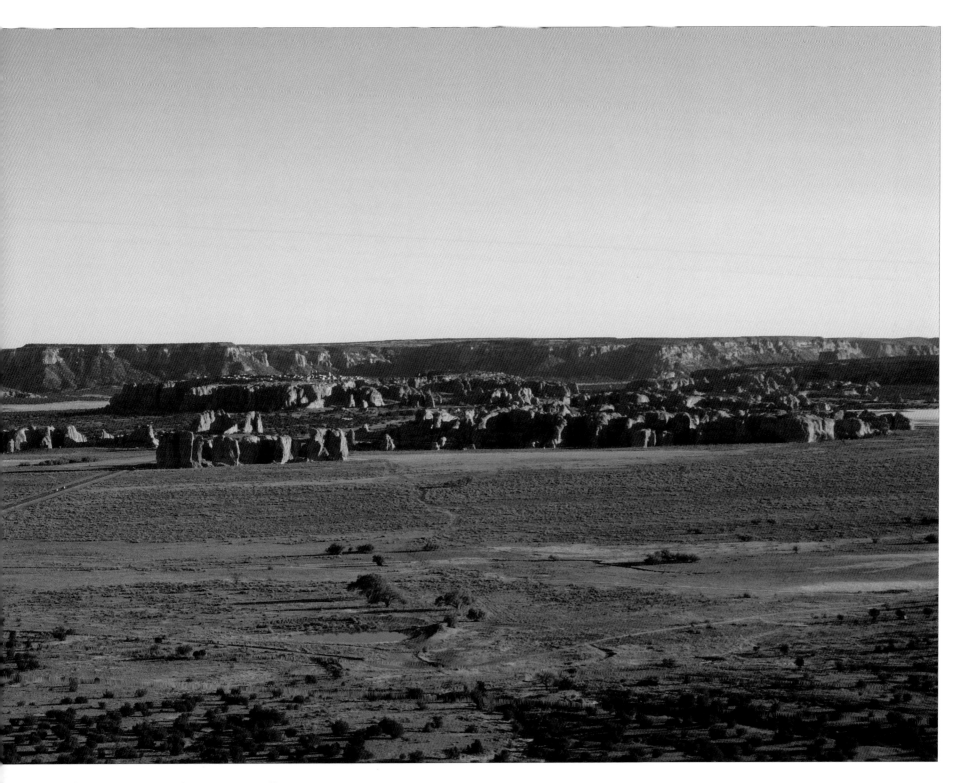

he ancient pueblo village atop a 367-foot sandstone bluff.

ACOMA PUEBLO SKY CITY

 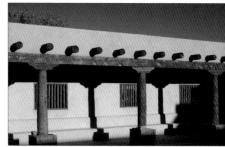

The Sky City Cultural Center provides a look into our heritage through a variety of activities and exhibits. Take a guided tour of the ancient pueblo village atop a 367-foot sandstone bluff, shop at the Gaits'i Gallery for beautiful Native American jewelry and Acoma pottery, have lunch in the Yaak'a Café, or attend celebrations held throughout the year.

The cultural center offers guided tours to the top of the sandstone mesa and home of the San Esteban del Rey Mission; this is considered one of the best cultural tours in New Mexico.

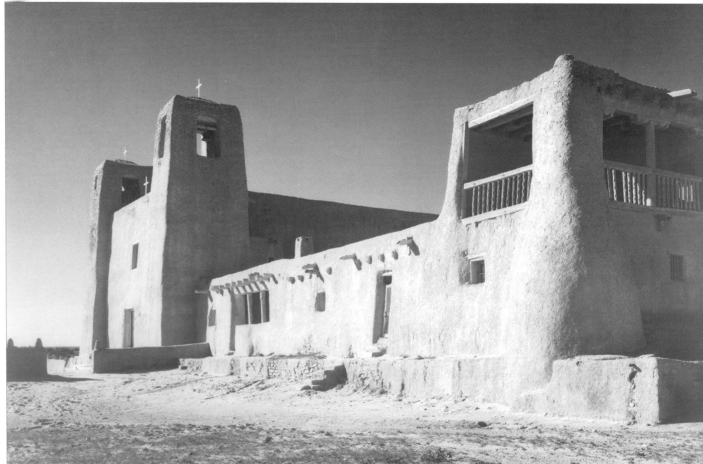

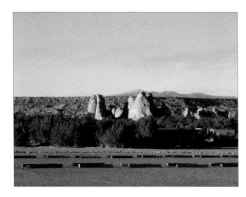

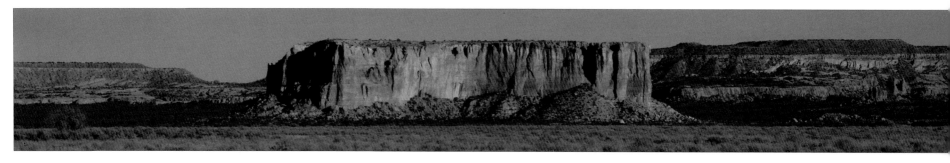

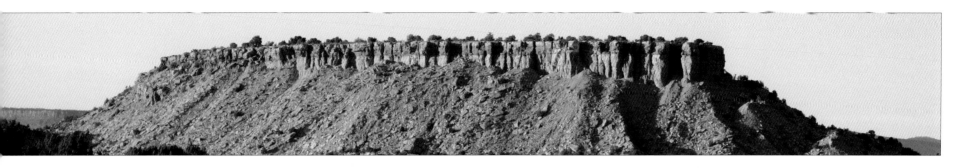

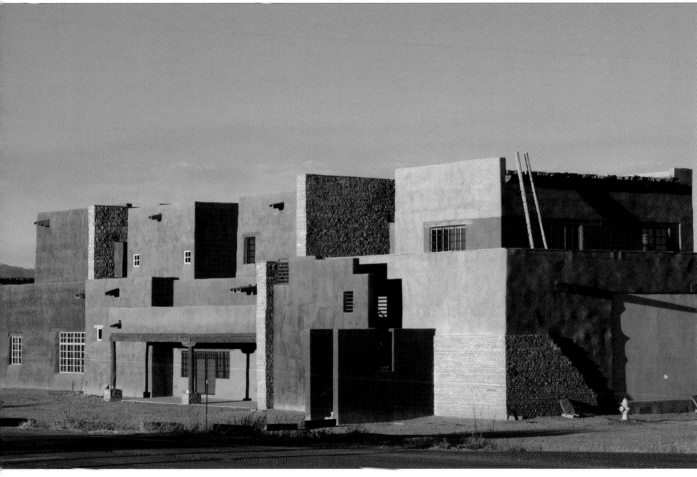

ACOMA PUEBLO SKY CITY

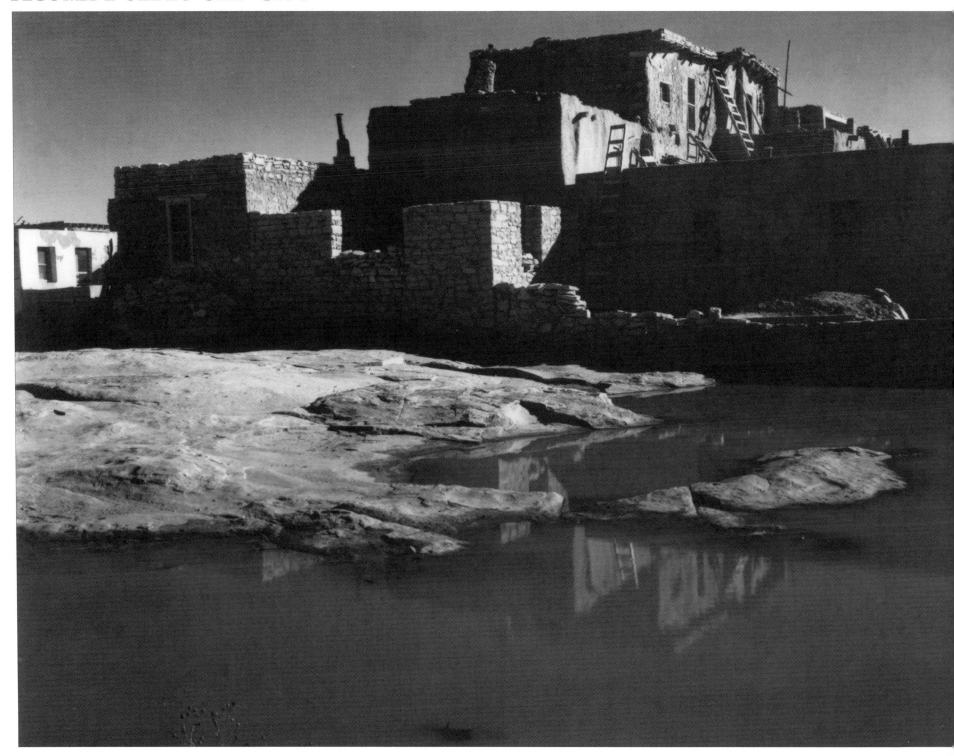

A photograph taken by Ansel Adams of the pueblo.

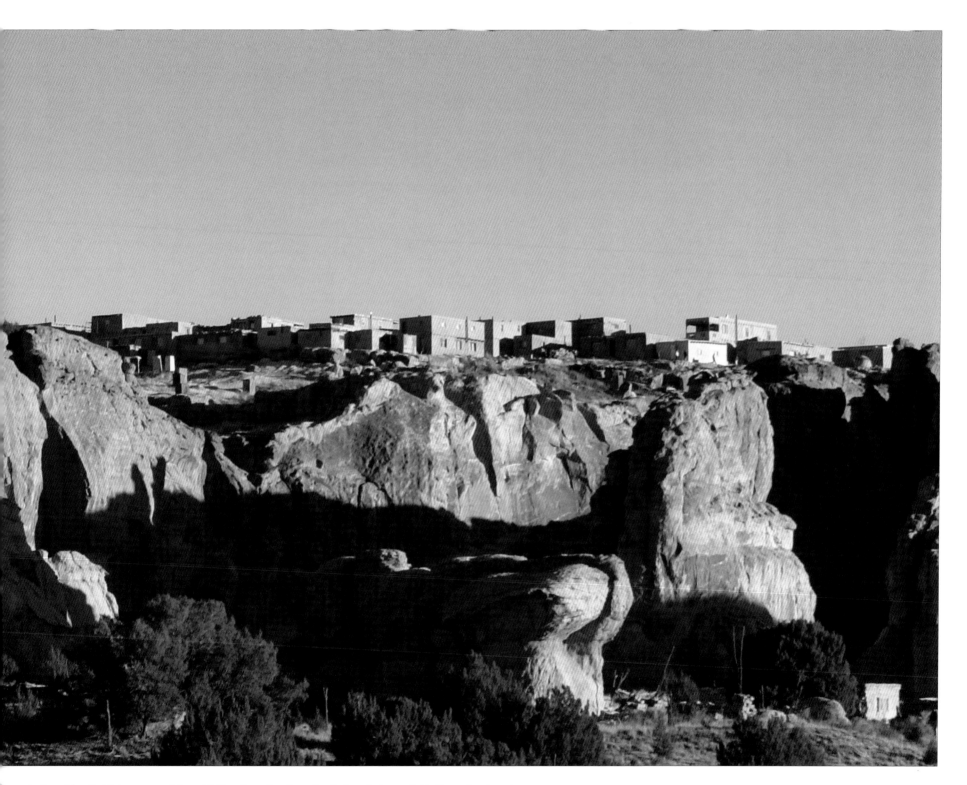

The actual pueblo sits high on a sandstone bluff and can be viewed only from below outside the cultural center.

GALLUP

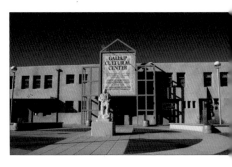

Founded in 1881 in McKinley County as a construction yard and railstop for the Atlantic and Pacific Railroad, the settlement was named after David L. Gallup, who at the time was a paymaster for the railroad. The railroad workers came to him for their pay and would talk of "going to Gallup" and so the name took hold and stuck.

The massive railroad construction project attracted workers from across Europe, Asia, and Mexico, many of these same people then stayed on and settled to work in the coal mines.

The area still has huge ethnic diversity, not least for the Native Americans who have occupied the land for thousands of years and hence Gallup's nickname of "the Indian Capital of the World." Gallup lies in the heart of Hopi, Navajo, Zuñi, Acoma, and other Native American lands; in Navajo the city is called Na'nizhoozhi. Studies show that at least a third of the city's inhabitants have Indian heritage.

Today Gallup is an important trading town and a thriving tourist center for visitors interested in seeing and studying Native American culture and is also the hub for "America's largest cottage industry," namely Native American arts and crafts.

The famous Route 66 runs through Gallup and the Bob Dylan song about the road name checks the city, "You'll see Amarillo and Gallup, New Mexico..." The surrounding area boasts stunning scenery with high desert mesas such as Canyon De Chelly, Church Rock sandstone spires, Pyramid Rock, and Mt. Taylor, and nearby Red Rock State Park.

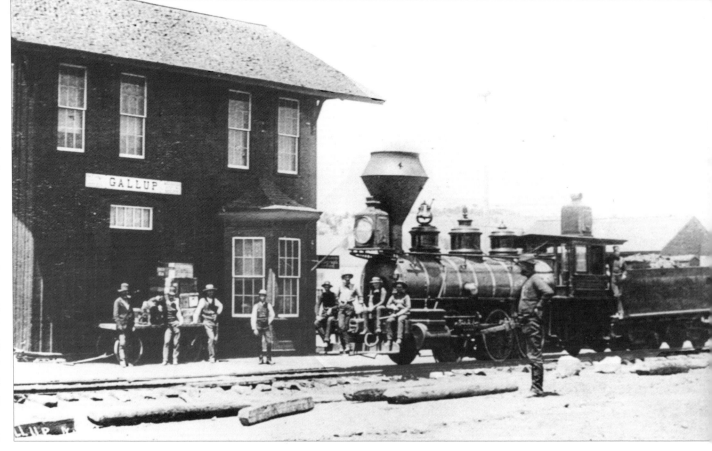

Railroad depot, Gallup, 1890.

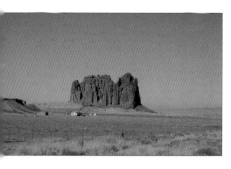

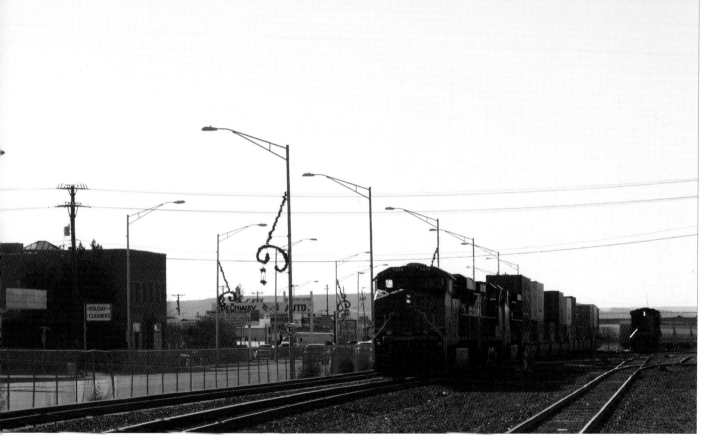

Modern-day freight trains are all that remain today of the once-powerful AT & SF railway, now part of the BNSF railway corporation.

FARMINGTON

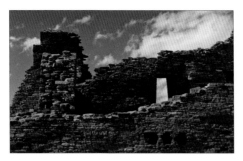

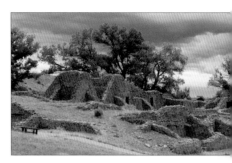

Called *Tótah* in Navajo, Farmington in San Juan County got rich in the twentieth century on the proceeds of growing apples. However, the area in which it lies was originally inhabited over 2,000 years ago by the Anasazi "basketmakers" who lived at first in pit houses before moving into pueblo-type homes carved out of the soft sandstone rocks. After the Anasazi left, the land was taken over by the Jicarilla Apache, Ute, and Navajo tribes whose distant descendants still populate the region. The settlement of Farmington grew around the confluence of the Animas, San Juan, and La Plata rivers on the Colorado Plateau and began around the mid-1870s when pioneers from Animas City, Colorado, settled there. It soon became a flourishing farming and ranching area and as the town grew its name was simplified to become Farmington.

By the early 1900s apples had become the most important local crop, a trend which continued well into the twentieth century. In 1938, for example, apple orchards containing around 53,000 trees occupied some 2,000 acres in the San Juan district. In common with other parts of New Mexico, oil and natural gas saw localized boom times during the twentieth century, even making Farmington for a time the leading production area in the whole of New Mexico. Although not so prominent, oil, coal, and gas are still mainstays of the local economy.

A number of important Native American historic sites lie close by. The Four Corners National Monument where the states of Colorado, New Mexico, Arizona, and Utah all meet lies to the Northwest.

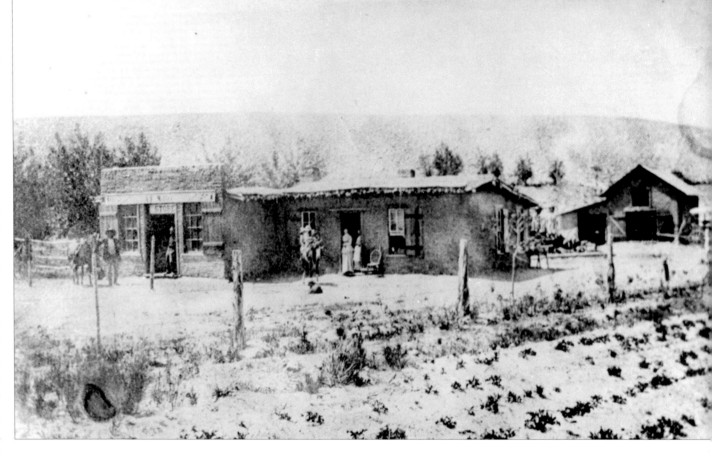
A.F. Miller store and home, Farmington, c. 1880.

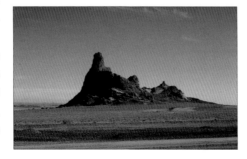

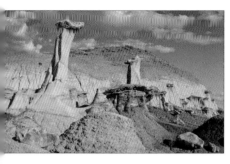

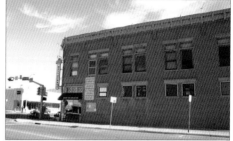

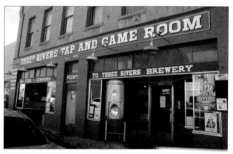

Farmington West Main Street today.

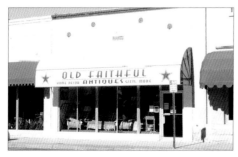

ABIQUIU

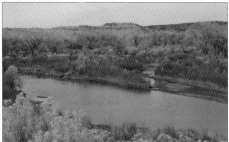

Called Ha'ashgizh in Navajo, Abiquiu is located in Rio Arriba County in northern New Mexico. Abiquiu's most famous resident was the artist Georgia O'Keeffe who lived here at Ghost Ranch between 1949 and her death at age ninety-eight in 1986. She first came to Taos in 1929 to visit friends and heard about Ghost Ranch and was intrigued. When she first saw Ghost Ranch it was a dude ranch and she would visit every summer. In 1940 O'Keeffe bought a small portion—seven acres and a house, Rancho de los Burros—of Ghost Ranch. However, wanting a winter home and a garden, she bought three acres in the village of Abiquiu which she moved to permanently after her husband Alfred Stieglitz died.

The Abiquiú Reservoir/Dam was constructed in 1963 by the U.S. Army Corps of Engineers. The Abiquiú Lake now covers about 2,000 acres of former Ghost Ranch land. This 4000-acre lake with camping at Riana Campground include excellent facilities surrounded by red sandstone cliffs and mesas.

In 1989 the Georgia O'Keeffe Foundation became owner and manager of the Abiquiu property. The Foundation, a nonprofit organization dedicated to perpetuating the artistic legacy of Georgia O'Keeffe for the public benefit, began a program to preserve and maintain the house and its contents as one of the most important artist's home and studio complexes of the twentieth century.

The Foundation has recently transferred the Georgia O'Keeffe Home and Studio to the Georgia O'Keeffe Museum.

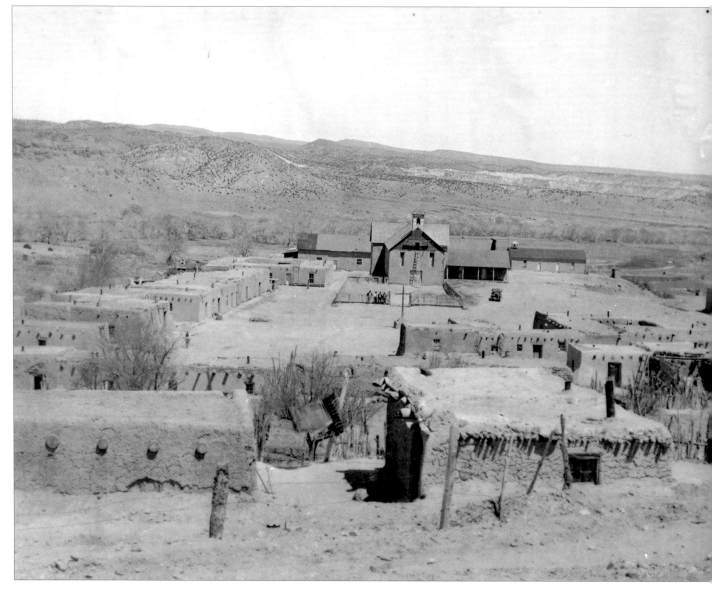

A 1920s photograph of the plaza in Abiquiu.

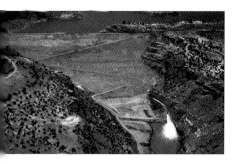
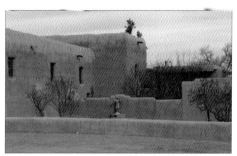
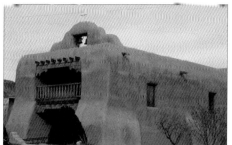

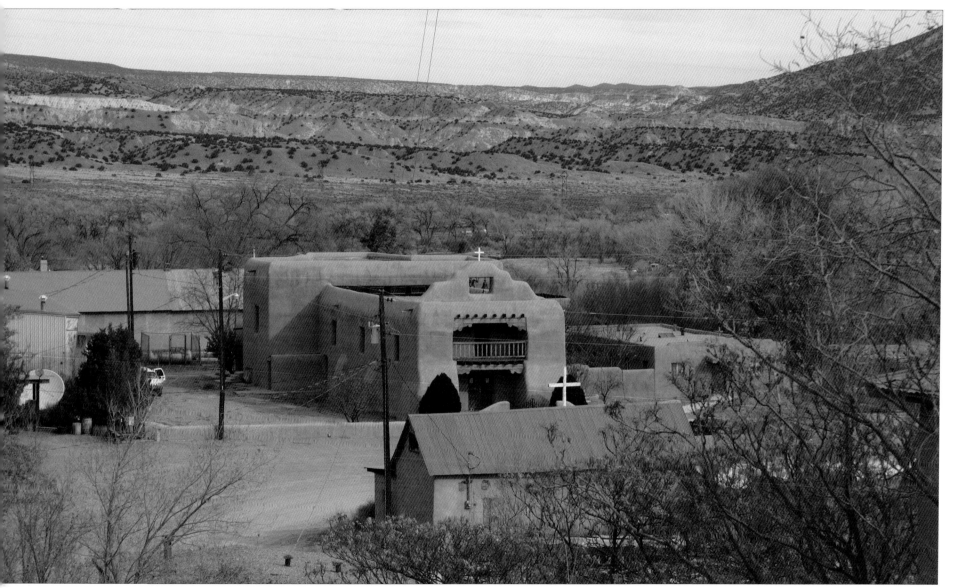

he plaza today is still beautifully maintained.

SANTA CRUZ

This area was not settled until after the Spanish colonization of New Mexico when people attracted by the fertile soils and the beautiful environment slowly started to inhabit the land. There was no formal administration, rather the local San Juan missionary kept an eye on things. During the Pueblo Revolution in 1680, the Spanish settlers fled to safety or were killed, and their houses and fields were taken over by Tanos Indians from the nearby pueblos of Galisteo, San Lazaro, and San Cristobal for the twelve years the settlers were away. During this time they formed a sizable community before being reconquered by De Vargas.

The Spanish settlers returned to New Mexico and Santa Fe after twelve years in 1694, but the capital had no accommodation for all the returning Spanish and new settlers from Mexico. The solution was for the sixty-six families to be established in a new town of Santa Cruz, but the Native Americans who were living there had to be removed first. They had settled happily there and were unwilling to move back to their old pueblos.

Santa Cruz was the first town to be established after the founding of Santa Fe: it was formally called La Villa Nueva de Santa Cruz de la Cañada. Their first priority was to build a church. The town grew well and became politically important, especially during the Mexican era from 1822 to 1846.

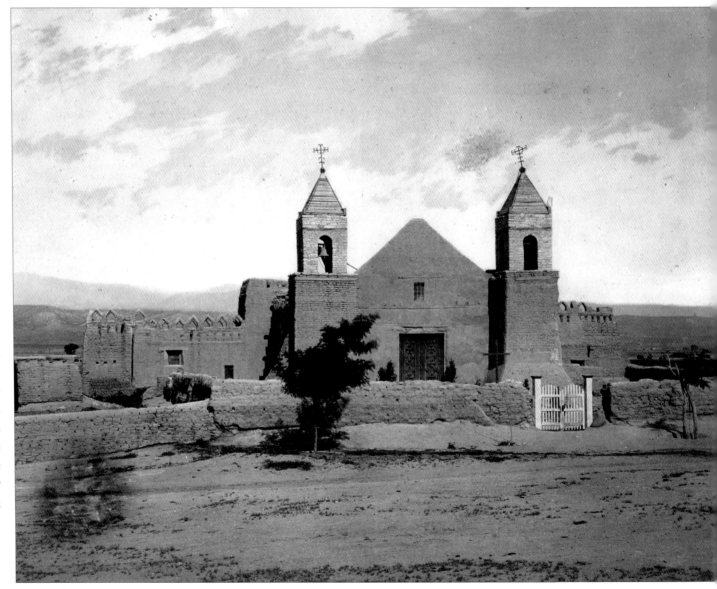

The church at Santa Cruz as it stood in 1881.

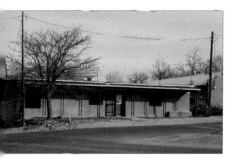 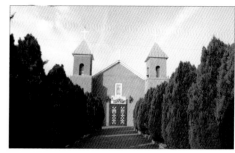

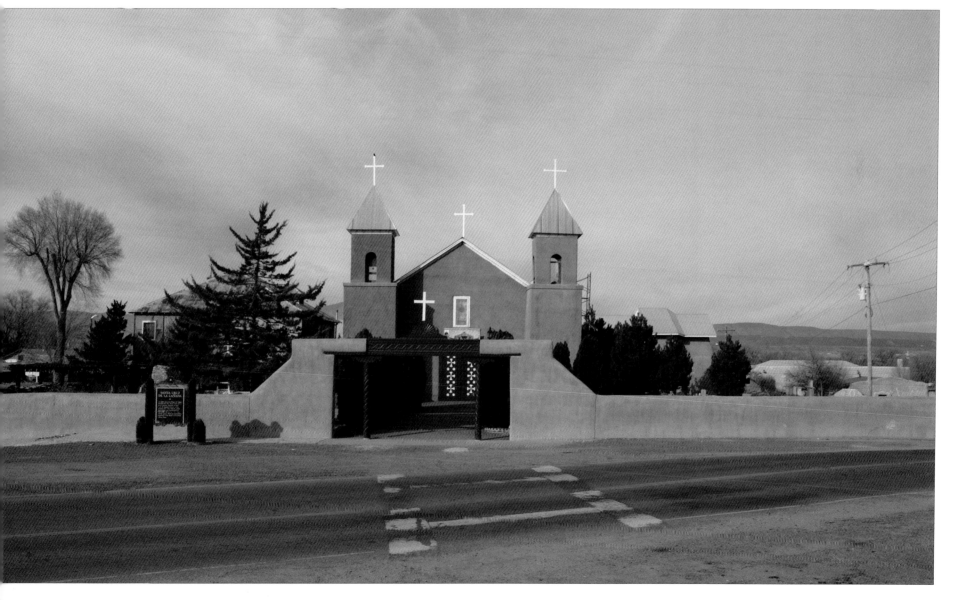

The mission church still stands after almost three centuries and is considered the best mission church in all of New Mexico.

BANDELIER

This area has been inhabited for over 10,000 years when nomadic hunter-gatherers roamed the land following migrating wildlife through the wild landscape. Archaeologists have shown that by about 1,150 ancestral Pueblo people started to settle and build themselves permanent settlements. They stayed in the area until the mid-sixteenth century when they moved to new pueblos along the Rio Grande—Cochiti, San Felipe, Santa Clara, Santa Domingo, and San Ildefonso.

When the Spanish colonized New Mexico the new government gave land grants to Spanish settlers in the Frijoles Canyon area. In 1880 Jose Montoya from Cochiti Pueblo brought Adolph Bandelier to Frijoles Canyon and showed him his people's ancestral homelands.

In 1916 legislation to create Bandelier National Monument was signed by President Woodrow Wilson.

In 1925 Evelyn Frey and her husband, George, arrived to take over the Ranch of the ten elders that had been built by Judge Abbott in 1907. Between 1934 and 1941, workers from the Civilian Conservation Corps (CCC) worked from a camp constructed in Frijoles Canyon. Among their accomplishments is the road into Frijoles Canyon, the current visitor center, a new lodge, and miles of trails. During the early days of the Manhattan Project, Bandelier Lodge was used to house Manhattan Project scientists and associated military personnel.

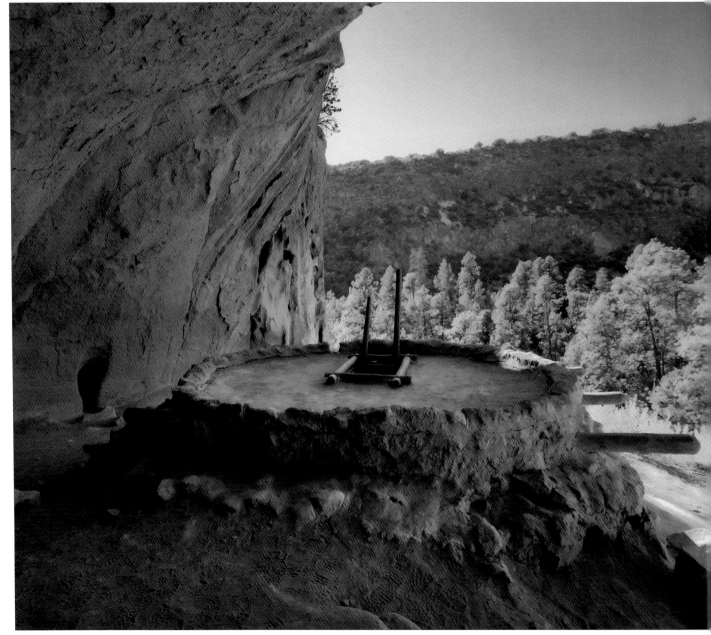

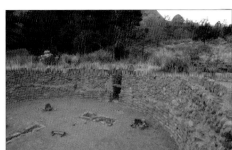

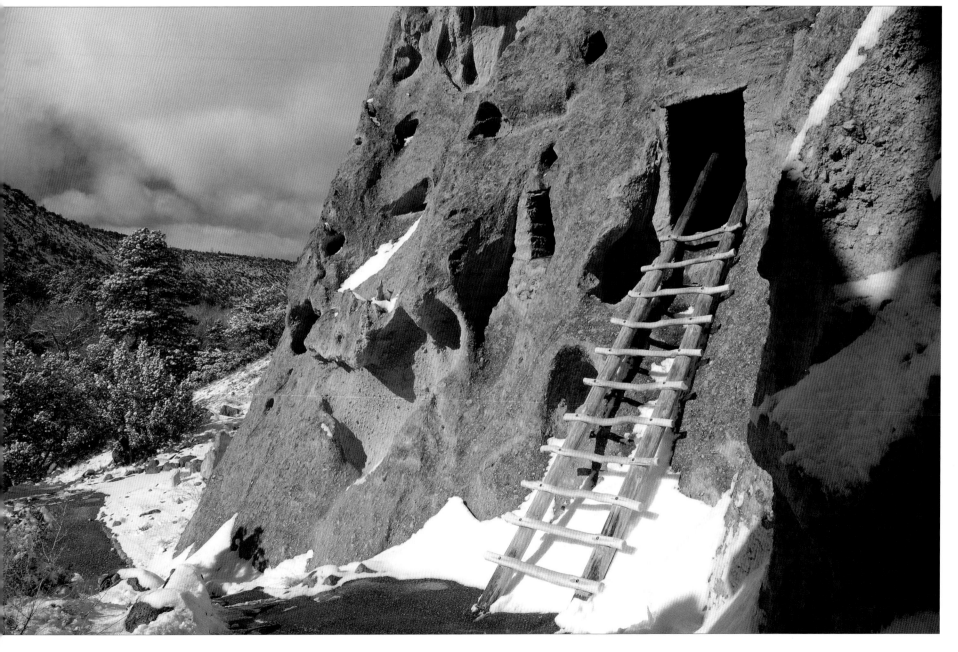

LOS ALAMOS

In north-central New Mexico lies the state's smallest county, just 8 miles wide and 13 miles long. Los Alamos sits on a high, gently sloping plateau, cut by a series of steep, fingerlike canyons. Early archaeologist Edgar Lee Hewett named the plateau *Pajarito*, which means "little bird" in Spanish. The county is bordered by the Jemez Mountains on the west and a labyrinth of 700- to 1,000-foot cliffs flanking the Rio Grande on the southeast. Elevations range from 5,400 feet at the river to 10,500 feet at the top of Caballo Mountain. Los Alamos is home to the Los Alamos National Laboratory which was established to research and develop the Manhattan Project—the atomic bomb. Before the nuclear laboratories existed, the site was occupied by the Los Alamos Ranch School founded in 1917. The area was first occupied by the Keres and later the Tewa tribes.

Los Alamos National Laboratory was code named Project Y and was instigated in 1943 during World War II to design and build an atomic bomb to combat the Nazi threat to Europe and by extension to the rest of the world. Project leaders decided a test of the plutonium bomb was essential before it could be used as a weapon of war. From a list of eight sites in California, Texas, New Mexico and Colorado, Trinity Site was chosen as the test site. The area already was controlled by the government because it was part of the Alamogordo Bombing and Gunnery Range which was established in 1942. The secluded Jornada del Muerto was perfect as it provided isolation for secrecy and safety, but was still close to Los Alamos.

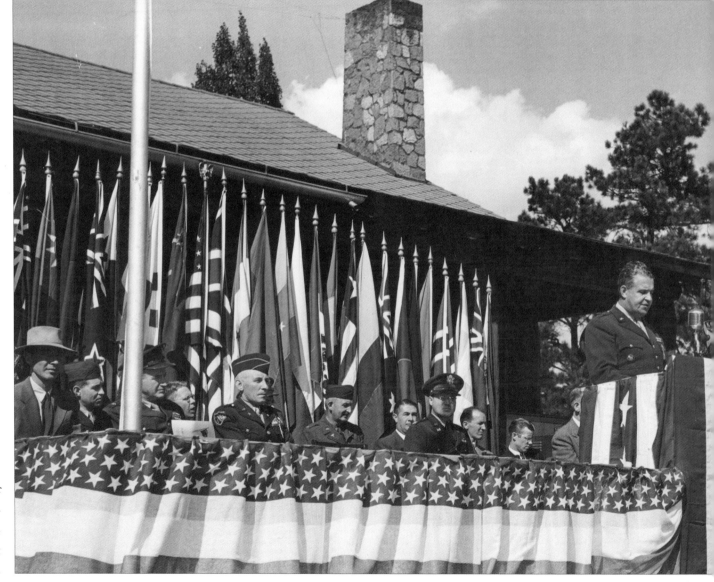

Among the people shown in this photograph are Lieutenant General Leslie Groves (standing), the military leader in charge of the Manhattan Project, and Robert Oppenheimer (far left wearing hat), who was commonly known as the "Father of the Atomic Bomb."

uller Lodge still exists and now incorporates a museum. The building was one of the main structures of the Los Alamos Boys Ranch School, serving s its headquarters in its later years. It was converted into a mess hall and guest quarters during the Manhattan Project.

LOS ALAMOS

The leading scientist on the project was Robert Oppenheimer who worked under the military direction of General Leslie R. Groves at Los Alamos. Peace in Europe was agreed in May 1945 but the war in the Pacific raged on against Japan. On July 16, 1945, the world's first atomic bomb was detonated 200 miles south of Los Alamos at the Alamogordo bombing range and the world entered the nuclear age. A few weeks later on August 6 and 9, atomic bombs were dropped on Hiroshima and Nagasaki respectively; five days later the Japanese officially surrendered.

The Los Alamos National Laboratory is one of the leading nuclear research institutions in the world. These days the laboratory is a world leader in advanced technologies with particular respect to energy technologies. As well as nuclear research the lab investigates areas such as hydrogen fuel cell development, super computing, and applied environmental research. However, Los Alamos's prime responsibility is to maintain the effectiveness of the U.S. nuclear deterrent.

Also to be found in the town of Los Alamos is a marvelous military surplus store, the Black Hole, founded by Ed Grothus, a former Los Alamos National Laboratory employee, and if you ask them nicely they'll show you the trailer full of relics from the Manhattan Project.

Pajarito Mountain Ski Area is located in the Jemez Mountains northwest of Los Alamos. It is located on 850 acres of privately owned land. The Los Alamos Ski Club (LASC) owns and operates Pajarito Mountain. A typical season runs from Christmas to early April.

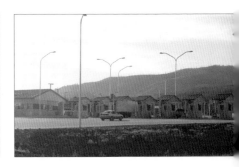

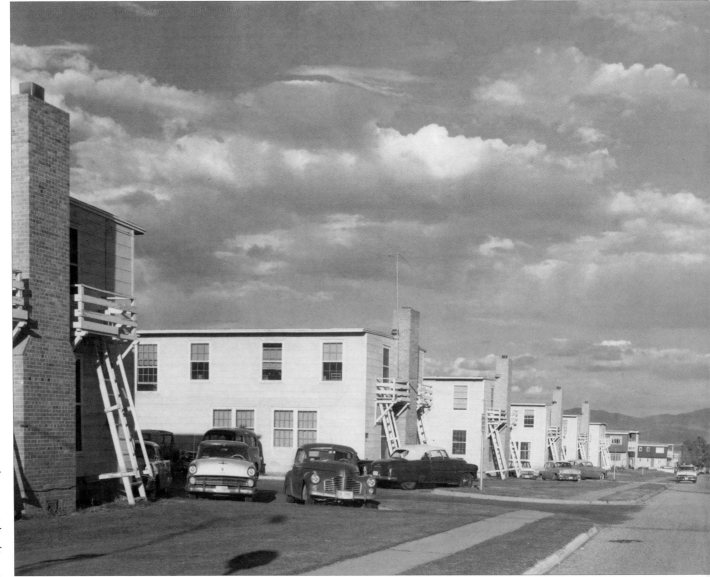

Dormitories at Los Alamos Scientific Laboratory, Los Alamos, 1955.

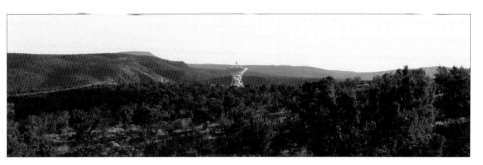

The Bradbury Science Museum is the chief public facility of the Los Alamos National Laboratory, with exhibits telling the story of the development of the worlds first atomic bomb.

LOS ALAMOS

The spectacular vistas of the Jemez mountain range.

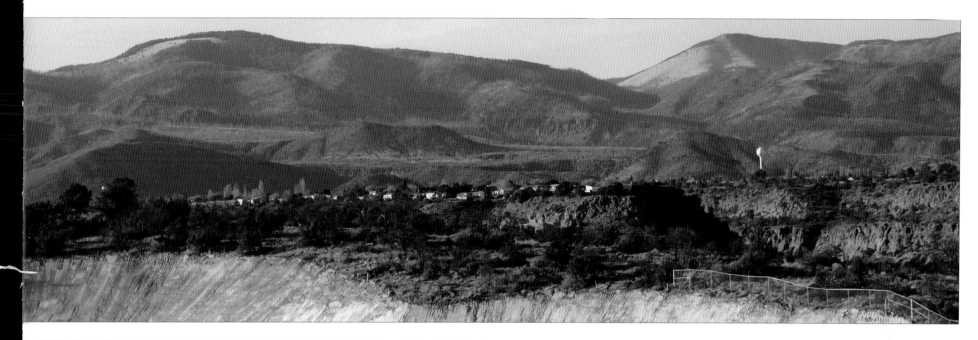

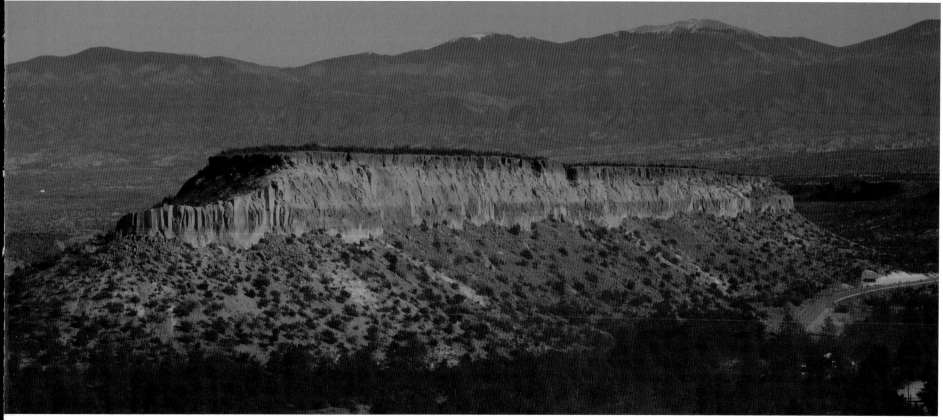

Battleship Rock, located near Jemez Springs, part of the Santa Fe National Forest.

INDEX

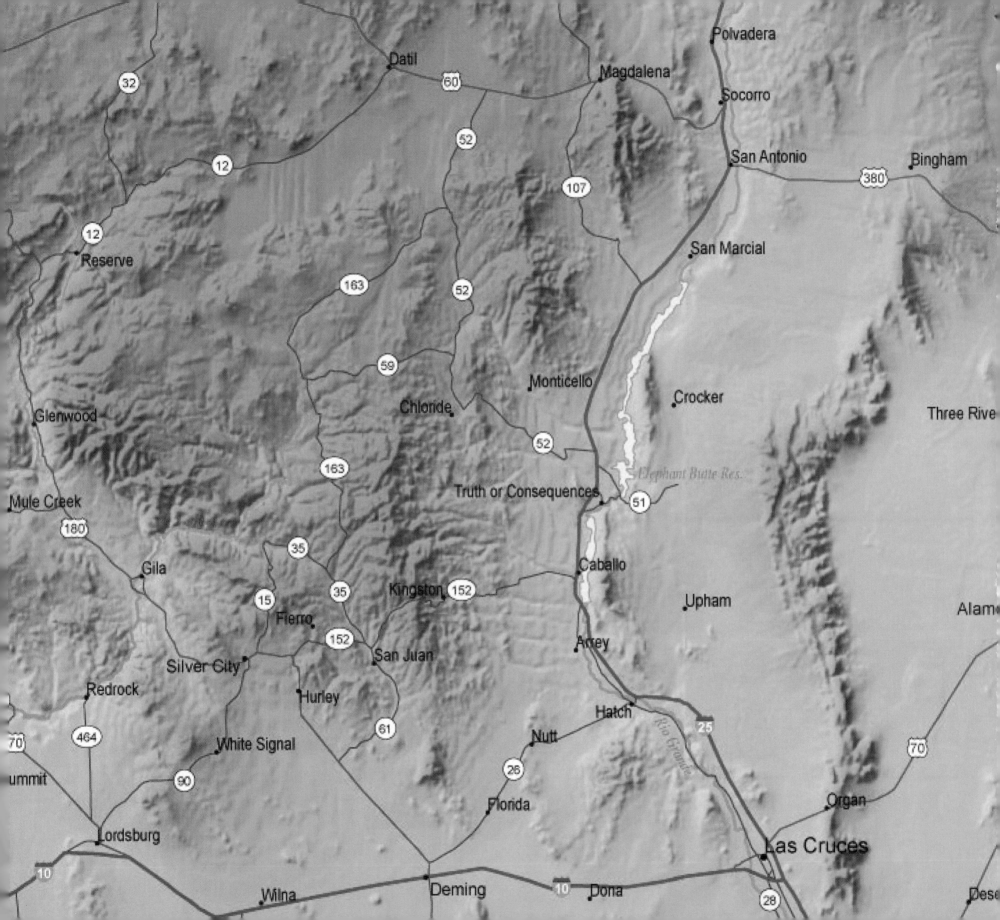